# THE PORTLAND VASE

# THE
# PORTLAND
# VASE

*The Extraordinary Odyssey
of a Mysterious Roman Treasure*

## Robin Brooks

HarperCollins*Publishers*

HarperCollins books may be purchased for educational, business, or sales promotional use. For information, please write: Special Markets Department, HarperCollins Publishers Inc., 10 East 53rd Street, New York, NY 10022.

FIRST EDITION

Designed by C. Linda Dingler

Printed on acid-free paper

Library of Congress Cataloging-in-Publication Data
Brooks, Robin (Robin Jeremy)
  The Portland Vase: the extraordinary odyssey of a mysterious Roman treasure/Robin Brooks.
    p. cm.
  Includes bibliographical references and index.
  ISBN 0-06-051099-4
    1. Portland Vase. 2. Glassware, Roman. 3. Vases—England—London. 4.British Museum. I. Title.

NK4653.P7B76 2004
748.8—dc22                                               2004047704

04 05 06 07 08 ❖/RRD 10 9 8 7 6 5 4 3 2 1

# FRAGMENTS

## THE LIP

## THE BODY

## THE BASE

# THE LIP

# PROLOGUE

G O UP THE MAIN STEPS of the British Museum and into the foyer. Resist the push of visitors drawn to the magnificent vista of the new Great Court straight ahead; instead, steer toward the left-hand side of the foyer, through the swirl of tourists and schoolchildren, to the broad stairway leading up. It has a slightly neglected air—dim, gray, and shabby; once the main stairway, it has been sidelined by the radical alterations and the rediscovery of the central courtyard of the museum. Go up it all the same, up two wide, high, echoing flights, and you will arrive on the upper floor of the museum. Turn sharp right, and start to walk through the galleries. This route will take you through a Bronze Age gallery, the HSBC Money Gallery, and finally down the long straight run of Galleries 69 to 73, devoted to Ancient Greece and Rome. There are many treasures here, and about halfway down you will find the Portland Vase, the most famous of them all, sitting on a plinth, at about chest height.

It's easy to walk straight past, even if you are looking for it. It's small, squat even, barely taller than the span of your hand; nine and

three-quarter inches high, and at its widest point only seven inches wide. There's a significant chance that it will be obscured from view by a small group of tourists; the vase is a highlight on tours of the museum, and more likely than not a guide will be holding forth about it, though very possibly in a language you cannot understand. Wait until they have moved on or elbow your way through, and take a closer look.

Once you see the vase properly, you realize that there is something striking about it after all. For one thing, it is different from everything else in the gallery. All around are stone and terra-cotta and other imperishable materials. There are many objects of metal: bronze, silver, even gold. But nothing like the vase, because the vase is made of glass: cobalt blue, opaque, with a deep, dull sheen. It has an air about it; it is so fragile, delicate, and yet so *old;* as much as two thousand years old. What has it seen? By whom has it been handled and admired, bought and sold, in all that time?

A decorative frieze runs around the body of the vase where an outer skin of white glass has been carved away, leaving figures in relief, against the deep blue backdrop to the scene. The carving is extraordinarily delicate; some parts of the white glass have been whittled down to a thinness that allows the blue to show through underneath, providing effects of shading, shadow, and distance.

Two handles of blue glass connect the neck with the shoulder of the vase. Below these runs the frieze of figures, set in a landscape of stylized trees and rocks. There are seven figures, divided into two scenes by the handles. On one side: a young man with a cloak hanging from his hand; a young woman, seated, with a serpent between her thighs, who reaches out behind her to clasp the young man's outstretched arm; a cupid, who flies above them with a bow and torch; a bearded man, standing, with his hand to his chin. On the other side: a young man, seated on rocks; a young woman, lying on a similar out-

crop, with a torch upended in her loosened fingers; a woman, seated, holding a long staff.

There is another object beside the vase: a disk of blue, again overlaid with white carved glass. This disk once served as the flat base of the vase. The carving shows the head and shoulders of a man, wearing a soft cap. He is holding his finger to his lips, as though doubtful, or keeping a secret.

Who are these figures? Who carved them and what were they meant to signify? The vase is silent. Here it sits: frozen, seemingly immortal, and pregnant with secrets. But look more closely still, and you will see that the surface of the vase is webbed with fine cracks; it has suffered during its long life. Here is palpable evidence of some catastrophic event—a first clue to the mystery and the extraordinary history of the Portland Vase.

# THE BODY

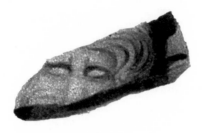

# BREAKING

FEBRUARY 7, 1845, could not be described as a quiet day at the British Museum. The museum was halfway through a painful process of total transformation from its original home in the outmoded and outgrown Montague House to the large new building designed by Robert Smirke, which was going up piecemeal in its place. The museum was a building site; Montague House was being slowly demolished, and beside it the new wing, known as the Lycian Gallery, intended to hold treasures from excavations in Anatolia, was rising apace. The site was covered with laborers, great wooden beams of scaffolding, draft animals, and even soldiers to guard the works. Iron wall ties were being forged in situ, a rather rickety-looking contraption called a "traveler" conveyed massive blocks of Portland stone (no relation) about the site, and top-hatted supervisors stalked through the confusion. The Keeper of Manuscripts, Frederic Madden, was still living with his family (including a very pregnant wife) in what was

left of the old buildings. He complained of the "insufferable dirt and noise." His water supply had been cut off. Rats and bugs, fleeing the demolition, infested his apartments. The western wall of the building was leaning at an angle that left him "in continual dread of its falling down" and burying him and his family in its ruins.

The new structures were no safer than the old. A contemporary artist recorded an accident during the building of the Lycian Gallery during which a five-ton girder that was being hoisted up to the roof—a process that took four hours—broke loose and crashed to the ground, breaking into fragments but mercifully missing the workmen.

In all this chaos, the business of the museum went on as best it could. The vase sat under its glass cover in Gallery 9, and at the end of a freezing winter afternoon a handful of visitors strolled about, enjoying the last look ever taken of the vase in its pristine state. A young man had entered the room, with "something strange in his looks and manner." He waited until the guard had walked out into the larger, adjoining gallery—Gallery 10—then he picked up a large fragment of sculpture from the ancient city of Persepolis that was lying at hand and heaved it at the vase. Had he hit it fair and square, he would have reduced the vase to an irreparable cloud of splinters and dust, but his hand was shaky, his aim was off, and the greater part of the missile hit the floor, leaving a hefty dent in the flagstone. Nevertheless, the solid glass cover was broken through, and the vase itself smashed into more than two hundred pieces. Something that was born under the Caesars and had survived countless generations perished in an instant.

The noise brought the public and the guards running. It brought "officers of the department" from an adjoining room, and they acted with commendable speed, immediately ordering the attendants to close the doors to Galleries 9 and 10. The five members of the public still in Gallery 9 were asked to walk next door, where they were questioned by the Keeper of Antiquites, Edward Hawkins. Four of them,

understandably worried that they might be falsely accused of complicity in the outrage, answered promptly. The fifth hung back until directly confronted. "A stout young man, in a kind of pilot coat, with both hands in his pockets before him, replied, when questioned, in a dogged and determined tone, 'I did it.'" He was handed over to a police officer. The attendants began gingerly to clear up the mess. Frederic Madden, summoned by a messenger, appeared to look over what was left of the vase:

> On proceeding up to the room where it was exhibited, I found it strewed on the ground in a thousand pieces, and was informed that a short time before a young man who had watched his opportunity when the room was clear, had taken up one of the large sculptured Babylonian stones, and dashed the Vase, together with the glass cover over it, to atoms! The man, apparently, is quite sane, and sober.

For Madden, no democrat, the moral was clear, and he confided it to his journal:

> This is the result of exhibiting such valuable and unique specimens of art to the mob! Had the *facsimile* been shewn to them, and the *original* kept in Mr Hawkins's room, this irreparable mischief could not have taken place. Indeed as to the mob of visitors, I am so confident that they never regarded it, that if the stone which broke it, were put in its place, it would excite a great deal more attention. It is really monstrous to witness such wanton destruction! I am quite grieved about it. Yet what will be the punishment? Perhaps a fine of a few pounds or a month's imprisonment and he may then come out and destroy something else!

Much has changed, of course, since Madden's day, but there are curators here and there who still find it hard to fight the conviction that the objects in their care belong to *them*, and not to greasy hoi polloi who so impertinently insist on trampling through the galleries for which their taxes are paying.

A trustee of the museum happened to be on site, looking at manuscripts in Madden's room, and it fell to him to grovel in a letter to the Duke of Portland, who had loaned his vase to the museum, with news of the "most lamentable occurrence which has happened only a few minutes ago within our walls. . . . I have this minute come from the room, where the attendants are occupied in sweeping up the remnants of what less than an hour ago was one of the noblest ornaments of this great National Collection, and a monument of your Grace's liberality and of the trust you reposed in our safe-keeping."

The duke replied, with remarkable understanding and forbearance, that the catastrophe was "a misfortune against which no vigilance could have guarded it on the part of the Officers of the Museum. . . . I have no doubt that that man who broke the Vase whoever he is is mad. . . . It is perhaps fortunate that his madness has shewed itself in the way it has done instead of injury to human life."

But according to Frederic Madden, and many others who met the strange young man, he was not mad. Who was he, and why had he done what he did? He had been taken before the magistrate at Bow Street for a preliminary interview, but had refused to cooperate, offering no explanation for his actions, not even giving his name. He was taken down to the cells. All that could eventually be discovered about him was that he had exactly ninepence on his person; that he had been lodging at a coffeehouse in Long-acre, Covent Garden, not far from the museum; that he was living under the name of William Lloyd, but this was not his real identity; and that he was from Ireland. These details were duly recorded in the London *Times* the next day, and as the reporters had nothing else to go on, they

resorted to speculation: ". . . It is therefore assumed that his only motive for committing the wanton destruction of this ancient and national relic was a morbid desire of notoriety, strengthened, no doubt, by straightened circumstances."

Three days later William, as he could now be named, was again brought before Magistrate Jardine at Bow Street for a full hearing. The landlady of the coffeehouse was first examined. She revealed that when the defendant had first arrived at her establishment, he had given the name Lloyd, and had told her that he was a theatrical scene painter, just arrived from Dublin, and that he had lost his trunk. She also described him as "regular in his habits," keeping to himself and avoiding the public rooms. There were more revelations: William had talked of how he left Dublin with a servant girl, and with eight hundred pounds in his pocket. Then William was brought in. Arrayed against him were Sir Henry Ellis, chief librarian of the museum, Keeper of Antiquities Edward Hawkins, two solicitors to the trustees—Messrs. Barnwell and Lutwidge—and the counsel for the prosecution, Mr. Bodkin ( "bodkin" is an archaic English word for a short, pointed instrument like a dagger or a needle, and a name for a prosecutor that surely even Dickens could not have bettered). There was no counsel for the defense; the prisoner stood alone in the dock. Everyone—*Times* reporters, museum officials, and learned counsel— had a chance to take a good look at him. At the time of the outrage he had been described as "stout," but now he seemed "thin." Perhaps the image he projected at the scene of the crime had been inflated by the emotional charge of his violent action, and certainly three penniless days in the cells would have been a deflating experience. He was in his early twenties, fair-haired, appeared "delicate," and reinforced this impression by speaking in a low, weak voice and the soft southern Irish accent. He was respectably dressed, and in an age when social distinctions were clearly marked by appearance, this was hard evidence that he did not come from the lower orders. He was not a mem-

ber of the brutish mob that Madden feared; as his speech revealed, he was educated and from a relatively well-to-do background.

The clerk of the court asked the accused if he still refused to give his name and address. The prisoner replied, "Yes, sir, I do. I wish to say that my reason for refusing to give my name is simply this—that I do not wish to involve others in the disgrace which I have brought upon myself." Having begun, he went straight on to the root of the matter: he seemed to want to unburden himself immediately. First came a confession: "I certainly broke the vase, and all I can say in extenuation of my conduct is, that I had been indulging in intemperance for a week before, and was then only partially recovered from the effects which that indulgence had produced upon my mind." This was not an explanation, but the prisoner immediately tried to supply this, too, apparently as best he could: "I was suffering at the time from a kind of nervous excitement—a continual fear of everything I saw; and it was under this impression, strange as it may appear, that I committed the act for which I was deservedly taken into custody at the Museum. I can assure you, Sir, there was no *malice prepense*—no design or evil intention whatever on my part towards any person."

The prisoner quoted legal jargon, as though to reinforce his social status and make it clear he was not just a common drunken vandal, but an ordinary, decent person suffering from an unusual affliction. He may even have been a law student, but his explanation was far too vague to satisfy the court. Psychoanalysis and psychiatry were hardly even in their infancy—Sigmund Freud was born more than a decade after the smashing of the vase—but now the twenty-first-century reader reaches automatically for diagnoses such as "nervous breakdown," "paranoia," and "schizophrenia." Even for us, armed with modern knowledge, the proffered explanation still leaves much obscure. Had some sort of mental disturbance driven him to flee from Dublin, or had he just eloped with the servant girl? Was some problem in his relationship with this girl the cause of his outburst? There was

no sign of her now in court, or anywhere else. Was the "eight hundred pounds" a fiction, or an exaggeration, or had he really acquired this money in some way and run through it all? Most important, what drove him into Gallery 9 that wintry afternoon? Did he just come in to escape the cold, or had he been haunting the gallery for days, peering continually at the vase, and deliberately singling it out for destruction? He cannot, as the *Times* had suggested, have harbored a "morbid desire of notoriety," since he was refusing to reveal his true identity. He had told his landlady he was a "scene painter"; did he have some artistic training that might have led him, out of obsession or envy, to the vase? It is difficult to prevent the imagination from providing answers to these questions. Inexplicable acts of violence are the currency of modern novelists, and one can picture "William Lloyd" as a dysfunctional protagonist, like Raskolnikov or Stephen Daedalus, with the blank city streets, the cheap room, and the disconnected thoughts of a stifling mother or a tearful girlfriend grinding round and round. All we know for certain is that, out of all the objects in the great treasure house of the museum, William chose the vase on which to vent his destructive fury. He did not go to the National Gallery to shove his walking stick through a Titian; he did not choose to throw paint over the Elgin Marbles, or take a chisel to the Rosetta Stone. It was the vase that attracted him—its beauty and fragility calling forth the strongest response from the human heart, for good or ill, as it always had.

In any case, none of this concerned Mr. Bodkin, whose own sense of justice seems to have been more about revenge that explanation. But—unable to live up to his name—he could not at first get to the point. He was a member of Parliament, and not the sort of lawyer to use one word where twenty would do. He expatiated on the "beautiful and valuable specimen of art which the prisoner had wantonly destroyed whilst exercising that privilege which was open to the public without restriction." He described how the medical officers had

found the prisoner to be of sound mind and therefore responsible for his actions. He took for granted the prisoner's guilt, and the rest of his speech was concerned not with whether the prisoner should be punished but with how he should be punished. Here he acknowledged an unfortunate aspect of the law, something of a loophole. The only way the offense could be dealt with was under Section 24 of the Wilful Damage Act. He read the relevant sections of tortuous legal language to the court. He debated their interpretation at length, having detected an ambiguity. Any person guilty of damage—"shall forfeit or pay such sum of money as shall appear to the justice to be a reasonable compensation for the damage, injury, or spoil so committed, not exceeding the sum of five pounds." (It would have taken the average workingman of the time five or six weeks to earn this kind of money.) Did this sum of five pounds refer to the value of the object damaged, or the amount of the fine? If the former, then it would appear that the prisoner would escape punishment, for there was no getting over the fact that the vase was worth rather more. This vandal would get off scot-free, in other words. Bodkin himself did not welcome this conclusion. He warned the magistrate of the consequences: Open season would be declared on the treasures of the British Museum. Any member of the public would be able to wander in and smash whatever he chose with impunity. He quoted the precedent of the man who had thrust his walking stick into a painting in the National Gallery, and who had been successfully fined by Magistrate Maltby at Marlborough Street under Section 24, despite the potential loophole. He rested his case.

The magistrate, who had doubtless been frowning through all this, turned first to the prisoner: "You have heard the statements which have been made to the Court. I am now prepared to hear anything further that you may wish to say." The prisoner thought it best to abase himself: "Whatever be the punishment you may feel it my duty to award me, I shall have the consolation of feeling that it has

been richly deserved." But Mr. Jardine had not made up his mind. He balked at the loophole and could not simply concede to the earlier precedent Mr. Maltby had provided. "It seems to me very doubtful whether I have any power at all to act in the charge before me, and therefore I shall take time to give that question more consideration."

One can imagine Bodkin sighing before rising to his feet again. Fortunately, he had a cunningly prepared fallback position: in addition to the complete demolition of the Portland Vase, a glazed case, by which the vase was covered, and which belonged to the trustees of the museum, was also destroyed. The value of this case was under five pounds, and therefore, without reference to the vase, he was instructed to proceed against the prisoner for the damage caused to the less important article. So, due to the complexities of the law, the prisoner was convicted not of the destruction of the vase, but of the case in which it sat.

Mr. Jardine was now ready to pass sentence: "There could be no doubt that, in the eye of the law, the prisoner had been guilty of wilfully and maliciously destroying this property, and—"

At this point the prisoner made his only protest, interrupting the magistrate: "It was not maliciously done," he objected.

Mr. Jardine answered him: "The law attributes malice to all such acts as these, in the absence of any other causes to which they could be ascribed. . . . I therefore convict you of the offence, and order you to pay three pounds; in default of which I commit you to hard labour in the House of Correction for two months." The prisoner was escorted out of the courtroom.

William Mulcahy was sent to Tothill Fields prison, where he immediately got on the wrong side of the turnkey and was handcuffed and put in solitary confinement. Perhaps this was because he was too much a gentleman; in the early Victorian period, London's criminal underclass was excessively brutal and base, even compared to the vilest modern gangsters, and the social divisions were far, far deeper.

A well-dressed student, however impecunious, might have been singled out. Wolf Mankowitz, in his book *The Portland Vase and Wedgwood Copies*, suggests, "Lloyd may have harboured other and even darker impulses, for which he was glad to gain correction," and that, disappointed with the leniency of his sentence, he took steps to exacerbate his punishment.

But if so, he was frustrated; only two days later a crudely written letter arrived for Mr. Jardine. "I take the liberty of enclosing three pounds as wich is the paultry penelty in default of paying wich you have sentenced my relation through Adam and Eve poor Mister William Lloyd the Irish gintleman to two months hard labour."

Three freshly minted gold sovereigns accompanied the letter, together with a warning that a copy had gone to the prisoner, so that the letter could not be ignored. Who had done this, and why? The mysterious benefactor supplied only a joke against the legal profession by way of explanation—he was himself, he said "an Irish Attorney," and having "robbed and imprisoned so many" to pay for the prisoner's release "will afford his consence some rest."

The prisoner was released, but the trustees of the museum were not done with him. They put him under surveillance and took steps to discover his true identity. "Lloyd" had admitted to being a pupil at Trinity College, Dublin. Now the college tentatively identified this pupil as one William Mulcahy, who had entered the college in the summer, and then disappeared. The trustees employed a private agent called Leonard Dobbin to investigate the Mulcahy family, hoping perhaps to bring a suit for damages. But Dobbin discovered that the father was dead, and "the mother is poor. . . . there is no property among them." William had a brother, who had studied at Trinity and was now a private tutor. His mother was a widow, "heartbroken" by her son's disappearance, but blissfully ignorant of the whole affair. The trustees told the Duke of Portland that they had uncovered Mulcahy's family, but he was once again in a forgiving

mood; he would, he said, "be very sorry" to make Mulcahy's family suffer for "an act of folly or madness which they could not control." There the matter rested, and whether William Mulcahy survived this episode and went on to live a normal if obscure life with his servant girl, or whether he spiraled down to misery and madness, is not known.

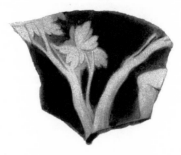

# MAKING

GLASS IS A TRICKY THING to work with, a paradoxical sub-stance. Apparently solid, it retains the structure and properties of a liquid. It is capable of displaying enormous strength; in theory a glass fiber can support more weight than steel. It is hard enough to blunt the sharpest, toughest cutting tools, and it is durable. It does not decay, and it can survive millennia untarnished. But it is also extremely fragile and brittle; because of its liquid structure, once a crack starts nothing will stop it from spreading. Although strong in compression, it is weak in tension. It is a poor conductor of heat, and a sudden change in temperature will create internal stresses that may prove fatal. If glass heats up, its surface will come under compression as it rises in temperature before the glass underneath it. If the glass is cooling, then the surface is put under tension, and this makes it even more vulnerable.

Glass occurs naturally, in the form of obsidian, a black glass cre-

ated by certain types of cooling lava, but men began to manufacture it at a very early date. Glass has been excavated from sites five thousand years old. Glass vessels have been discovered in Egyptian tombs. Tablets from the royal library of King Ashurbanipal at Nineveh, dating from some time in the seventh century B.C., carry recipes for making glass. The Roman writer Pliny tells a story of how glass was invented: a group of merchants, camped on the banks of a river, decided to use the blocks of soda they were carrying as supports for their cooking pots. In the morning they discovered that the heat from the cooking fires had turned the sand and soda into glass. This story, however, is apocryphal; temperatures of more than a thousand degrees centigrade are needed to make the necessary ingredients fuse into glass, far higher than could be generated by a cooking fire at a bivouac.

Early glass was colored by the addition of iron oxides and used to imitate precious stones; the treasures of Tutankhamen are much decorated with such things. Blue was the favorite colour of glass-makers; tiny amounts of cobalt and copper were added to the glass to create this color. White glass was made by adding antimony, which could also be used to produce clear glass. The first glass vessels were made by covering a core of straw and mud on a metal rod with molten glass. When the glass had cooled, this core could be picked out. Then vessels were built up from rods of molten glass, bent into circles, and fused together to build what is known as mosaic glass.

The technique of glassblowing was developed in Roman times, and the basic process has not changed much in the last two thousand years. Sometime in the first century B.C., glassworkers discovered that a gob of molten glass, set onto the end of a hollow metal rod, could be inflated into a globe and then shaped into a vessel. At first they blew the molten glass into prepared molds to form the desired shape, but the technique of blowing glass into shapes without a mold was soon perfected, possibly by Syrian craftsmen, and spread quickly

across the Roman empire. Right from the start it was recognized that there was something special about the manufacture of glass, an alchemical mystique that put it above other trades. Glassmakers kept their trade secrets closely guarded, and they had cachet. A street was named after them in ancient Rome. In the later empire they were exempt from taxation. By the time of the Renaissance they were a class apart, and even considered to be on a par with the aristocracy.

Blown glass was a luxury in ancient Rome. The emperor Nero paid huge sums for blown glass cups, and he is even said to have regarded broken fragments of rare vessels as worth keeping. His friend and adviser Petronius wrote a novel that satirizes the crass ostentation of a nouveau riche called Trimalchio. This oafish nabob boasts of his glassware, rating it above even his Corinthian bronze dinner set, because "it doesn't smell. If it didn't break, I'd like it better than gold." Trimalchio then tells the story of a craftsman who discovers the secret of unbreakable glass, which he demonstrates to the emperor, by dropping a piece of it on the pavement. He then picks up his work, and casually hammers out the resulting slight dent. The emperor, impressed, asks if he has shared his secret with anyone else; and when the craftsman replies in the negative, the emperor has him taken out and beheaded, in order to protect Roman industry.

Cameo glass was also developed by the Romans. Cameos are sculptures carved in low relief on precious stones. Craftsmen took advantage of the naturally occurring layers of different color in a precious stone, such as agate or onyx, to create a work in which the carving stood out from the layer beneath. A taste for such items was supposed to have been developed by the Romans after they defeated Mithridates, King of Pontus, and looted his treasures, among which were many cameo gems. The historian Pliny lamented the deleterious effect this influx had on the simple values that had made the republic great, and turned up his Roman nose at the kitsch extravagance of the warlord Pompey, who at his triumph over Mithridates paraded a

portrait of himself made entirely of pearls. But neither Pliny nor anyone else could hold back the tide of imported luxuries, as republican Rome exercised its growing military might by conquering the decadent Hellenistic empires and plundering their treasure houses. Artists and craftsmen gravitated to the new center of power and patronage to cater to the tastes of the new rulers, and with them came glassmakers and engravers from Syria and Alexandria. The Roman elite now acquired the tastes of the conquered, as well as the wealth to satisfy their newfound aesthetic desires. Any Roman with pretensions to rank had to have his own carved seal. Both cameos and intaglios (where the design is cut into the surface rather than being left proud of it) were popular. The dictator Sulla collected carved gemstones, and Julius Caesar himself developed a passion for them.

Very early on, glassmakers learned to imitate the naturally occurring layers of color in gemstones. Instead of adapting a design to the haphazard layers of an appropriately formed, naturally occurring stone, the form and color of layers of glass could be dictated by the engravers, who, knowing that no natural irregularity was going to spoil their efforts, could then go confidently to work. Glass "gems" and plaques were produced, which could be carved into cameos, by craftsmen who directly transferred their skills from the cutting of gemstones. Some stones, like agate, sardonyx, and chalcedony, are softer than glass, but some, like quartz and obsidian, are harder. The engraver, or "diatretarius," had already perfected his skills of cutting, carving, and polishing, and simple lathes had been developed, grinding wheels that could be fed with abrasives to supplement the hand tools. So great was their skill that microscopes are now needed to appreciate the complexities of some cameo carving. The craftsmen themselves, of course, did not have magnifying lenses of any kind, and how they managed to carve these details remains a mystery; it has been suggested that myopic individuals were employed, to take advantage of their naturally close vision.

With the development of blown glass, the cameo technique was extended to vessels. The Roman glassmakers had discovered the secret of creating works made up of layers of different glass. These are extremely difficult to produce, because different batches of glass made in different colors will contract at different rates, and if an item is made up of these, as it cools, potentially fatal tensions are created, which can cause a work to fly apart at the touch of a fingernail. But these problems were overcome. A blown-glass vessel, while still hot, was dipped into, or overlaid with, another layer of glass, blown, shaped, and then cooled slowly in an oven by a process known as annealing. The overlay could then be carved away to create a cameo vessel. Cameo vessels represented the highest achievement of Roman artistry, and the Portland Vase is the finest existing example of these, the best-preserved work of the most highly skilled craftsmen in the ancient world, a pinnacle of the glassmaker's art.

★ ★ ★

WILLIAM MULCAHY'S LUMP of basalt lands on the vase, and it explodes into fragments. These litter the floor, mixed with the ruins of the glass case under which the vase sat. Anxious guards clear room, and the staff, appalled, surveys the devastation. Then they get down on hands and knees and begin to pick up the pieces. It is an unpleasant task: the shards are sharp enough to draw blood, and the museum workers must be wary of kneeling on them, not only for the sake of their own skin, but to avoid further damage to the remains. Some fragments are large, suggesting the possibility of restoration, but many more are impossibly small splinters. Bit by bit they are collected. A few are lost forever. Some are difficult to identify; perhaps they will never find their rightful place in the restoration. There will be gaps, holes, places where two pieces do not fit as they should. This complicated and frustrating process provides an obvious metaphor for the long history of the vase. There are gaps in the sequence of

events, and some of them now seem impossible to fill. There are places where the story doesn't quite make sense however the evidence is configured and reconfigured. There are some larger pieces of the puzzle, as the records supply generous details of a particular stage in the vase's life and adventures, but then the records fall silent again, and only hints are left, and more lacunae appear. One of the biggest gaps is at the very beginning of the story: How does the vase emerge into the historical record? The answer to this question is far from clear.

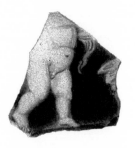

THIRD FRAGMENT

# DISCOVERY

IN 1582, FABRIZIO LAZZARO starts to dig a hole. He owns a large mound, fifty meters in diameter, on the southern outskirts of Rome, just a few miles from the gates of the city. The mound is popularly known as the Monte del Grano, so called because it resembles a cone-shaped heap of grain. Local legend explains how impious farmers, having harvested on a holy day, saw the fruit of their labors blasted by a thunderbolt of divine outrage and turned into this solid heap of earth. Monte del Grano is in fact a burial mound from the days of imperial Rome. Once it was lined with marble blocks, but these have long since been carted off and burned for their lime. A passage at ground level leads to a large, empty chamber, now robbed of its stone cladding and anything it once contained. Fabrizio is a man of substance, with a palazzo in the city that already houses a collection of antiquities. He has a theory that above the empty tomb is hidden another, secret chamber. Hoping to prove his theory and add

to his collection, Fabrizio starts on top of the mound and digs downward toward the center; he is digging for treasure.

In Rome at this time, the dead appear to outnumber the living. The sixteenth-century city huddles inside the ancient walls, leaving large tracts of wilderness. Montaigne visited the city a year before Fabrizio began to dig, and he declared that nothing remained but desolation. The Forum was a cattle market, the Arch of Constantine was up to its knees in shops and shacks, and many other monuments were buried in weeds and oblivion. The sixteenth-century Romans lived cheek by jowl with their past and were contemptuously familiar with it; it was all around them, just under their feet, and if they dug down, they uncovered it easily enough. They hacked up ancient foundations for building materials, and very often they found evidence of past glories—coins, statues, inscriptions. A position called *Cavatori* evolved, a man responsible for the exploitation of whatever resources might lie belowground. An official appointed by the pope in 1573 was the "Commissioner of Treasures and other Antiquities, and of Mines"; the past was there to be exploited like a seam of coal. Fabrizio Lazzaro was one of many laboring at the coal face.

Fabrizio continues to dig down, through a great mass of concrete. The tumulus is a massive monument, with plenty of room for a hidden chamber, perhaps the resting place of significant remains. Who knows what might be preserved with them in the silent darkness? He hopes to find something, but what? At the bottom of the shaft, the workman hefts his pickax, swings, and feels no resistance. A hole gapes black, earth trickles in; they have broken through.

The past was not understood then as we understand it today. For some, the very idea of a past buried under the earth was a concept hard to grasp. Some years before Fabrizio began to dig, a Polish duke decided to excavate a field. He found many vases—funeral urns perhaps—but he could not believe that they were the work of men from past ages, that they had survived in the ground. He concluded that

they were "created by the wondrous action and work of nature"; the pot shape was just an extraordinary coincidence. These curious finds, he speculated, must have grown in the earth like seeds or tubers, and he was so taken by this theory that he adjusted the facts to fit it; when the pots first came out of the ground, he declared, they were soft and pliable, and hardened only when exposed to the daylight.

The Romans of the sixteenth century had a better understanding, but they were not all antiquarians by any means. Pope Sixtus V was busy refurbishing the city, but his efforts were directed toward the Christian monuments—the churches and catacombs. The generals and emperors of imperial Rome were deposed from their obelisks and columns and replaced by the statues of saints. Sixtus decided to demolish one of the great monuments of the republic, the tomb of Cecilia Metella on the Appian Way. He wanted the stone; fortunately he was dissuaded from this act of vandalism by the protests of his more enlightened citizens. However, he successfully presided over the destruction of another important tomb, which stood near to the Monte del Grano. He even dreamed up a scheme to turn the Colosseum into a wool-weaving factory and workmen had already begun to take the structure apart when, luckily for the future tourist industry and the decor of Italian restaurants worldwide, Sixtus died.

But many admired classical artworks for their power of expression, for the passions they exposed and proclaimed, passions that were forbidden in contemporary art. The austere Pope Pius V had disbanded the collection of classical statues he inherited, seeing them as one more element of corruption to be rooted out along with the courtesans and sodomites who infected his holy city, and against whom he campaigned furiously. But not even he could bring himself to get rid of the finest works. Instead he erected wooden shutters around them and simply forbade anyone to look at them. The trade in antiquities, and the activities of those who dug for them, went on unabated.

Fabrizio has broken into the roof of a cavern. He ropes himself up,

lights a lantern, and is lowered slowly into the darkness by his assistants. The swinging lantern reveals a burial chamber; below him lies a sarcophagus, and it appears to be undisturbed. Fabrizio finally stands on the floor of the chamber, disturbing the dust of centuries, perhaps the first person to have stood here since grieving relatives closed up the tomb more than a thousand years before. He examines the sarcophagus by the light of the lantern. It is a sumptuous piece of work, decorated with reliefs that show scenes from the life of Achilles. It's old—pre-Christian—very old. On the lid are represented two reclining figures; are these the people whose remains lie inside? Could they be members of the imperial family?

Trembling with excitement, Fabrizio orders his assistants to lift of the heavy sarcophagus lid. The chamber itself seems to be holding its breath. What he finds surpasses his expectations. Inside the sarcophagus lies one of the greatest treasures of the ancient world; Fabrizio has hit the jackpot; he has found the vase.

This description of the discovery of the vase is based on an account written by Pietro Santi: Bartoli, a seventeenth century antiquarian, in a work on ancient Roman tombs. Bartoli claimed that the vase contained the ashes of the Emperor Alexander Severus, and identified the two figures on the lid of the sarcophagus as those of the emperor and his mother, Julia Mammea.

★ ★ ★

THE EMPEROR ALEXANDER SEVERUS came to power in Rome in A.D. 222. At a time when the empire was on its slow slide into bloody chaos, he was something of a rarity, because he was a benign and successful ruler. His reputation is in stark contrast to those who came before and after him—two of the very worst of the whole long line of criminals and psychopaths who ruled the Late Roman Empire.

Alexander's predecessor was Elagabalus. He was a member of the imperial family; in fact, he was Alexander's older cousin, but his

mother had retired to the eastern city of Antioch, and Elagabalus was raised there, far from whatever remained of "Roman virtue." According to Edward Gibbon, in his *Decline and Fall of the Roman Empire*, when Elagabalus's time came to ascend to the throne "corrupted by his youth, his country, and his fortune, [he] abandoned himself to the grossest pleasures with ungoverned fury."

Although Gibbon is disappointingly short on detail, he describes "a long train of concubines," mentions the ravishing of vestal virgins, and tells how "the master of the Roman world affected to copy the dress and manners of the female sex." But his conclusion is fairly explicit: "It may seem probable, the vices and follies of Elagabalus have been adorned by fancy. Yet attested by grave and contemporary historians, their inexpressible infamy surpasses that of any other age or country."

His rule was not, in other words, a particularly hard act to follow. So when the legions—who could make or break an emperor at this time—tired of Elagabalus's excesses, they murdered him, threw his mutilated body into the river Tiber, and hoisted his young cousin onto the throne. Alexander Severus was already in their eyes a paragon. And he does seem to have been the very opposite of his predecessor: "A natural mildness and moderation of temper preserved him from the assaults of passion, and the allurements of vice," writes Gibbon. Instead of orgies and outrages, Alexander conducted himself like a philosopher-king: "The greatest part of his morning hours was employed in his council. The dryness of business was relieved by the charms of literature. The exercises of the body succeeded to those of the mind. . . . Refreshed by the use of the bath and a slight dinner, he resumed, with new vigour, the business of the day. . . ."

Peace and prosperity seemed to be returning until, that is, Alexander and his mother—who ruled with him as regent—attempted to reform the army. A military commander called

Maximin took advantage of the disaffection this caused to stage a coup. Maximin was "a young barbarian of gigantic stature." He had come up through the ranks to become the tribune of the Fourth Legion. Cunning and ambitious, he was also a "real soldier" in the eyes of his men, and they happily murdered Alexander for Maximin's sake. Maximin was the first emperor unable to read or write, and he seems to have nursed a massive inferiority complex. As Gibbon puts it, "He was conscious that his mean and barbarian origin, his savage appearance, and his total ignorance of the arts and institutions of civil life, formed a very unfavourable contrast with the amiable manners of the unhappy Alexander."

Maximin soon became a paranoid and murderous tyrant, somewhere between Joseph Stalin and Conan the Barbarian. Flanked by these two monsters, Alexander's reputation gained by contrast until, by the time the vase was discovered, he was regarded as a sort of pagan saint.

The connection of the vase to the fondly remembered Alexander Severus and the suggestion that it served as an urn for the ashes of this emperor were first broached by Girolamo Teti, a scholar who wrote a description of the vase some time before Bartoli described its discovery. Teti was convinced that the figures on the vase referred to the story of Alexander. His description contains the first of these theories. There will be many, many more.

In the drawing of the vase (see plate section), the figures are labeled from left to right, A–G. A–D sit on what will be called side I of the vase; E–G appear on side II. The second figure, B, is Cupid. He is winged, and he carries a bow and arrows. He, however, is the only figure who possesses such easily identified attributes; the rest are up for grabs. The following is Teti's attempt to interpret them:

Side I: A is Alexander the Great, assisting at the birth of Alexander Severus.

B is Cupid. C is Mammea, Alexander Severus's mother. Mammea gave birth to her son in a temple dedicated to Alexander the Great, and on the night of that birth she dreamt of a purple serpent, foretelling his imperial destiny. There is the serpent beside her. D is Old Father Time.

Side II: E is Youth, symbolising the shortness of Alexander's reign. F is Death, symbolising, well, his death. And finally G is an elderly man, symbolising the decrepit Roman Empire itself.

If you are looking closely—more closely perhaps than Teti himself—you will have spotted that G, the "elderly man," has full breasts, rounded hips, and long hair, and is, in fact, a woman. The story of the vase is, in one respect, the story of how scholars are willing to develop a theory on the slightest grounds, and, having once developed it, assert it against all the evidence. But if you think Teti was a complete idiot, you must understand that some of those who come after him make him look like an antiquarian Sherlock Holmes.

So, do the figures on the vase support the theory that it contains Alexander's ashes? Not particularly. There are a few other flaws in Teti's theory. We know, for instance, that Alexander Severus and his mother were murdered by the legions in far-off Germany. In an age when deposed emperors had their mutilated bodies thrown into the nearest river, it seems unlikely that his ashes would have been brought back to Rome to be interred inside a vase and a large mound. We also know that the Romans simply weren't in the habit of using glass vases to store the ashes of the dead, however delicately carved those vases may have been. There is one more problem: we simply cannot rely on the evidence.

Just over three centuries after Fabrizio Lazzaro opened his tumulus, another man went digging, this time in the city records. He was an Englishman, Henry Stuart-Jones, and he revealed his findings at a meeting of the British School at Rome, held in the library, in January

1909. Stuart-Jones was a celebrity of the school, an ex-director, no less, and his meeting was attended not only by members of the British community and Italian archaeologists, but by the British ambassador himself, Sir Rennell Rodd. Stuart-Jones read a paper to this distinguished gathering, illustrated by lantern slides. His talk was billed "Miscellanea Capitolina," on various topics connected with the Capitoline Museum, but its unstated theme was "Setting the Record Straight about the Vase."

Stuart-Jones examined the evidence as presented by Pietro Santi Bartoli, the seventeenth-century artist and antiquarian who first told the story of the discovery of the vase. "From his time," noted the lecturer, "this view gradually acquired currency, and is unhesitatingly accepted by some of the Eighteenth Century writers." Stuart-Jones, however, knew how to hesitate. He had examined the official record in the Capitoline archives and had tracked down a memorandum related to the meeting of the Communal Council on the May 4, 1582. At this meeting the council had discussed whether or not to acquire the sarcophagus from the tomb in the Monte del Grano; another memo showed that by 1590 the sarcophagus was placed in the municipal collection. The discovery of the sarcophagus was thus firmly dated to the end of the sixteenth century. The council, significantly, had discussed only the sarcophagus; what of the vase itself, and the crucial question of when and how it was discovered?

Now, at the climax of his performance, Stuart-Jones delivered his coup de grace. He had discovered another description of the opening of the Monte del Grano, and this one was not by someone writing a century after the fact, but by a contemporary. Flaminio Vacca, an architect and writer, had left an account of Fabrizio's excavation. It was written in 1594, only a few years after the opening of the tomb and more than a century before Bartoli left his account. *It contains no mention of the vase.* All Vacca says is that a sarcophagus was discovered, and in it, some ashes. But if these ashes were contained in a glass vase

of exquisite workmanship and astounding rarity, Vacca does not say. How could anyone have failed to mention such a treasure? This is surely enough to destroy any faith in Bartoli's story, as well as any firm connection between the vase and the tomb in the Monte del Grano.

Bartoli, the imputation runs, made it all up in order to enhance the reputation and value of the vase by putting about the story that it had contained the ashes of a saintly emperor. Can we blame him for this embroidery? All that business about the swinging lantern and Fabrizio trembling with excitement is not in the record either. How do we know whether he was trembling or not? The problem is, human beings just can't resist telling stories, and the whole history of the vase is testament to this unreliable but entertaining attribute. But if the vase had not been excavated from the tomb, then where was it found? How did it appear from obscurity in the sixteenth century? Because appear it did—as from this time on an increasing number of witnesses would testify. Stuart-Jones could only shrug; in default of other evidence, it could only be concluded that the provenance of the vase was "absolutely unknown."

Over the centuries Rome had suffered wave after wave of calamities. The city had been sacked by the Goths under their King Alaric in A.D. 410. The citizens were slaughtered, the streets filled with corpses, and while the Goths piled their loot into wagons, "many a vase," as Gibbon appropriately remarks, "was shivered into fragments by the stroke of a battle-axe." Only forty-five years later, the city was sacked again, this time by the Vandals, whose name has since become synonymous with wanton destruction. In A.D. 472, Rome was sacked a third time, by soldiers under the leadership of the Gothic warlord Ricimer. In the following century, the city was besieged by Goths again; during its desperate defense by the famous Byzantine general Belisarius, priceless statues were broken up and hurled down on the attackers. As the Western Empire was extin-

guished, the city sank into the violence and obscurity of the Dark Ages, and its suffering did not end with its re-emergence in the Modern era. The city underwent what was perhaps its most savage treatment only a few decades before Fabrizio's excavation of the Monte del Grano. In 1527, when Italy was serving as a battleground for the opposing powers of France and Spain, a Spanish army joined forces with a group of German mercenaries to revenge themselves on Pope Clement VII. They burst, leaderless, into the city, and for many days, inflicted appalling cruelty and destruction. Churches were sacked, priests murdered, nuns raped, and two-thirds of the city laid to waste.

How did the vase survive? It is hardly possible that for so many centuries something so valuable was simply gathering dust at the back of someone's wardrobe. It must have been underground and, to survive intact, deliberately buried. Common sense indicates that it was indeed buried in a tomb.

There is another theory, which attempts to reconcile the conflicting evidence. In the *Journal of Glass Studies*, two modern scholars, Kenneth Painter and David Whitehouse, reassert the connection with Alexander Severus. They point out that the Monte del Grano was built with bricks that date from the time of that emperor and was perhaps intended to be the resting place of his remains. They suggest that a later emperor, Decius, who venerated Alexander Severus, could have brought Severus's ashes back from Germany and installed them in the tomb. They mention a piece of legislation passed three years before the sarcophagus was sold to the Communal Council, specifically intended to protect ancient monuments from the "greed" and "lack of respect" of those who owned them. With sly, scholarly hints, they suggest that Fabrizio himself inspired this legislation because of his nefarious activities in the tomb-robbing line; that he found the vase in the tomb and secretly removed it (tipping the imperial dust back into the sarcophagus) in order to dispose

of it and thus enjoy his reward without attracting public attention. Thus, a secret dig, and a swinging lantern, and trembling excitement might not be far off the mark after all.

But the theory held by Painter and Whitehouse is far from conclusive, and the mystery still remains, to be picked over by scholars until civilization runs out of ink. The only thing we know with any certainty—the first recorded, attested *fact*—is that at the end of the sixteenth century, the vase came into the collection of Cardinal Francesco Maria del Monte. So it is to the home of this intriguing cleric that we must go.

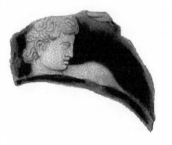

# CARDINAL DEL MONTE AND NICOLAS FABRI DE PEIRESC

ODDLY ENOUGH Cardinal Francesco Maria del Monte is now the subject of some controversy among scholars, because of his sexuality. It is for this, and related matters, that the cardinal is now famous, but we need not concern ourselves with that—at least not immediately.

It seems that the vase was able to attract the very best kind of owner, because Francesco was by all accounts a very interesting, agreeable, and above all discerning individual. He was born in Venice in the middle of the sixteenth century, and the painter Titian attended his baptism. His father was in the service of a princely family, the Della Roveres, and he grew up at court in Urbino. This court was already famous for its refined pleasures; it was the setting for Castiglione's *The Courtier*, that indispensable handbook for any gentle-

man-scholar still clinging to medieval ideals of chivalry and courtesy. Castiglione described the palace in Urbino:

> To the opinion of many men, the fairest that was to be found in all Italie; and so furnished it with all necessary implements belonging thereto, that it appeared not a Palace, but a Citie in forme of a Palace, and that not onelye with ordinary matters. . . . but also for sightliness; and to decke out withall, placed there a wondrous number of ancient images, of marble and metall, very excellent paintings and instruments of musicke of all sorts. . . .

So Francesco was ideally placed to cultivate a knowledge of the arts, history, and the antique, and we know that he became passionately interested in music and painting. In his early twenties he moved to Rome, and he became a close friend and adviser to a member of the Medicis, the ruling family of Florence. Cardinal Ferdinando de' Medici was the younger brother of the grand duke, and he lived in great style in Rome. As his secretary evenhandedly described him: "He did not lack an inclination to licentiousness, but did not so abandon himself that he won disfavour."

Francesco soon became indispensable to his powerful patron, even to the extent of helping to arrange his love affairs. But this relaxed lifestyle came to a dramatic end with the sudden death of the grand duke and his wife, apparently by poison. Ferdinando had to rush back to Florence and assume the title, and he took Francesco with him. So now Francesco was right-hand man to the new grand duke, and, through the influence of the Grand Duke Francesco himself, became cardinal, then returned to live in Rome. He took up residence in a Medici palace—the Palazzo Madama—and he began to gather around him beautiful things of every description.

We have an appealing sketch of Francesco in a gossipy letter of

the time. The writer exclaims in amazement how well Francesco manages to live on what is—for a cardinal—a fairly limited income. He only has fifty servants and they are well treated; his home is beautiful; people seem to flock to him for the pleasure of his company, rather than for any political dealings. He has style, wit, charm, and a thirst for life. All in all, it seems, he is quite a guy.

The Palazzo Madama has a modest and austere façade. The floor plan is only ninety meters by sixty, but Francesco fills it with treasures. Eventually his collections contain sixty sculptures, medals, gems, and cameos. There are tapestries and musical instruments, and, above all, works of art. Francesco acquires pictures by the superstars of the renaissance: Michelangelo, Andrea del Sarto, Raphael, Leonardo da Vinci. He has no less than five Titians. And, of course, he has the vase.

But there is one more important acquisition. In an upstairs room, in one of a row of cubicles in which sleep the fifty servants, a dark-skinned, curly-haired, rather surly young man has taken up residence. Francesco has—almost literally—picked him up off the streets. He is in his early twenties, and we know him now as Caravaggio.

When Francesco found him, Caravaggio was trying to make his own way in Rome, and he was struggling. He had no studio, no buyers, and no money; according to one account he had to paint his own face in the mirror because he couldn't afford to pay a model. Francesco's patronage meant everything; through it Caravaggio became the most famous painter in Italy, and the most powerful religious artist of his age. Moreover, Francesco's personal interests directly influenced Caravaggio's work. His first painting for his new patron is *The Musicians*, and it clearly reflects Francesco's love of music. But is that all it reflects?

In *The Musicians*, a group of boys, in rather off-the-shoulder white robes, prepare to sing and play. The central figure is tuning a lute,

and he gazes out but away, his eyes seemingly full of tears, his red, sensual lips parted, as though he is in the grip of some passionate emotion. The homoerotic content of this, and of many other of Caravaggio's paintings, is to some perfectly plain; the academics, of course, cannot agree. Apart from the paintings there is very little evidence one way or the other, and so they turn their attention to the patron. *Was Francesco gay?* Suddenly the question is terribly important, and his reputation is now picked over by scholars in an attempt to provide an answer one way or the other.

A contemporary records that Francesco liked young men, and "indulged his inclination openly." This writer, however, was an acknowledged enemy of Francesco, writing after his death. He also accused Francesco of being so mean that he had holes in his shoes, an accusation that certainly doesn't ring true. On the other side, there is a rather wistful letter from Francesco himself, remembering happy times spent in his youth with "Artemisia and Cleopatra," who were, presumably, young ladies.

But, anyway, *so what?* The next painting that Caravaggio produced under Francesco's patronage was *The Lute Player.* Again, a beautiful, full-lipped boy in a very open shirt, plucking at the strings and turning on us a gaze of erotic melancholy. Yet what is important here is surely not specific sexual leanings. The lutenist is framed by fruit and flowers—fresh, fragile, transient. The flowers are placed in a glass vase, and the handling of the reflected light in the glass is a virtuoso performance. According to Caravaggio's biographer Helen Langdon, the whole compositon is redolent of the "refined and aristocratic pleasures" of Francesco's palace: "Caravaggio's pictures of these years have an exquisite quality, a sense of the beauty of precious and fragile objects."

Caravaggio himself was a naturalist, who turned deliberately against the classical tradition: when told that he should be copying ancient sculptures, his response was to grab a Gypsy girl off the

street and take her home to paint. That, he said, was the only fit subject; his master was nature. So he is hardly the man to be influenced by the vase. But something of its precious nature, of its fragility, Langdon is suggesting, appears in his work, mediated through the exquisite taste of Cardinal Francesco Del Monte.

★ ★ ★

WE KNOW THAT the vase belonged to Francesco Del Monte only because of the writings of a Frenchman, Nicolas-Claude Fabri de Peiresc. De Peiresc in fact supplies us with our first official sighting of the vase, long before Girolamo Teti recounted his story of the finding of the vase in the Monte del Grano. This is entirely appropriate and pleasing, because de Peiresc is regarded by many as the first real antiquarian. The people whom we will meet as we follow the story of the vase divide roughly into two groups: the rich and powerful who owned the vase, and the learned who studied it. Rarely does an individual manage to straddle both categories; more often we will find ourselves alternating between the two. Cardinal Del Monte is our first example of the former category, and de Peiresc of the latter. The cardinal, with his taste and discernment, may have appreciated the vase as a thing of beauty and historical curiosity, but for de Peiresc it was much, much more.

De Peiresc was a scientist and historian; he collected books and manuscripts, and corresponded with nearly all the great minds of Europe, as if holding together by his letter writing the entire intellectual community. He was driven by a desire to serve society by throwing light on the past, as his friend and biographer, Gassendi, described:

For the Fame and Memory of things, resembles the evening Twilight, or shutting in of the day, which being at first exceeding clear, does by little and little, in such sort vanish away, as to

be swallowed up in darkness; and therefore History is needful, as a Torch, to bring the same to light.

De Peiresc had "endeavoured to give light to the darkness of History." So he was among the first to value ancient artifacts because they threw light on the world from which they came. Antiquities like the vase were not just curiosities or ornaments; they were vital pieces of evidence.

An incident recorded by de Peiresc himself makes explicit the divide between the wealthy collector and the scholar. In 1625, de Peiresc was visited by a friend who was traveling with Cardinal Barberini (who will come to figure more largely in the story of the vase). The friend brought de Peiresc a present, a set of ancient bronze weights. De Peiresc had made a special study of ancient weights and measures, and his friend must have hoped that his gift would go down well. But de Peiresc modestly attempted to refuse it, telling his friend the set should go to his patron. De Peiresc himself recounted how the friend then "reproached me that I not render myself guilty in the eyes of posterity of having deprived her of the fruits that could be extracted from these fine pieces. That, moreover, it would be worth almost as much to toss these into the sea as to give them to men of this sort." So much for the rich and powerful. De Peiresc sounds more in tune with these democratic times than with the age of hereditary monarchy, and for those of us who have not yet achieved either wealth or power, his is, of course, a consoling doctrine.

De Peiresc was born in Provence, at about the same time the vase itself came to light. At the age of nineteen he traveled to Italy. He trained as a lawyer, and he was interested in everything—from astronomy to cat breeding—but his real passion was for antiquities. De Peiresc was a collector, but of ideas as much as objects. This is how his biographer describes his activities:

He would carry about selected coins which he compared with the statues, seeking their date and type. He was such an expert that he knew immediately what was genuine antiquity and what a copy. He wished to have copies of every ancient inscription, and he tried from his own knowledge to fill in the gaps and to restore the most hopeless texts. . . . He also noted everything which he deemed worthy of interest in the collections of metalwork and statuary, in the cabinets and the museums, in the galleries and various houses. In this way he brought together an extraordinary body of objects—by asking to borrow them, or by exchanging items, or receiving them as gifts, or by obtaining impressions, casts, fragments or drawings.

This is exactly what happened with the vase. This dispassionate curiosity brings De Peiresc to the Palazzo Madama, where he sees and examines the vase, some time around 1600. Soon after, he got hold of a cast of it in lead (which he later passed on to the painter Rubens). He doesn't want or need the real thing; he wants knowledge. He doesn't need to go digging; he finds ample opportunity for his researches in the things that have already been found and collected. His role is to analyze, understand, and explain. For those of us who live in a world where the great treasures are kept in museums, open to all and curated by acknowledged experts, this attitude seems obviously right and proper, but in de Peiresc's time this was far from the case, as he himself made clear.

Many people loudly scorn our studies, saying that they bring no glory to those who pursue them and no usefulness to others. The only ones who deserve such reproach are those who seek scholarship of a meretricious sort, or even worse, content themselves with collecting antiquities to adorn their cupboards and decorate their their houses, only desiring them in

order to be seen to possess them. On the other hand there are those who are entirely praiseworthy—they research the antiquities, study them and publish them in order to throw light on the works of the classical historians, to illustrate the unfolding of history, the better to impress upon the minds of men its personalities and their deeds, and great events.

If only de Peiresc had been at the opening of the Monte del Grano. One can't help thinking his account and explanation, based on his methodical approach, would have been so much more convincing than the later claims of Girolamo Teti. But he wasn't; and, anyway, de Peiresc never actually got around to publishing anything. We only know of his achievement through the writings of his biographer at the time, and from his own copious correspondence. His real legacy was the profound effect he had on the antiquarians who came after him, and all those who wanted "to illustrate the unfolding of history."

★ ★ ★

CARDINAL FRANCESCO DEL MONTE suffered a long, final illness during which he had ample leisure to decide where he might bestow his choice possessions. As a cleric, he had, of course, no direct heirs, but there were plenty of family members clustered eagerly round the bedside. What would become of the vase? In his will, Francesco had bequeathed it to someone denoted as "Monsieur," who seems to have been the French prince who would become Henry II of Conde. But as the illness went on, the family went to work and the will was changed. By the time Francesco died, the vase was safe in their hands. That these grieving relatives were not prompted by any deep-seated love of antiquities is demonstrated by the fact that, almost immediately, they sold the vase for six hundred scudi.

So the vase changed hands and began its journey down the river of history, bumping from rock to rock, bobbing at the surface, now

caught in an eddy, now sweeping on again, its course following the currents of the great and the peculiar. It now passed from its first attested owner to the second, and the second was one of the very greatest and most peculiar it would encounter in its long career. In 1627, after the death of Francesco, the vase made a short journey from the Palazzo Madama to the Palazzo Barberini. This particular swirl of the current had at its center Maffeo Barberini, known to posterity as Pope Urban VIII. The vase's career as a top-flight status symbol was only just beginning, and far from being used to illuminate the past, it was about to be mixed up in the most excessive social posturing imaginable, not to mention black magic and murder.

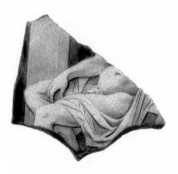

# THE POPE

THE TROUBLE WITH MAFFEO began at his election, and even by the standards of the Vatican it was an extraordinary affair. The previous incumbent was Pope Gregory XV. He hadn't lasted long in office, but during his short reign he had effected one significant achievement: he had changed the rules by which popes were elected.

Until Gregory, popes were elected by a system known as acclamation, although "system" is perhaps too dignified a term. A politically powerful cardinal would introduce his candidate to the conclave. He could do this at any moment, day or night; in the sight of his fellow cardinals, he would simply say the words *Ego eligo*—"I choose *him*"—and everyone would cheer (or boo and hiss). The candidate who inspired the loudest cheers was given the job, so cardinals would find themselves operating by a sort of herd mentality—all stampeding to join in the cheering for fear of being left off the winning side.

Acclamation may be well suited for choosing the leader of a bar-

barian horde, but the Roman Catholic Church needed something a bit more sophisticated. Certainly Gregory was of this opinion, and he wisely decreed that his successor would be chosen by secret ballot; then he promptly died.

Everyone was thrown into confusion; the goal posts had been moved. All the wheelers and dealers and power brokers were caught out, so when the conclave sat to decide who should follow Gregory, there was no backstage maneuvring of the sort that in the past had made the proceedings a foregone conclusion.

The conclave began on July 19, 1623, during a heat wave. There were two main contenders: Gregory's nephew, Ludovico Cardinal Ludovisi, and the nephew of the pope before last, Cardinal Scipione Borghese. They were very evenly matched; Gregory's reign had been so short that no party or clique had had time to become dominant. It was stalemate. The reactionaries began to shake their heads over this newfangled ballot business, and some resolved to initiate a return to the good old days of election by pantomime audience response.

It took ten days of stifling heat and shortening tempers before a compromise candidate was finally suggested. Cardinal Maffeo Barberini was the popular choice. He belonged to neither faction, coming from a relatively obscure Florentine family, and had demonstrated extraordinary talents in the service of the Church. He was also—so it was said—careful to secretly assure each faction that he was *on their side, really*. But Maffeo was only fifty-six—by papal standards a mere babe in arms. Older cardinals, of whom there were many, objected, and it became clear that Maffeo was not going to get the two-thirds majority he needed. He bowed out.

Any summer spent in Rome was spent under the threat of malaria. By the August 3, ten of the fifty-four cardinals present had gone down with it, as well as many of their secretaries and servants, some of whom began to leave. No less than eight cardinals and forty of their followers were to die of the disease over the summer. Things

were getting truly desperate. A vacant papal throne also meant a relaxation of law and order; the crime rate soared, and there was a sudden outbreak of headless bodies found lying in the street or floating in the Tiber. Prayers for divine intervention in the election process grew increasingly heartfelt.

Under these circumstances, Maffeo was persuaded to reenter the list. Cardinal Scipione Borghese was his main competitor, but now he himself went down with fever. On the morning of August 6, the votes were cast yet again, and Maffeo received no less than forty-nine, a clear majority. But even as the word went out and a relieved city began to celebrate, it was discovered that one of the votes cast had gone missing. Pandemonium in the conclave ensued. Maffeo himself called for a recount. The missing vote was found (according to one report, a cardinal involved in the count and hostile to Maffeo had hidden it up his sleeve), and Maffeo was, finally, elected.

In this way a youngish man with a relatively obscure background suddenly found himself elevated to the papal throne. Maffeo's provincial, second-rank family, the Barberini, was in a single, giddy moment hoisted up above the old established Roman families. But how could the Barberini justify this revolution and cope with the attendant inferiority complex? Maffeo found a rationale in the circumstances of his election. So chaotic, so out of control had the whole process been that surely no human agency was responsible for his election; it must have been the hand of God Himself. God, in His mysterious way (secret ballots and malaria) had put him, Pope Urban VIII, above the Borgheses, and the Colonnas, and all the others; Maffeo ruled by divine right.

Having, so he thought, acquired heavenly backing, it only remained for Maffeo to assert his new status in the eyes of the world. He set about establishing the standing of his family by any and all means. Maffeo had an elder brother, Don Carlo, who had three sons: Francesco, Taddeo, and Antonio. Brother Carlo and nephews

Francesco and Antonio were made cardinals, and Maffeo invented the title "eminence" for them. But Taddeo was singled out for even greater honor: his role would be to found a dynasty (the pope himself, of course, being technically unable to produce an heir).

As pope, Maffeo was not just the head of the Catholic Church; he was also the temporal ruler of the Papal States, with the income of this considerable territory at his disposal. He began to pour money into his nephews' pockets. Maffeo may not have invented nepotism, but, according to contemporaries, he certainly took it about as far as it could go. One diarist of the time wrote, "Avidity for accumulating wealth so blinded the Barberini nephews that night and day they thought of means to make themselves princes, how to render their family eternal, and how to redouble the filling of their storehouses." It is calculated that during his pontificate, Maffeo siphoned over a hundred million scudi into the family coffers: palaces, vineyards, pictures, statues, silverwork and gold, precious stones, and, of course, one small but important antiquity. To give you some idea of the worth of a scudo, the vase cost the Barberini six hundred of them, the equivalent of several thousand of today's dollars. But they had to have the vase for the papal mantelpiece, and, of course, they had to have a palace in which to put the mantelpiece. They bought the vase from Cardinal del Monte's heir, Alessandro, on December 9, 1626. It would remain in their family for the next 150 years.

In 1627, they began to build the Palazzo Barberini, to demonstrate their new rank, and they commissioned the foremost artists and sculptors to adorn it. A painted ceiling by Andrea Sacchi in the grandest conceivable manner illustrates the theme of divine election; a female figure representing Divine Wisdom sits enthroned and backed by a glorious sunburst. At her foot hangs the globe of the Earth, with Italy at the top, illuminated by the Sun's rays, and in shadow, a rather speculative Southern Hemisphere, which, of course, had not yet been visited by Europeans. A program in the family

archives makes the theme of the painted ceiling explicit: "Such a painting is appropriate to the majestic edifice of the Barberini family in order that it be understood that since that happy family was born and elected to rule the church in the place of God it governs with Divine Wisdom, equally loved and revered."

Maffeo's nephew, Taddeo Barberini, had honors heaped upon him. At the age of twenty-three he was made lieutenant general of the Church. The following year he married Anna Colonna, thus linking the Barberini with one of the most distinguished Roman families. At the age of twenty-eight he was made prefect of Rome, a hereditary post with enormous social cachet. Maffeo, as paranoid parvenu, now insisted that all other notables—including the foreign ambassadors, who traditionally were accorded the status of the ruler they represented—observe Taddeo's right to superior honors. In Rome, at least, twenty-eight-year-old Taddeo was a bigger fish than the King of France. It was stipulated that, according to his new standing, whenever Taddeo traveled through the streets of the city, all other drivers must give way to his retinue of coaches. But the ambassadors simply refused to accept this, with fatal results.

A few weeks after his investiture as prefect, Taddeo is making his progress through the city, when a wheel of his carriage gets caught in a rut. Coming up behind him is the carriage of the Venetian ambassador, Giovanni Pesaro. According to the rules of precedence, Pesaro should pull over, but Rome and Venice have long been enemies, and instead the ambassador goes sailing past, diplomatic thumb to nose. Taddeo is infuriated. He gets in touch with Pesaro's coachman and offers him a bribe if he will rein in the next time Taddeo passes. It is not the principle of the thing that interests Taddeo; it is merely the observation of precedent by any means, fair or foul. The coachman agrees to betray his master, and he is promised reward and protection. Taddeo hangs around outside the gates of the Venetian embassy, waiting for Pesaro, and a few days later, when Pesaro is

returning from the Vatican, the clash occurs. Taddeo's coach approaches Pesaro's. Pesaro's coachman pretends to drop his hat, and he pulls over as if to pick it up; but Pesaro realizes what is going on. He jumps out, kicks the coachman off the box, seizes the reins, and drives on.

Pesaro left the city in protest shortly after, and his coachman was found murdered, despite Taddeo's promise of protection. This unhappy story not only shows how driving in Rome has always been a potentially fatal activity, the Venetian ambassador himself noted Maffeo's acquisitive posturing: "Avidity for glory, the passion of great men, excessively agitates him, and he is always intent on those things that can aggrandise his personal image in the eyes of men and history." Among those "things," of course, was the vase.

The vase was always regarded by the Barberini as being among their greatest treasures. When Girolamo Teti wrote his *Aedes Barberini*, a book describing their new palace, which was mostly a shameless piece of flattery, he devoted four whole pages to the vase, and used it to make an explicit link between the Barberini and the vanished glories and virtues of imperial Rome. He compared the saintly Alexander Severus to Cardinal Antonio Barberini, who is "attended even more gloriously than Severus by a more learned and more holy circle of illustrious men." Slathered with this kind of sycophancy, the Barberini no doubt drew great satisfaction from their ownership of the vase.

Now in the hands of Maffeo Barberini, Pope Urban VIII, the vase was witness to all the incidents and excesses of his reign. Urban VIII became notorious for many reasons. There was his extreme nepotism and the greed of his nephews. There was his campaign to murder all the singing birds in his gardens because they disturbed his rest. There was another more costly and unsuccessful war that he began against the Farnese family—in an attempt to wrest land from them—a war that drew his disparate enemies into an alliance against

him, devastated the Papal States, and exhausted its finances. Worst of all, perhaps, there was his poetry. Urban liked nothing better than an afternoon spent with a select group of fellow authors in the Quirinal gardens (uninterrupted by birdsong), declaiming his dry, pedantic, and utterly mediocre verses. He was opinionated, stubborn, and so enjoyed the sound of his own voice that visiting ambassadors found themselves forced to listen to lengthy perorations on any and all subjects. One ambassador reported that he heard a weary cardinal mutter that now one gave an audience to the pope, rather than the other way round.

There were above all two scandals for which Maffeo was most notorious, and both involved men who studied the heavenly bodies. One was a private affair, secret and illicit. The other was one of the greatest public embarrassments ever to befall the Catholic Church. Both can be traced directly to the overweening pride of Pope Urban VIII.

# GALILEO GALILEI AND TOMMASO CAMPANELLA

GALILEO GALILEI's career greatly benefited from the influence of Cardinal Francesco del Monte. In 1588, thirty-five years before the election of Urban VIII, when the vase was still in the hands of Cardinal del Monte, the twenty-four-year-old Galileo was trying to get a job at the University of Pisa. Del Monte had a brother, Guidobaldo del Monte, who was a mathematician of some ability, and had just published a definitive work on mechanics. Galileo found common ground with his noble colleague; they shared work on the gravity of solids. Through Giudobaldo del Monte, Galileo reached Cardinal Francesco, who could command the powerful interest of his own patron, the grand duke. Between them, Francesco and Guidobaldo del Monte ensured that Galileo was offered a new post as junior lecturer at the university.

Having been launched on his career, Galileo's advancement con-

tinued to be influenced by Cardinal Francesco del Monte; he helped Galileo to achieve his next significant move, to the chair of mathematics at the University of Padua, then part of the Venetian Republic. Another member of the del Monte family was a general of the Venetian land forces, had played a hero's part in the wars of that powerful republic, and was now responsible for its fortresses. General del Monte commissioned Galileo to write a tract on fortification, and the ambitious young man, scenting the financial rewards offered by defense contracts, was happy to comply. He invented a device to help artillerymen calculate the distance and height of their target, but it was the military potential of another invention that captivated the Venetian Senate.

Galileo did not invent the telescope, but he was perhaps the first to understand the implications of the device, particularly its military value, and he was determined to bring it to fruition. He heard rumors about the instrument's development in Holland, then that a Flemish craftsman had arrived in Padua, with a prototype, and was now—horror—already bound for Venice. This news galvanized him into frantic action. He retreated to his own workshop and sought the services of a glassblower.

In Galileo's time the techniques of glassblowing had hardly changed since the days when the vase itself was made, but the artisans of the Venetian Empire were the ones who now practiced such skills in their workshops at Murano. One of these created different globes of glass for Galileo, from which were cut lenses. Galileo himself later claimed, perhaps not quite reliably, that in twenty-four hours he had worked out the configuration of convex and concave lenses that would magnify objects at a distance. Sneaking ahead of his hapless Dutch competitor, Galileo presented his "invention" to the doge, the Council of Ten, and the commanders of the all-powerful Venetian navy.

The ruthless old graybeards climbed the tower of St. Mark's and, one by one, they gazed through Galileo's spyglass. Suddenly the mouth

of the Rio de Verieri, the river on which stood the workshops of the glassblowers of Murano, sprang clearly into view, though many miles distant. When they turned the glass toward the sea, the admirals could descry ships far out in the Adriatic. For the defense of a maritime power like Venice the implications of this new invention were obvious. The council voted Galileo a lifetime salary—his fortune and his reputation were made. In turn, the grateful Galileo dispatched one of his first telescopes to del Monte to join the vase in his collection of curiosities.

Compelled by arrogance and ambition, however, Galileo left the Venetians, despite their generous offer, for what he hoped would be the even more lucrative patronage of the grand duke in Florence, and there he trained his telescope on the sky instead of the sealanes and defenses of the Venetian lagoon. In the autumn of 1609, standing on the top floor of his house in Padua, he looked at the Moon. Over the winter, through the clear night skies, he watched the silver disk wax and wane. At the same time, he refined his instrument, doubling and redoubling its power. He gazed, fascinated, at the craters and the mountains, comparing the pitted lunar surface to a peacock's tail, and noting that the moon resembled "those glass vases which, while still hot, have been plunged into cold water and have thus acquired a crackled and wavy surface."

He saw the moons of Jupiter and the rings of Saturn, and he wrote *The Starry Messenger*, recording and analyzing his findings. It became one of the most important books of the seventeenth century, and it decisively overthrew the Aristotelian view of the universe: the Sun did not go round Earth. Seeming directly to contradict several passages of scripture that described the movement of heavenly bodies, the book brought Galileo into conflict with the Church.

In the Vatican a committee of clerics and theologians convened to consider Galileo's findings, and they rejected them as foolish and absurd; the Sun went round Earth, and that was that. Galileo was not to hold or teach any other view; he was to limit his research to safer

matters. This announcement was made in 1617, under Pope Paul V, long before the election of Urban VIII. Frustrated and dismayed, Galileo retreated and forced himself to work on lesser, and less controversial, questions. He became involved in a debate about ice. His Aristotelian opponents asserted that ice was heavier than water and only floated because of its flat, thin shape. Galileo reasoned that ice was lighter than the liquid form of water, and would float, whatever its shape. A formal debate was organized at the Pitti Palace in Florence, and present was an up-and-coming cleric, Maffeo Barberini. Maffeo eagerly took Galileo's side, and he watched with enthusiasm as Galileo routed his opponent. When Galileo sent Maffeo his tract on floating bodies, and his next work on sunspots, Maffeo replied effusively about the pleasure he would have in reading and rereading Galileo's work. Maffeo was even moved to celebrate Galileo's achievement in nineteen stanzas of breathless verse. He called this ode "In Dangerous Adulation."

When Maffeo was so unexpectedly elevated to the papal throne, Galileo was overjoyed. He traveled to Rome and enjoyed an audience with Maffeo, who dispensed favor and approval. They even debated the old and new theories of the heavenly bodies, and Galileo came away with the impression that he could return to the forbidden subject. He began a masterwork intended to set forth his theory in relation to the contending claims of the Aristotelian and Copernican systems. He couched it in the form of a dialogue; different characters would represent and discuss the different positions. By putting his ideas into the mouths of these characters, Galileo could keep his own views at one remove. He used the names of two old friends, "Sagredo" and "Salviati," to denote his characters; these two were the sophisticates who understood and espoused the new ideas. He added a third, "Simplicio," the opponent who would state the case for the old established ideas of Aristotle. Galileo's finished his *Dialogue Concerning the Two Chief World Systems* in 1629,

and in the spring of the following year he brought the manuscript to Rome, where it received provisional approval. In 1632, the first printed copies were in circulation. It was only now that Maffeo himself became familiar with the work. It threw him into a rage, turning him from devoted, delighted fan to implacable enemy.

Galileo had made a dreadful error. Though putting his arguments into a dialogue between advocates of the Copernican system and a defender of the Aristotelian meant that it was harder to hold him directly responsible for the dangerous new ideas being debated, it was clear where his sympathies lay. It was also evident that "Simplicio" was the loser; as his name makes clear, he was the simpleton whose arguments were dismantled and whose blunders were courteously explained and corrected. One of Simplicio's arguments was that however strong the scientific evidence may be, the human mind could not be certain of any interpretation, because an omnipotent God may have created the universe in a way beyond human understanding. This was a point that Maffeo himself had made, and, along with a hefty dose of paranoia and the memory of his personal interviews with Galileo, it was enough to convince him that Simplicio was intended for his own portrait. This was what enraged Maffeo: Galileo had been a friend, a recipient of admiring verses and benign patronage; and instead of showing his gratitude, Galileo had taken advantage of Maffeo's favor, turning on his generous, unsuspecting friend and exposing him to ridicule.

Scholars wishing to protest about Urban's treatment of Galileo turned to Peiresc, relying on his acquaintance with Urban and his nephew, Francesco Barberini. Peiresc warned Francesco that the persecution of Galileo "would run the risk of being interpreted and perhaps compared one day to the persecution of the person and wisdom of Socrates in his country, so condemned by other nations and by posterity itself." This prophecy, entirely accurate, fell on deaf ears.

The whole repressive machinery of the Catholic Church moved

into action. The Inquisition, the Jesuits, all those who felt threatened by Galileo's work, or had been subject to his arrogant and devastating putdowns, could now gleefully assist in his destruction. But Galileo's interrogation, trial, and imprisonment, the threats of torture, his forced confession, the destruction of his books, and above all the fatal damage done to the progress of learning and science in Italy—all this can be traced directly to the wounded vanity of Maffeo Barberini.

★ ★ ★

IT IS SOMETHING of an irony that while Maffeo condemned Galileo's heretical theories, he himself harbored far more subversive ideas concerning the heavenly bodies. Maffeo was addicted to astrology, firmly believing that the influence of the planets could drastically effect life on Earth. He himself identified with the Sun. At the time of his dramatic and unforseen election, the Sun had been in conjunction with Jupiter, confirmation of the Divine Will. The Sun was his sign, prominent in his astrological birth chart as the "Lord of the Ascendant" and "Giver of Life," and it became the badge of his papacy. The head of Apollo, the Sun God, appears on the façade of the Palazzo Barberini. Maffeo decorated his Vatican apartments with a picture of the rising Sun so that this auspicious image would greet him when he opened his eyes in the morning. According to the Venetian ambassador, Maffeo's knowledge of astronomy was profound, and his every move was dictated by what he saw in the stars.

The practice of astrology was common enough at the time, but Maffeo went further than just—regulating his behavior according to the movement of the heavenly bodies. Subject to all the superstitious terrors inherent in his beliefs, he resorted to magical practices. Soon after he was elected in 1623, in order to impress his cardinals, Maffeo began to cast their horoscopes, asserting that he could predict the time of their deaths. This tactic backfired badly; astrologers were promptly commissioned by his victims to draw up *his* horoscope, and

speculate about *his* death, and some of them began to suggest that this unfortunate event might even be imminent. Along with the desire for a fitting revenge there were serious political motives behind this: the Spanish, who disapproved of Maffeo's sympathy for their great rival France, were trying to stir up trouble. They even pretended to prepare for another conclave, apparently so certain of the truth of the predictions that they sent Spanish cardinals to Rome in eager anticipation of Maffeo's demise and the election of a new pope. Rumors spread and began to be believed.

Maffeo issued a somewhat hypocritical decree forbidding the astrological prediction of the demise of the pope, on pain of death. He had an abbot called Morandi, a keen student of the occult, put on trial for compiling a birth chart for the pope. Morandi was imprisoned and quietly poisoned. Another victim of this crackdown was the nephew of Cardinal Felice Centini. Believing through astrological prediction that his uncle would become the next pope, in order to hasten this happy event, Giacinto Centini performed the Black Mass and a ceremony involving a wax effigy of Maffeo, in order to kill him by witchcraft. He was put to death for this crime. Maffeo even took steps to conceal the date of his birth, to prevent more birth charts from being drawn up. But the damage had been done. If the Spanish intended to scare Maffeo, they succeeded; indeed, it could be said that they frightened him nearly to death, because Maffeo truly believed in the influence of the heavens, for good and ill, and a whole string of perilous astrological events were fast approaching. In 1628, there was to be an eclipse of the moon in January. In December, an eclipse of the Sun, and then another in June 1630. The solar eclipse in particular filled Maffeo with dread; during it his sign would be darkened, and, left unprotected, he would be threatened by all the inimical powers of the heavens. He needed protection, and in his desperation he turned to a most unlikely source—an eccentric friar and notorious millenarian called Tommaso Campanella.

Tommaso Campanella had been tortured and imprisoned in Naples for his heretical and revolutionary ideas, which centered on a belief in the imminent approach of the Sun to Earth, and hopes of a utopian society. He had been involved in a revolt in Calabria, and avoided the death penalty only by pleading insanity. After many years in prison he was released and made his way to Rome, where he was again incarcerated, in 1626. But in 1628, rumors began to circulate that, at liberty again, he had been performing black magic rituals— "nocturnal rites with lighted candles"—and that his companion in these mysterious ceremonies was Maffeo himself.

Campanella based his magical practices on the work of a predecessor, the fifteenth century magus Marsilio Ficino, who believed that a cosmic spirit flowed through the universe, permeating all things, and that through the action of this spirit heavenly bodies affected the Earth. Ficino believed that the energy of this spirit could be attracted and focused by particular actions and objects; certain foods, scents, plants, music, and talismans, properly deployed, might attract a benign influence or turn aside a malign power. Campanella adapted these beliefs to suit the anxieties of his new patron, and he devised a magical ceremony to protect Maffeo from the dangers of an eclipse.

Naturally, Campanella kept these practices secret, but he made the mistake of writing them down. When he submitted a six-volume work on astrology to a publisher in Paris, it seems that some of his enemies who had gotten got hold of the clandestine treatise added it to the manuscript without his knowledge. The final work was published in *seven* volumes—with the seventh volume describing Campanella's magical rites for the eclipse. This cunning piece of malice proved highly effective; Campanella was bewildered to see his mysteries in print, and Maffeo was infuriated by what he saw as a breach of trust. Maffeo commissioned spies to keep Campanella under observation, and to ensure that he did not betray any more embarrassing secrets. However, the long-term effect of this publication gives us a fascinating glimpse of

what went on in the Palazzo Barberini, in June 1630, when the eclipse threatened, and the terrified pope sought Campanella's aid.

A room was prepared, hung with white silk draperies, and decorated with the signs of the zodiac. Maffeo and Tommaso dressed themselves in white robes. As the eclipse approached, this room was sealed against its pestiferous influence. The heavenly bodies were represented within the room by candles or torches. Strong-scented essences like rose vinegar were sprinkled about, and aromatic herbs—rosemary, laurel, and myrtle—were burned. These were to guard against the pestilential elements spreading under the darkness of the eclipse, and in particular the evil influence of Mars and Saturn, which could operate unchecked when the Sun was dimmed. Stones, plants, and colors associated with benign planets—Jupiter and Venus—were deployed, to attract their protection. Music associated with these planets was performed discreetly, while Maffeo drank specially distilled liquors.

The music played, pungent scents wafted about, the candles burned, the smoke of the burning herbs drifted up, wreathing among a row of talismans—perhaps around the vase itself—and Maffeo sipped his prophylactic drink in perfect safety. He emerged from the eclipse with his life force miraculously unharmed and gratefully ascribed his survival to the efficacy of the measures devised by his necromantic adviser.

Did the vase oversee these bizarre goings-on? It would be nice to think so, and we have solid proof that the vase was in the Barberini Palace at this period. It was during this time that the first careful drawings were made of the vase. The artist, another member of the Barberini entourage, was Cassiano dal Pozzo; his activities were less unusual but every bit as remarkable as those of the eccentric Tommaso. Anticipating its fate by several hundred years, Cassiano decided that the vase belonged in a museum, and he determined to put it there.

# CASSIANO DAL POZZO
# AND THE BARBERINI

CASSIANO DAL POZZO moved in the same heretical circles as Galileo, and the two became close friends. Like Galileo, he was a member of the Accademia dei Lincei, the ancestor of all scientific societies. It was founded by the wealthy and powerful young nobleman, Prince Federico Cesi, in 1603, and initially there were only four members. They were all young, single men dedicated to scientific investigation. Galileo, whose new telescope delighted the lynx-eyed academicians, became the fifth member in 1611; Cassiano himself joined about a decade later.

Cassiano, again like Galileo, had befriended the Barberini family before Maffeo's unforseen elevation to the papacy, and he, too, reaped the benefits of this association. When Maffeo's nephew Francesco Barberini was made a cardinal, Cassiano was given a position in Francesco's household and a comfortable income. He advised Francesco,

who himself was not blessed with the keenest of intellects, but was keen to bestow his patronage. He traveled on diplomatic missions with the cardinal to Paris and Madrid, and although the missions were miserable failures in diplomatic terms, they allowed Francesco to indulge his growing passion for the arts, and they cemented his regard for Cassiano's learning and sophistication. Cassiano thus became one of the most influential individuals in the cultural life of Rome. He was not interested in financial gain for himself, as we know from plaintive letters sent to him by his father, urging him to take more advantage of the favor he enjoyed with the Barberini. He contented himself with his relatively moderate income and spent all his time and money on science and learning. An admirable contrast to his greedy and extravagant patrons, he gained the respect of other scholars, corresponding for instance with de Peiresc, but he seems to have had a rather cold and reserved personality. There is a caricature of him, drawn by Bernini, that captures a bristling mustache, a bull neck and double chin, and something rather choleric about the eye.

Cassiano could not aspire to the priceless objects that adorned the Palazzo Barberini; he was not the kind of player who could afford the vase. But he began to collect: rare birds and plants, mechanical instruments, medals, precious stones, sculptures, books, and paintings. Most important, his collection was not merely a heap of curiosities; it was arranged, categorized, and presented for the furtherance of knowledge and scientific understanding.

When the chief Lynx, Prince Cesi, died in 1630, Cassiano eagerly acquired some of his books and scientific equipment. Unfortunately, Cesi's death marked the decline of the academy. Without his power and influence, the members were left exposed to the forces of reaction, with Galileo as the first, spectacular victim. Cassiano tactfully turned his attention away from natural science to a less heretical area of study—antiquities. But he still tackled his subject with the rigorous systematic approach that the Academia dei Lincei had fostered in

him, determined to make a record of every surviving trace of ancient Rome that he could find. He bought existing drawings and commissioned artists to go out and make fresh images of antiquities wherever they could be found in the city. The guiding principle, moreover, was not simply to describe and celebrate the beauty of statues, sculptures, and inscriptions; Cassiano wanted to piece things together, to gain as broad an understanding of the past as possible. Accordingly he needed to record every detail of the remains around him.

He collated these drawings into a vast work of twenty-three volumes. He called it his *Museum Chartaceum*—his Paper Museum—and in it the drawings were arranged by subject matter. Volume 1 contained images relating to religious beliefs and practices (cautiously labeled as "False," just in case some zealous Jesuit accused him of paganism). Other volumes dealt with marriage, clothes, theatrical spectacles, and baths. In particular, volume 4 contained statues, utensils, and vases. Naturally the vase itself took pride of place in this gallery of the museum. Six drawings of the vase were included in the Paper Museum, some of which, like the vase itself, are now preserved in the British Museum.

One of the artists that Cassiano commissioned to provide the entries for his Paper Museum was a young Frenchman, arrived in Rome from Paris, called Nicolas Poussin. This employment had a profound and lasting influence on Poussin, who breathed in the spirit of the classical world as he made detailed studies of antiquities for the museum. Cassiano for his part realized that in Poussin he had found an artist uniquely disposed to understand and revive the images and atmosphere of ancient Rome. There is some testimony, from an English visitor to Italy in the eighteenth century who claimed to have seen it, that Poussin made a painting of the vase for Cassiano, although any such work has long been lost. Cassiano did commission more than fifty paintings from Poussin: in particular, the *Seven Sacraments*, a cycle of paintings portraying the rites of the Church—marriage, ordination,

baptism, confirmation, holy Eucharist, penance, and extreme unc-
tion—as performed in its earliest days. These revolutionary paintings
(which will figure again in the history of the vase) show Cassiano's
interest in the past, and also suggest some unorthodox religious views.
Living in the pocket of the religious establishment, Cassiano was
hardly able to make such beliefs apparent, but it appears that he was
far from conventional in his thinking. Jean-Jacques Bouchard, a con-
firmed unbeliever and *libertin*, bequeathed his private papers to his
good friend Cassiano. What Cassiano thought of these is not recorded,
but he showed them to another, more conventional friend, who was
shocked by "filth" and "devilish things." As we know, Cassiano was
drawn not only to the early practices of the Christian Church, he also
showed a keen interest in the pagan rites of the ancient Romans, as his
volume in his museum dedicated to such "False" practices demon-
strates. The inference is that he viewed both pagan and Christian
beliefs with an equally learned and skeptical eye.

Some of the drawings of the vase that made up the entry in
Cassano's museum are now kept in the royal library at Windsor. They
are a careful study of the whole frieze, laid out in a rectangular com-
position, done in black chalk. They have been ascribed to a close
friend of Poussin's, called Pietro Testa. Testa was certianly one of the
artists whom Cassiano employed, along with Poussin, to make draw-
ings of the ancient reliefs and sculptures, but he does not seem to
have enjoyed the task as much as Poussin, and he fell afoul of
Cassiano's authoritarian approach. When Testa lost patience with
the work of copying, and tried to escape from his employment,
Cassiano had him thrown into jail for breach of contract. Testa went
on to attempt a career as a painter on the grand scale, but he met
with no success and eventually drowned himself in the Tiber.

Cassiano, like his colleague and correspondent de Peiresc, was
another of those who appreciated the vase without owning it. He was
not a "player"; his influence as a patron and arbiter of taste was in-

evitably tied to the fortunes of his patrons. Although he continued his scholarly activities in private, until his death in 1657, his life at the center of power and wealth came to an end with the fall of the Barberini, which was every bit as spectacular as their original rise.

★ ★ ★

MAFFEO BARBERINI REIGNED as Pope Urban VIII for more than twenty years, and the longer his power lasted, the more unpopular he and his family became. Nepotism was an accepted part of life in the Vatican, but Maffeo took it to an extreme, siphoning such colossal sums into the pockets of his family that even the jaded Romans grew outraged. He also consistently raised taxes to shore up the finances of the Church, which, after a long history of maladministration, were already in a parlous state. He had no scruples about taxing basic commodities, including corn, and this turned popular opinion firmly against him. Finally, he embarked on his disastrous war against the Farnese family, which owned a princedom neighboring the Papal States.

Relations between the pope and Duke Odoardo Farnese soured when, on a visit to Rome, the duke refused to bow to Taddeo Barberini or to pay his respects to Antonio Barberini. Garrisons were reinforced, and economic sanctions were applied, until the dispute escalated into all-out war. Taddeo marched out of Rome on the offensive, but Farnese raised an army, defeated Taddeo, and threatened the city itself. Eventually a peace treaty was signed, with terms overwhelmingly favorable to the duke. Huge sums had been squandered on the war, serious damage had been done to the lands across which it had been fought, and the Barberini had been clearly worsted. Only a few months after the peace treaty was signed in 1644, seventy-six-year-old Maffeo, disappointed and defeated, took to his bed to die. His conscience finally pricking him, he summoned his advisers to his bedside and asked them if, perhaps, he had been slightly too generous toward his family. The throng of sycophants reassured him that he

had behaved with perfect propriety, but when news of his death was announced, a grateful populace pulled down his statues. Worse still, in the ensuing conclave, the successful papal candidate, despite the best efforts of the Barberini faction, was Giambattista Pamphili, known for his opposition to Maffeo's nepotism and the disastrous war. He became Pope Innocent X, and immediately took steps to arraign the remaining Barberini. Antonio, Francesco, Don Taddeo, and his family all fled to Paris. Innocent was forced to content himself with confiscating their possessions and shutting up their palaces.

What then of the vase? It was left in the care of Taddeo's wife, Anna. She alone stayed behind in Rome to defend the interests of the family as best she could. Somehow, despite Innocent's strictures, she managed to hang on to the family treasures, and in particular to the vase, which was one of their most prized possessions. The vase remained a totem of the Barberini's status, which the family guarded proudly long after its wealth and standing began to decline. Once it had been a symbol of status; now, as its fame increased, it actually conferred that status itself; if you were an owner of the vase, you were still *somebody*.

When Francesco, Antonio, and Taddeo arrived in Paris, they sought the protection of the chief minister, the all-powerful Jules Mazarin, who eventually forced Innocent to accept the return of the Barberini. Only a few years after their flight, they reappeared in Rome (except for Taddeo, who had died in Paris), magically repossessed of their wealth and status. The dynasty and its fortune survived. By 1653, the family was once more taking an ostentatious part in the city's festivities; the theater in the Palazzo Barberini was reopened, and tickets offered to the public. The following year, Taddeo's son, the Prince of Palestrina, appeared in the carnival parade on a float drawn by four horses. He was dressed as the sun, seated on a throne, accompanied by four horsemen representing the seasons and a hundred young men in gold costumes, carrying torches symbolizing the solar

rays. The Barberini were back, and they had come to stay. Despite everything, Maffeo's dynastic ambitions had paid off. The vase remained in their possession, a symbol of the family's survival.

However, after their triumphant recovery, over the next few decades the Barberini followed the fate of all the Roman aristocracy; that is, they slipped into a slow but inexorable decline. The aristocracy had for generations supported itself on what were known as *monti*, shares issued by the state that paid an annual yield of about 5 percent. This yield lasted forever, and it could be sold or inherited. Those who could afford to own these shares were thus provided with a sort of everlasting pension, which removed the need to invest in, say, agriculture, or indeed in any kind of enterprise. Paying the interest on these shares came to absorb a significant proportion of the revenues of the state; at the time of the discovery of the vase, at the end of the sixteenth century, this proportion had already reached about 60 percent. The money that poured into Rome from the sale of offices and other revenues of the Catholic Church was often spent on distributing food for the poor, and even on dowries for underprivileged young women. None of this encouraged an entrepreneurial spirit or a healthy economy. The Papal States were exceptional in that they were run by clerics, and although these men may have fostered the spiritual well-being of their subjects, they were poorly qualified to audit the finances. Worse, this theocracy, funded by the enormous riches of the Church, indulged in luxurious living and lavish display. The aristocracy as a whole could not help competing, and often it ran into debt doing so. The Barberini, as the Prince of Palestrina's extravagant carnival float demonstrates, were no exception. Without Maffeo to channel millions of scudi into the family coffers, slowly but surely their fortunes dwindled.

But as the Barberini family decayed, the reputation of the vase grew. In 1688, a French traveler made a journey to Italy and subsequently published an account of his experiences. In *A New Voyage to*

*Italy, with Curious Observations on Several Other Countries,* François-Maximilien Misson made a great deal of the vase, which he visited in the Barberini Palace, and described it in detail. He noted how one visit was not enough; he was impelled to go back the next day to take a second look. He could not believe that the layered glass was the work of man: "[T]his vessel was formed by Nature almost the same Figure as it is at present, with a white crust, or rather thick superficies. So that when this crust was cut into Figures and the pieces of the same matter that separate them taken away they discovered the black substance which serves for a background to the ornaments or white figures."

From this time on, every guidebook or traveler's account of Rome mentioned the vase; accordingly, every educated visitor was eager to see it. One of the earliest of these was no less a figure than John Milton, who attended a concert at the Palazzo Barberini in 1639, and was shown round by the Barberini's librarian, a friend from his Oxford days.

As the number of guidebooks and the flood of visitors clutching them swelled, so the number of interpretations of the figures depicted on the vase multiplied, and so, too, did the startling contradictions between these different theories. In 1690, one Michael Angelus Causeus published his *Romanum Museum sive Thesaurus Eruditae Antiquitatis,* which contains both illustration and explanation of the vase. (Find the diagram of the figures again, to follow his twisted reasoning.) At first, Causeus limits himself to one side only, that is to say, figures A–D. He believes that this scene tells the story of the birth of Alexander the Great. His clue is figure C—the lady with the snake. According to his theory, she is Alexander's mother, Olympias; there is a myth that she was visited by Jupiter in the form of a snake, and that the result of this meeting was Alexander himself. Figure D is Jupiter in his proper form, surveying his handiwork. Figure A is described by Causeus as a "Genius." In the classical world there was a belief that everyone had a spirit, or Genius, that had

influence over an individual's nature and character; this is such a figure. Although Causeus does not specify to whom this spirit belongs; perhaps it is to Alexander himself, who is in the process of being conceived, by the reclining lady and her serpent, whose up-reared attitude now takes on new connotations.

What then of Cupid, flying above Olympias, who seems to beckon Alexander's Genius? Causeus makes no remark; nor does he address the other side of the vase, until his *Erudite Thesaurus* is reprinted in 1746, when the three figures E, F, and G are identified as the Muses. The Muses, however, were all female, so this interpretation is undermined by the appearance of figure E, whose manly chest and male genitalia, carelessly exposed by the drapery that hangs across the lap, hint that perhaps figure E at least is not one of the Muses after all.

So Causeus (who turns out like his predecessor to be either rather cavalier about the sexing of the figures or just chronically short-sighted) can hardly be regarded as having cleared the matter up once and for all, and we cannot be surprised to find that only seven years after the publication of the *Erudite Thesaurus*, another theory appears. This was formulated by Pietro Santi Bartoli, the very same writer who gave us the unreliable description of the finding of the tomb in the Monte del Grano; let us not hold this against him, but rather judge his case on its merits.

Bartoli strikes out in an entirely new direction: He links the figures to the myth of Proserpina. She was the daughter of Ceres, goddess of agriculture, and when she was not helping her mother with the harvest, she liked to idle away the time picking flowers on the island of Sicily with a train of nymphs. One day, their singing and laughter attracted the attention of Pluto, the god of the underworld. Pluto drove about in a chariot drawn by four black horses; he carried a two-pronged spear, with which he could strike any obstacle in his path and thereby remove it. Pluto's gloomy character was in part due to his misfortunes in love; none of the goddesses would agree to be

his bride and live in the infernal courts of Hades, and in fact he had suffered so many refusals that he had sworn never to ask again. This perhaps explains, though it does not excuse, his actions; having spied on the beautiful young Proserpina from a nearby thicket, he burst out, seized the hapless goddess, dragged her back to his chariot, whipped up his coal black steeds, and galloped away. To evade pursuit, he struck the ground with his spear, opened a crevasse, and disappeared down into the Land of the Dead. Ceres, missing her daughter, wandered the world in vain seeking her and letting the harvest rot. Jupiter finally took pity on her and decreed that Proserpina should be allowed to return to her mother if she had eaten nothing during her stay in the underworld. But it emerged that Proserpina had nibbled six pomegranate seeds in her captivity, and so Jupiter decided that for six months of the year Proserpina must return to Pluto's side.

Bartoli maintains that figure C is Proserpina, and figure E Pluto, and figure G Proserpina again, but this is hardly satisfactory. What of the snake, of Cupid, and all the other figures on the vase? Where is Pluto's two-pronged fork, or the pomegranate, or Ceres? What prompted this theory in the first place? Figure F, with her up-ended torch, the fallen capital at her feet suggests—perhaps—death. Bartoli's interpretation, however, is disappointingly cursory; he is the first of the merely slap-dash theoreticians who content themselves with identifying one or two figures only. Theirs is hardly a satisfactory approach.

The next contender is Bernard de Montfaucon, who published his *L'antiquité expliquée* in 1722; unfortunately, he was another of the same cursory stamp. He attempts to identify only two figures—C and D. In order to do so, he selects yet another myth from the inexhaustible catalogue—that of Leda and the swan.

In this myth, the god Jupiter fell in love with Leda, the wife of the King of Sparta. Jupiter, who was endowed with all-too-human pas-

sions, conducted many liasons and, often arousing the jealous rage of his wife, Juno, made a habit of assuming some disguise before having his way with whichever nymph or mortal woman had caught his eye. He ravished Europa, the daughter of King Agenor, by assuming the form of a bull and carrying her off on his broad back. When Juno caught him out with Io, the daughter of a river god, he quickly changed the nymph herself into a beautiful heifer (unfortunately Juno saw through this ruse, and she sent a gadfly to plague the heifer to madness). In the same fashion Jupiter assumed the disguise of a swan in order to ravish the mortal woman Leda. Leda then gave birth to the twin heroes Castor and Pollux, and subsequently to Helen, whose face would launch a thousand ships to the siege of Troy.

Bernard identifies figure C as Leda, and D as Jupiter. He does not try very hard with the rest: "It is not easy to discover what the other figures are doing," he notes, without pausing to wonder whether his theory might not be cast into doubt by this, "nor what relation there is between this fable and the ashes of Alexander Severus. Perhaps it is best to say that the first precious vessel which came to hand was made use of for this purpose." Bernard's theory is not only incomplete, it is also seems to be based on a serious misapprehension: that the creature rearing up beside figure C is the swan, or rather Jupiter in swan's form. If the creature caressed by figure C had been a giraffe or a rhinoceros—something that Bernard himself had never seen— or a mythical creature, about whose appearance he could only guess, perhaps we could forgive him. But a *swan*? Perhaps Bernard knew of the myth as Leda and the snake, or perhaps, like so many of those before and after him, he rushed into print without having actually looked closely at the vase at all.

In 1756, Ridolfino Venuti published his *Spiegazione de'bassirilievi dell' urna sepolcrale detta d'Alessandro Severo*. He hit on the myth of the Judgment of Paris to explain the frieze. In this story, the goddess of discord, having failed to receive her invitation to the marriage of

Peleus and Thetis, turns up anyway and throws an apple onto the table labeled FOR THE FAIREST. The three chief goddesses—Venus, Minerva, and Juno—all lay claim to it, and appeal to Jupiter. He, being no fool and not wanting to incur the wrath of two of them, decides that a lucky mortal—Paris, Prince of Troy—shall make the decision. The goddesses duly parade before Paris, who is at this time, for reasons too complicated to go into here, living as a shepherd on Mount Ida, and dangle appropriate bribes: Minerva offers wisdom, Juno offers power, and Venus offers the favors of the most beautiful woman in the world, i.e., Helen, daughter of Leda. Venuti identifies figure A as Paris, C as the goddess of discord, "who, as if thrown out of heaven, sits on earth," fondling a serpent to symbolize her tricksy nature, and D as Jupiter. On the other side, the rocks on which the three figures sit represent Mount Ida, and the figures themselves are the goddesses. This theory would fit better if the three figures were female, but Venuti, like his predecessors, showed some confusion in the matter of gender, and endows figure E, whom he takes to be Venus the goddess of love, with male genitalia.

This might seem like a bewildering array of theories, but it is just the beginning, a mere trickle of scholarly hypotheses that gradually swelled to a flood. They all served to inflate the reputation of the vase, and more and more visitors came to the Palazzo Barberini to admire it. By the time Venuti published his theory in the mid-eighteenth century, the vase had become an acknowledged stop on the Grand Tour. Everyone who saw it marveled at it. The Sienese artist Bernardino Capitelli, who worked for Cassiano dal Pozzo and made an engraving of the vase in the 1630s, described it as holding "the first place . . . among the most precious treasures" of the Barberini. He described how the vase, "a precious pearl," had "often aroused my admiration, and made me long to equal it." He was not the last artist to succumb to this powerful feeling.

EIGHTH FRAGMENT

# JAMES BYRES

MOTHER DABS A TEAR AWAY, Father claps you on the shoulder and shouts a last command to your tutor, John the coachman folds up the steps and jumps onto the box, and you are off in a cloud of dust down the road to Dover. Your belongings are strapped up behind in a great mass of trunks and bundles: tinder box and tea caddy, handkerchiefs and hats, penknife and passport holder. You clutch your guidebook, with its lists of questions to ask, places to visit, and works of art to view. Dover to Calais, Calais to Paris, down through France and over the Alps to Italy; you are off on the Grand Tour, an established part of every young eighteenth-century aristocrat's education, an experiential finishing school in which you are supposed to acquire languages, grace of address, broader horizons, self-reliance, and taste. You put up at noxious inns, and are fleeced by the innkeeper; you bribe your way through the innumerable custom houses, fighting off vermin, beggars, and banditti; you gawp at for-

eign customs and clothes, bridle at unfamiliar and garlic-laden food, face the terrors of the mountains and the heat of the plains, until at last, having braved the Simplon Pass (where your faithful King Charles Spaniel is eaten by wolves) and the rapacious *douaniers* and appalling roads of Piedmont, your carriage tops a rise, and you behold the roofs, towers, steeples, and domes of the Eternal City, far-thest and foremost destination of everyone who ever went on the Grand Tour.

In Rome you take rooms (cheap and generously proportioned for less than six guineas a month), browse the shops (watchmakers on the Piazza Capranica, booksellers around the Chiesa Nuova), venture down into the catacombs, and have your portrait painted by Pompeo Batoni, as you stand proudly in front of the Colosseum. If you have arrived before Easter, you enjoy the spectacle of the carnival and observe the solemn ceremony during which the pope washes the feet of twelve aged pilgrims. But most of all, you are here to view the antiquities, to pick your way through the maze of ruins— columns, obelisks, arches, and temples—often obscured by weeds and rubbish, but beside which you may attempt to bring to life the verses of Horace or the noble periods of Caesar that were beaten into you in childhood. Dutifully you take notes as your tutor holds forth, and dutifully you tick off the stops in your guidebook. The sights are inexhaustible; how long you are prepared to spend on them depends on your enthusiasm and stamina. Dr. John Moore, in his *View of Society and Manners in Italy*, describes the behavior of a fellow country-man, who did not want to spend every afternoon trailing round the sights, but still wanted to claim that he had, so to speak, gotten the T-shirt:

> He ordered a post-chaise and four horses to be ready early in the morning, and driving through churches, palaces, villas, and ruins, with all possible expedition, he fairly saw, in two days, all

that we had beheld during our crawling course of six weeks. I found afterwards, by the list he kept of what he had done, that we had not the advantage of him in a single picture, or the most mutilated remnant of statue.

For all eighteenth-century visitors, high speed or snail's pace, fascinated or bored, the vase, still displayed in the palace of the surviving, though much reduced, Barberini family, had become a must-see. For any tour that would include the most important highlights, a guide was needed, a local expert. Pick of the bunch was Johann Joachim Winckelmann, the eminent German antiquarian.

The vase was an object that every visitor had to see, and Winckelmann stood before it in the Palazzo Barberini many times, showing it off to his charges, his own admiration undimmed by repeated viewings. As he presented the vase to his distinguished guests, he developed his own theory as to the meaning of the figures on it. If you were a member of the extremely select group gathered round with him in one of the cool halls of the palazzo, you would have heard him identify figure A as Peleus and figure C as the beautiful sea nymph Thetis, daughter of the sea god Nereus. This identification depends on the serpent she is fondling; Winckelmann, one of the few who seems to have examined the figures closely, saw the fan-shaped fin hanging from the creature's throat, and the small fins on the back of its neck, and he determined quite reasonably that this was a sea serpent. Backed by Winckelmann's life of intense study of classical literature and art, this theory has an excellent pedigree, and it is worth considering in some detail.

The story of Peleus and Thetis begins when Neptune and Jupiter both fall for the lovely nymph. Any rivalry is quickly curbed when Themis, goddess of order, prophesies that when Thetis gives birth to a son, he shall be greater than his father. At the prospect of siring an heir more powerful than themselves, both the gods step swiftly back

and agree that Thetis must be married to a mortal so that she will not produce some powerful young godling capable of supplanting them. Themis suggests the hero Peleus, who had sailed with Jason on the quest for the Golden Fleece. Thetis, however, does not acquiesce. According to one version of the myth, when Peleus approached and embraced the nymph, she resisted him by changing her shape, so that the hero finds his arms around a lion, then a snake, then a raging fire, and so on. Peleus, however, had been warned by his friend Chiron the Centaur that something of the sort might happen, and Chiron had advised him that if he held on long enough, Thetis would return to her proper form and submit to his advances. This proved to be the case; after Peleus's vigorous and successful wooing, the gods themselves graced the wedding feast, and at length Thetis bore a baby son would become the greatest of all mortal heroes—Achilles.

But, of course, there is no sign of a wrestling match on the vase, no clutching and shape-shifting, only a calm and decorous scene in which Cupid leads the suitor toward an entirely acquiescent-looking nymph. How then does the theory stand up? There is another version of the myth, in which Thetis is brought up by Juno, wife to Jupiter, and when Jupiter courts her, she rejects him out of loyalty to her guardian. Jupiter, frustrated and annoyed, decrees that Thetis shall be married to a mortal. Juno, however, makes sure that the mortal is the finest then living—the hero Peleus. As he is Juno's choice, Thetis makes no protest but accepts the match. This version of the myth certainly accords better with the figures on the first side of the vase. Figure A is Peleus, approaching his intended, but looking anxiously over her head at figure D, Jupiter, who gives his approval. This less violent version of the myth is celebrated by the Roman poet Catullus, who describes in highly sensual and romantic terms how Peleus first glimpses and then falls for Thetis. From the deck of the *Argo*, he and the other Argonauts look down into the water, and see Thetis and the other daughters of Nereus:

As the moving waves took the keel the water chopped with oars, grew white and from the runnels of foam faces peered of Nereids, wondering. Then and not since men with their own eyes saw the bare bodies of nymphs in broad daylight, caught in the marbled runnels of foam as far down as the nipples. So Peleus was stirred towards Thetis, so Thetis came to a woman's bridal, and Jupiter gave his blessing.

Beautiful and logical, Winckelmann's theory was by far the most convincing yet formulated, and would be reasserted and reworked by several later theorists. He was one of the most reputable and influential scholars ever to write about the vase. Winckelmann had acquired his knowledge the hard way. Born in utter poverty, the only child of a Prussian cobbler, he worked his way through school and college, drudging as classroom assistant and private tutor. Unable to afford books, he developed the habit of borrowing works and copying extracts to create his own library. After college, he worked for five years as a teacher in a school in the provincial town of Seehausen. After a day spent teaching, he would study until midnight, sleep in his chair until four, then wake and study again. He was also giving private lessons to a young man living with him, whom he had tutored, and who had followed him to Seehausen. Winckelmann was certainly gay, and extant letters from him to this roommate are full of endearments, but even if there was more to this relationship than meets the eye, it's hard to see how he would have had the leisure to indulge in it much. Winckelmann, according to his sentimental nineteenth-century biographer, was

. . . like a slave, only half belonged to himself in the day. His real life began at night, when he invited the ancients to be his guests. There he sat, the pale and lean man, in his narrow, bare, ice-cold cell, with his dark, sparkling eyes peering out from the

depths of his cloak into a parchment copy of Plutarch or Sophocles, dreaming, in the midst of impenetrable, snow-covered fields, of the Mediterranean and its people. . . .

Slowly, and with great pains, he clawed his way up the ladder of employment. He landed a job as research assistant to a court official in Saxony, who was compiling a history of the German Empire. Winckelmann was given the deadly task of checking dates for this massive, turgid tome. But the work gave him access to a large library, which he was then asked to catalogue. He taught himself English, and copied excerpts from Pope and Milton (and delighted in John Cleland's *Fanny Hill*). But in his studies he inclined more and more to the world of ancient Greece, and to Greek art in particular. He determined that this should be his life's work. From his reading and dreaming, he developed a vision of ancient Greece as a utopia, producing ideal forms of "noble simplicity and quiet grandeur." It is an idea that has embedded itself in our consciousness.

While working in the library, he came into contact with Count Alberigo Archinto, papal nuncio to the Court of Saxony. Archinto recognized Winckelmann's skill, and he gave Winckelmann a golden opportunity—to work as librarian to Archinto's friend Cardinal Passionei, in Rome. The cobbler's son became librarian to His Eminence the cardinal secretary of state, with an apartment in the Palazzo della Cancelleria. Once settled in the Eternal City, Winckelmann began to study the antiquities stored there, and to gather materials for his *History of Ancient Art*. He also experienced more sexual freedom; Casanova joked about catching him in flagrante with a young man, at which Winckelmann explained he was only indulging in homosexuality in order to imitate the ancient Greeks.

In 1763, the cobbler's son was appointed papal antiquary by Pope Clement XIII. Winckelmann had a salary, prestige, and minimal official duties. One of these was to keep track of antiquities and make

sure they were not being smuggled out of the country—but there were troops of underlings to take care of this. Winckelmann's real task was to take any prominent visitors who expressed an interest on a tour of the city; he was now hobnobbing with the rich and powerful. Bishop, milord, diplomat, statesman—all were to be charmed, informed, and entertained, their foibles or drunkenness ignored, and their demands for erotic satisfaction tactfully passed on to "Viscioletta," a top-ranking courtesan of the day. The Duke of York, brother to George III, was escorted by Winckelmann, who described him as "the greatest idiot I know." Writer James Boswell and demagogue John Wilkes both enjoyed his company (Wilkes had a mistress in tow, and their guide sometimes had to turn a blind eye when the besotted pair seized an opportunity to retire to a secluded corner of the church or palazzo and enjoy each other's company). One morning, Winckelmann complained, he had the Prince of Mecklenburg, the Prince of Anhalt-Dessau, and the Duc de la Rochefoucauld, "each of them desiring me to spend the day with them alone." And, doubtless, to be conducted to the Palazzo Barberini to see the vase.

★ ★ ★

IF, WHEN YOU ARRIVED in Rome, you were not important enough, or just not lucky enough, to be able to engage Herr Winckelmann, you might fall into the hands of another famous guide for Roman tourists, James Byres. Byres was a Scot, effectively in exile from his native land, and the fate that brought him to Rome was decided during the revolt of 1745, when Bonnie Prince Charlie, the "Young Pretender," sought to seize the throne of England. Byres was the next person to gain possession of the vase, so it could be said that the fate of the vase was also determined on the bloody battlefield of Culloden.

James's father, Patrick Byres, Lord of Tonley, rallied to the rebel flag raised by Bonnie Prince Charlie in Glenfinnan in August 1745, and

became a major in a Jacobite regiment. Prince Charles Stuart was fighting to regain the throne after his grandfather James II—hence "Jacobites"—had been kicked off it by the Glorious Revolution of 1688. Patrick Byres fought at the battle of Prestonpans, a brilliant victory for the Jacobite forces, and marched with them as far south as Derby, as they evaded the forces sent to bar their way and threw London into panic. He was also part of the retreat, when the war council suffered a failure of nerve and lost Charles his golden chance. He was present when the Jacobite army was brought to bay by the Duke of Cumberland, younger son of King George II, in a marshy wasteland near Aberdeen. The Jacobite soldiers were exhausted; they had spent the previous night on an abortive forced march to try to take their enemy by surprise, and more than a thousand of them actually slept through the battle. They had rain and snow blowing in their faces, and they were outgunned by Cumberland, who took advantage of the wide, open battlefield to decimate the rebels with his artillery before their attack could be brought home (the word to advance failed to get through for some time because messengers kept being killed by the cannon). When it finally launched, the wild Highland charge with shield and broadsword (which is perhaps something of a myth—most of the Jacobite soldiers were armed with muskets like their opponents) broke two British regiments, but it was halted by a fierce counterattack. The impetus was lost, and under murderous musket volleys the whole army disintegrated. In the ensuing rout, "Butcher" Cumberland's soldiers killed more men than died on the battlefield. The revenge of the house of Hanover was ruthless and barbaric. Soldiers committed many atrocities, including the piling up of wounded Jacobites into heaps to be used for target practice by the cannon. They hunted Prince Charles through the heather for months, and he spent three weeks living in a cave before he could find a ship to take him to refuge in France. Patrick Byres, along with the few who escaped unharmed, fled for his life.

After Culloden, Byres was hidden by a friend in a castle near to his own lands and then, like his prince, he escaped to the continent with his son, James. James was eleven years old at the time of the 1745 rebellion, and the course of his young life was thus drastically changed by this disaster; he went into exile with the rest of the family, was educated in France and brought up in the Catholic religion. Exactly how these dramatic events shaped him we can only conjecture, but he must have identified with the cause, because, like many other Jacobites, when he reached manhood, James followed his father into service with the forces of France in the Royal Scottish Regiment, serving under the Jacobite general Lord Ogilvy. In 1756, he left the army, probably because of a law passed by the British government that was designed to seize the estates of Jacobites who did not return to Scotland. Although Patrick Byres's lands should have been forfeit after the rebellion, there is a story that, due to an administrative sleight of hand performed by a sympathizer, his name never appeared on the list of proscriptions and his possessions escaped confiscation. However, even if the family could retain their possessions, Scotland could not be home for James. At the age of twenty-four he went to Rome, the last resting place of the Jacobite cause, where a despairing and drunken Prince Charles resided. There, James began to study painting. Eventually it became clear that he did not have the talent to make a successful career as an artist, so he switched to architecture. He did not have the talent to make a successful career of this either, but it took him the rest of his professional life to realize it.

To begin with, he showed a moderate amount of promise. After ten years in the city he won third prize in a competition run by the Academy of Saint Luke. His first commission, in 1768, was to design a house for a fellow countryman, Sir Lawrence Dundas, to be built in Edinburgh, but the design was rejected. Then the College of Physicians in Edinburgh asked him to draw up designs for a library; it was never built. The following year Lord Arundel asked Byres to

design an altar for the chapel in his house at Wardour, and even this small-scale project came to nothing. In 1770, Sir Charles Watkin Williams-Wynn commissioned Byres to design a house for him in the Dee Valley. Once again, the project was not taken up. Nor were his designs for Henham Hall, commissioned by Sir John Rous, nor his temple for an island on Lord Breadalbane's estate, nor his plans for a house for the Earl of Charleville. Byres's persistence is admirable, but the constant rejection must have had an adverse effect on his spirit. Moreover, unable to find success in his chosen field, Byres was forced to resort to another—antiquities.

While pursuing his studies in Rome, Byres had gradually fallen under the spell of the ancient remains. He traveled to Etruria and made a study of the Etruscan tombs. He published a large volume of beautiful architectural drawings, *Sepulchral Caverns of Tarquinia*, Tarquinia being the capital of the Etruscan lands. These highly detailed pictures give a powerful impression of the spooky mausoleums, decorated by a vanished and forgotten people. Byres seems to have identified to some extent with the Etruscans, sympathizing with their unsuccessful struggle against the dawning power of ancient Rome, perhaps seeing in the destruction of Etruscan culture by the Romans a reflection of the fate of his own nation.

Thus, his love of the past and his artistic and architectural training perfectly equipped him for a career as a guide to visitors on the Grand Tour, and here he finally found his uncomfortable niche. Byres charged twenty sequins for, his course, or thirty for two pupils together. His reputation as an expert ensured a steady stream of takers. But he does not seem to have chosen his career out of any love of, or even ability for, communicating with his European clientele. On the contrary, it seems Byres hated his chosen profession. He did it for the money, and he resented it bitterly. Resented the need of the failed artist and architect, the exile from the ancestral lands, to lower himself to earn a living as a tour guide and thereby compromise his sta-

tus as a gentleman. Although his close relationship with his noble and wealthy pupils gave him the ideal opportunity to attract architectural commissions, the constant failure of these schemes must have only contributed to the anxieties he felt about his status. It is more than likely that he harbored animosity toward his English clients because of the political conflict he had lived through; after all, these were the sons of the men who had murdered his father's friends and driven himself and his father from their homeland.

James Byres was certainly very learned, but as the accounts of his many pupils attest, he was a miserable, foul-tempered pedagogue. "I am (as you may suppose) up to the ears in Antiquities under the Auspices of Mr Byres," recorded Thomas Clarke, "of whose lessons, entre nous, I begin to be rather sick." Philip Yorke, who visited Rome in the 1770s, gives us a sketch of Byres's methods. Byres had "no regular system of showing Rome" but determined his agenda according to the weather: "antiquities and ruins when fine, statues and palaces when wet, and if it should be a clear day but unpleasantly windy we see pictures." Thomas Clarke described him as: "An intelligent man, though a very disagreeable one." Another visitor to Rome, Thomas Brand, mimicked Byres's "Ayberdeen Deealect," and was even more forthright: "A sad, peevish fellow who would quarrel with his own shadow." Brand assiduously tried to take notes, "but he went on at such a rate . . . that it was impossible to keep up with him." Byres's rival guide, Winckelmann, thought him a timid hypochondriac. Charles Long was ". . . not sorry to have done with a man who is one of the most irritable I ever met with."

Dr. John Parkinson, who visited Rome in the early 1780s, left a detailed description of a single day spent under Byres's tutelage, and just reading it leaves one feeling dazed and footsore. They visited the Theatre of Marcellus, the Temple of Piety, the Arch of Janus, the Arch of Septimius Severus, the Cloaca Maxima, the Temple of Pudicitia, the Temple of Vesta, the Temple of Fortuna Virilis, the

ruins of the Palatine Bridge, the House of Crescentius, the Aventine Hill, the Temple of Juno Regina, the Priory of Malta, and the Pyramid of Caius Cestius, at the foot of which, presumably, Dr. Parkinson collapsed, begging for mercy. Byres accompanied the tour with a never-ending flow of information. Dr. Parkinson records how their stop by the Cloaca Maxima tempted Byres from speculation about the origins of the ancient city, to extravagant deviations and divagations into such matters as why Syrens' feathers became the emblems of the Muses, and whether the Mediterranean had once been dry land. To begin with, his pupils found this unstoppable flow impressive, but before long, most of them were wishing he would just shut up.

Perhaps Byres's greatest achievement as a teacher manqué was his baleful effect on Edward Gibbon, a man who possessed so great an interest in and sympathy for the classical world that he determined to make it his life's work, and whose *Decline and Fall of the Roman Empire* is still regarded as the first and greatest work of modern historians. Gibbon arrived in Rome in October 1764, and the excitement he describes in his memoirs at this epiphanic experience comes as a telling contrast to Byres's contemptuous familiarity. "At the distance of twenty-five years I can neither forget nor express the strong emotions which agitated my mind as I first approached and entered the *Eternal City*. After a sleepless night, I trod with lofty step the ruins of the Forum; each memorable spot where Romulus *stood*, or Tully spoke, or Caesar fell, was at once present to my eye; and several days of intoxication were lost or enjoyed before I could descend to a cool and minute investigation." Unfortunately, he elected to make this under one guide in particular, and he also made the mistake of signing up for a truly epic course of instruction: "My guide was Mr Byres, a Scottish antiquary of experience and taste. But in the daily labour of 18 weeks the powers of attention were sometimes fatigued." This then is James Byres's claim to fame; he managed to

bore the author of *The Decline and Fall of the Roman Empire* with Roman antiquities.

Fortunately Byres had another string to his bow, and one that better suited his taste and vinegary temperament; he also dealt in antiquities. His house was a showroom, stocked with valuable and beautiful objects, arranged with exquisite taste in order to catch and enchant the buyer's eye. In the reception rooms of his apartment, plaster busts stood on gilt- and marble-topped tables. Works by painters such as Claude Lorraine and Correggio hung on the walls.

In addition to taking more pleasure in dealing antiquities, Byres was also more successful in this role than as a teacher. He pulled off some major deals. In 1764, he bought a Poussin from Count Solderini and sold it to Lord Exeter. His biggest coup was the acquisition of Poussin's cycle *The Seven Sacraments*, which belonged to the Bonapaduli family. Byres sold these paintings to the Duke of Rutland in 1785. There was a significant amount of skulduggery involved in this exchange, because then as now there were regulations restricting the export of artworks, and Byres and his clientele resorted to deception in order to evade them. Byres was keen to remain anonymous, as a surviving note in his hand makes clear:

> It should never be mentioned through whose hands he got them, for my name being mentioned might be attended with the worst consequences to me here, where we live under a despotic government who are more jealous than ever of things going out of Rome.

The paintings were removed one by one, and replaced by specially commissioned copies. But these pictures were, like the vase, a customary stop on the Grand Tour. How could Byres now take his charges on a visit to look at copies? According to the contemporary English artist Joshua Reynolds, Byres did not balk at the necessary

deception, combining his role of black-market art dealer with that of guide and teacher, in order to reinforce the fraud: "One of the articles between Byres and the Marquis was that he should bring the strangers as usual to see the copies, and which he says he is obliged to do, and, I suppose, swear they are originals." Reynolds even spitefully speculated that the same trick could be pulled again—another wealthy patron could be duped into buying the copies in the Palazzo Bonapaduli as originals, and more copies put in their place, and so on. There is also some evidence that Byres passed off a modern copy of an antique gem, made by a friend and famous engraver of gems called Giovanni Pichler, as original on an unsuspecting customer. That the copy was good enough to fool Winckelmann, when he was asked to examine it, is a tribute to Pichler's talent, but not to Byres's honesty.

Though as a communicator Byres can be said to have lacked certain skill, he still had a genuine love of antiquities and of the ancient world. He took an interest in the vase, which amounted almost to an obsession, not only holding forth about it to his unfortunate charges with his usual dizzying display of erudition, but also giving a great deal of thought to the way the vase had been constructed. From subsequent attempts to reproduce it, we know that he came close to the truth:

> The glass-maker who formed it for the hands of the sculptor first took on the end of his pipe a mass of the deep blue glass, but before he began to form his vessel he dipped this mass into a pot of white enamel, and thus gave it the form which the sculptor desired, but it is probable that he spoiled several before he succeeded in making one fit for the purpose intended. This being accomplished, the sculptor cut and formed all the figures and ornaments in the white coating, and then cut or ground off all the other parts of the coating, so as to lay bare the deep blue, and make it the surface from which the white fig-

ures and ornaments projected. These, in consequence of a small degree of transparency in the white enamel, have an amazing delicacy and beauty in their parts, such as the foliage, and the wings of the flying figure, and the hair.

So when the vase came onto the black market, as it did sometime in the 1780s, as a man with a reputation for being able to deal in such things, and a deep personal interest in the vase, Byres was the obvious customer. When Princess of Palestrina, Donna Cornelia Barberini Colonna, could not pay her gambling debts, it was to Byres that she turned, in the hope of raising some ready cash. Donna Cornelia was the descendant of the Barberini, guardian of the heir to the dwindling family fortune (a boy who had not yet come of age and was in no position to prevent the princess from squandering his inheritance). Unfortunately her weakness for card play had fatally exacerbated the financial troubles of that once proud family. Being a princess, she had no desire to part with her jewels or her gowns, but one thing she did have was the vase. According to one account, the princess wanted to put several antiquities from the Barberini collection onto the market, including some significant and substantial classical statues. (The "Barberini Faun," for instance, was a large classical work that depicted a sensual young creature in a state of exotic languor, and was the favorite work of the Marquis de Sade, who described it as a *sublime statue grecque.* It was eventually sold to Crown Prince Ludwig of Bavaria in 1814.) Unfortunately, the pope heard of the projected sale and forbade any of these items from being removed from Rome. The vase, however, despite its still growing reputation, was small enough to slip through the official net. To Byres, who could spirit away an entire cycle of large oil paintings, a small piece of glassware presented little difficulty. The princess sold it to Byres in 1780, and it was the "Barberini Vase" no longer.

Byres, however, was a dealer, not a wealthy patron of the arts.

This transfer was an epoch for the vase. No longer the prize of cardinals or popes, it was now in the hands of a man who appreciated its value professionally, and he saw it as a way to make money; we might say that it passed now into the hands of a truly modern man. Whatever pleasure he took in handling the vase, and placing it in a position of honor in his apartment's showroom, Byers was only buying the vase in order to sell it; he bought it for about five hundred pounds, expecting to make a profit; as we shall see, his expectations were fully realized.

A few years later, in his mid-fifties, Byres left Rome and returned to Scotland. The political climate had changed, transformed by the cataclysm of the French Revolution. Revolutionary France posed a far more serious threat to the British ruling class, and returning second-generation Jacobites no longer risked decapitation on Tower Hill. Byres could even reinhabit his ancestral home at Tonley. He spent the last thirty years of his life improving and beautifying his estate in Scotland, living to the age of eighty-four. His unhappy heart and his ill temper seem to have been mollified by his long-deferred homecoming. He even, according to a family chronicler, "cherished affection for a Miss Fraser of Castle Fraser, but something came between them." Neither of them married, and when Miss Fraser died, she left Byres her carriage and her picture, and we can only hope that he was more interested in the subject of the portrait than in the relative merits of whichever artist produced it.

# JAMES TASSIE AND JOHN KEATS

Before Byres sold the vase, he considered other ways to turn it to his advantage. He asked his engraver friend Giovanni Pichler to take a mold from the vase. Pichler made a mold of plaster of Paris, and it was divided up into four sections: three for the body of the vase, and one for the base. Once this delicate operation had been successfully performed, Byres could then commission copies from the mold. For this he went to James Tassie.

Tassie is a small but significant figure in the story of the vase, not just because he was the first person—but by no means the last—to make a three-dimensional copy of it, but because his work, and the part the vase played in it, is a prime example of the hold that the vase, along with other works of antiquity, was beginning to exert over the contemporary imagination.

Tassie was another Scot, born in Glasgow to a working-class family, and he apprenticed as a stonemason. But he had talent and hopes

of becoming a sculptor, and he managed to get himself into the Glasgow Academy. He then took a job in Dublin, as assistant to Henry Quin, a professor of physics. Quin had a hobby: casting reproductions of engraved gems and precious stones. Together, he and Tassie invented a medium for reproducing such items, which has been variously described as a "white enamel paste" and a "vitreous paste." It seems to have been made of powdered glass and pigment, which, when heated, became a workable medium that could be pressed into a mold. But this invention became an industrial secret, because what was merely a pastime for Quin became a profession and a thriving business for James Tassie.

Tassie learned how to reproduce seals, cameos, and antique jewels, and in the 1760s he brought his new skill to London. He was apparently a shy and diffident man: simple, modest, benevolent. His portrait shows a long, pale face and pale gray eyes, with a sober, earnest expression. Tassie had some difficulty getting started in the turbulent marketplace of the capital, but his reputation soon began to spread as the quality of his work became apparent. Having set up a shop in Great Newport Street, not far from Josiah Wedgwood's showrooms, he began to supply Wedgwood with molds for cameos and intaglios, which Wedgwood would then cast in his own ceramic medium.

Tassie's gems became a fashion, then a rage. Jewelers took to setting them in rings, bracelets, and necklaces. A catalogue was compiled—*A Catalogue of Impressions in Sulphur of Antiques and Modern Gems from Which Pastes Are Made and Sold*, by J. Tassie, Compton St., 2nd Door from Greek St., Soho. It described a vast variety of items copied from ancient originals, but now available to the common man for a few shillings. Together, the items were a compendium of ancient history and mythology. An early edition of this catalogue promised that "the Antiquarian and the Scholar may find gratification of their taste—the Student an assistance to his memory." It

listed over three thousand different entries, under many headings. In the Egyptian section, for instance, were "Osiris," a "Crocodile," and an "Egyptian Hawk." In "Gods and Goddesses" were "Saturn," "Jupiter," "Juno," a "Bacchante," "—with a mask," "—sitting with a tiger," "—blowing with pipes," "—dancing like a fury." Other sub-headings included "Philosophers, Poets and Orators," "Kings, Queens and Heroes," "Roman History," and "Masks, Chimeras, Vases and Sphinxes."

By the time Tassie died in 1799, his business was a fixture on the London scene, and it was carried on by his nephew, William. There were now more than fifteen thousand items in the catalogue. (Catherine the Great, who was an obsessive collector of gems, placed an order for the entire collection.) William opened a studio in Leicester Square, which became a magnet for artists and poets. The Tassie gems seemed to have a peculiar fascination for the Romantic poets. Byron was a frequent visitor to the shop. Shelley wrote to his friend Peacock from Italy in 1822: "I want you to do something for me, that is, to get me two pounds worth of Tassie's gems, in Leicester Square, the prettiest, according to your taste, among them the head of Alexander."

Three years earlier, in 1819, John Keats had written to his school-girl sister Fanny: "On looking at your seal I cannot tell whether it is done or not with a Tassi—it seems to me to be paste—As I went through Leicester Square lately I was going to call and buy you some, but not knowing but you might have some I would not run the chance of buying duplicates." He asks her to let him know if she would like any, and if so, "whether you would rather have motto ones like that with which I seal this letter: or heads of great Men such as Shakespeare, Milton &c—or fancy pieces of Art, such as Fame, Adonis, &c . . ." A month later he writes again, to let her know that although he has not forgotten the errand, he has not yet been to the Tassie shop. Perhaps this is not surprising, because as well as running

errands for his sister he is also, at this time, revolving in his mind the thoughts that will shortly inform the composition of his most famous and successful works, the four great odes, including his "Ode on a Grecian Urn."

*Thou still unravished bride of quietness,*
*Thou foster-child of silence and slow time . . .*

The subject of Keats's poem is neither Roman, nor a vase. But Keats must have seen the vase, and it is highly likely that it contributed, along with several other ancient artworks, to the impressions that inspired the poem. He made a drawing of a Greek vase in the Louvre, known as the "Sosibios Vase," which he found in a book by Henry Moses, *A Collection of Antique Vases.* He was also thinking of the Elgin Marbles, newly displayed in the British Museum only a few years after the vase itself was installed there. His ode is the most successful and profound meditation on an ancient work of art in literature, and what it says about the anonymous composite urn of the title can be applied often word for word to the vase.

Having celebrated the great age of his urn ("foster-child" because the craftsman who made it, its father, is long dead) Keats questions it directly: "What leaf fringed legend haunts about thy shape? . . . What men or gods are these? What maidens loth?" Nothing could be more appropriate; these are exactly the questions that scholars have asked, and continue to ask, about the Portland Vase. Keats, perhaps more wisely than they, does not attempt to provide any answers. Instead, he considers the permanence of the work, its figures frozen for eternity. He could have been addressing these lines directly to figures A and C on the vase itself:

*Bold lover, never, never canst thou kiss,*
*Though winning near the goal—yet, do not grieve:*

93

*She cannot fade, though thou hast not thy bliss,*
*For ever wilt thou love, and she be fair!*

Love on a vase, then, is better than the real thing.

*More happy love, more happy, happy love!*
*For ever warm and still to be enjoyed,*
*For ever panting, and for ever young—*
*All breathing human passion far above . . .*

With the power of his own imagination Keats creates the warmth and passion that the vase itself can never supply. He himself, young and unhappy in love, knew what it was to pant, and the contrast between the heat of his verses and the cold, unfeeling vase now undermines his admiration for the work; perhaps it is only a "Cold Pastoral," sterile and inhuman.

*When old age shall this generation waste,*
*Thou shalt remain, in midst of other woe*
*Than ours, a friend to man, to whom thou say'st,*
*"Beauty is truth, truth beauty,—that is all*
*Ye know on earth, and all ye need to know."*

The final, famous couplet has quotation marks around it; this is not the poet speaking, but the vase itself. Keats, while insisting that the vase is a "friend," remains ambivalent about its value. It cannot share human suffering, or feel love, and its dictum "Beauty is truth, truth beauty" is something that a cold and unfeeling piece of perfection might say; it is too simple for the complexities of real "breathing" passion, or for the poet himself. Its immortality is undeniable; less than three years after he wrote these lines, Keats himself was dead and buried, in a cemetery in Rome, ending where the vase began. While his

body moldered, the vase sat on impassively in its glass case, as it will continue to do, presumably, when we, too, are all reduced to handfuls of dust, and laid up in our own urns on a shelf in the hereafter. But Keats is immortal, too, and his verses live, while the vase it at the mercy of any passing vandal with a hangover and a lump of basalt.

<p style="text-align:center">★ ★ ★</p>

BYRES GAVE PICHLER'S MOLD to Tassie in about 1783. With it Byres extended permission for Tassie to make sixty copies; after that the mold was to be broken, in order, presumably, to preserve the rarity and value of the copies. At first Tassie seems only to have produced copies of the vase to order. In 1793, for instance, the ninth Earl of Burghley ordered one. The procedure for creating a copy was not a particularly speedy one; the finished article was not delivered until May of the following year, along with a bill for ten pounds and sixteen shillings, which was paid by the tenth Duke, his predecessor having died while waiting for his Tassie copy of the vase. But at some point Tassie seems to have decided to produce more copies en masse. These continued to sell slowly, and by the time Tassie himself died, the limit of sixty had not been reached. Half a century later, in 1845, William Tassie had inherited his uncle's stock, and he was still advertising a remaining number of copies of the vase:

> Although these casts have been made more than fifty years, some
> of them still remain unsold, and may be had of Mr William
> Tassie, No. 8, Upper Phillimore Place, Kensington, who retains in
> his own possession the very large Collection of Gems made by
> his late uncle and himself.

A handful of copies of the vase by Tassie survive to the present day. Some of them are glazed, but all are monochrome; they do not reproduce the contrasting colors of the original. They are, however,

an important record of the way the vase looked before it was smashed in 1845. The Tassie copies demonstrate that the vase was not in perfect condition, even then. They all faithfully reproduce, on the otherwise pristine vase, a crack, semicircular in shape, and about eight inches long, that curves up from the base of the vase, and down again, running through figures C, D, and E. The Tassie copies supply the only firm evidence that this early crack existed, because it was, of course, subsequently disguised by later damage.

When did this crack appear? We have no way of knowing whether the damage was done after the vase made its appearance in the collection of Cardinal del Monte, or long before, in antiquity. But it raises the intriguing possibility that the vase suffered a serious accident soon after it was made. The Tassie casts also show that the base disc was not fully inserted into the bottom of the vase. It was, in fact, slightly too wide, and was cemented onto the rim of the base instead of fitting snugly inside it. Weathering on the rim of the disk strongly suggests that it was fitted in antiquity. But removal of the base disk in modern times, during restoration, has revealed that the body of the vase was altered, in order to fit the disk.

Under close examination, the rim of the base is revealed as jagged; it has been "grozed." Grozing is the process whereby glass can be taken away in tiny bites, using a small metal tool, to alter a piece once it is in its hardened state. At some point in antiquity, it would appear that the vase had a somewhat different form to the one that has survived. The base must have extended downward, probably to a rounded point or knob, and the consensus is that this extension gave the vase an amphora-style shape, so that it would have required a support to stand upright. Below the existing base of the vase, another frieze may have run around the narrower lower section, and this has been lost. It is even possible that the alteration took place during the carving of the vase. Perhaps a crack appeared in the bottom of the vase during the process of carving, which threatened to

spread up the entire body, and drastic action was taken to prevent this, by removing the damaged section, and reshaping the vase. If this occurred when the carving was well forward, and perhaps years of work had already been invested in the piece, then desperate measures would certainly have been called for.

Here, then, is another mystery. The vase has not come down to us in its original shape. The grozing is undeniable proof of this, and we have no way of knowing for certain what that shape was. But once this idea is entertained—that what remains is a sort of cut-down version of an original—it is easy to imagine that there is something not quite right about the shape of the vase. Josiah Wedgwood had an opportunity to examine the vase only a few years after Tassie began to produce his copies. Although he could not see the grozing on the base of the vase (he would have had to remove the base disk to detect it), and didn't realize the vase had been cut down from its original shape, Wedgwood the potter had made the study and production of ancient and modern vases his life's work, and he felt instinctively that there was something wrong with it. Despite being drawn to the vase—to the point of obsession, as we will see—he admitted to himself that the shape of the vase "is not so elegant as it might be made if the artist had not been possessed of some very good reason for contenting himself with the present form." Wedgwood speculated as to the reasons for this shortcoming, and he found himself making rather lame excuses; perhaps the artist who produced the bas-reliefs had deliberately chosen a less impressive form so as not to distract from his own achievement.

It would seem, then, that misadventure has been part of the vase's fate from its very conception. We do not know what tears were shed over its original manufacture; or whether some hardworking craftsman's eye or fortune was ruined; or if his heart was broken by the fiendishly difficult process of producing the vase, with all its attendant risks. Tassie and Pichler seem to have survived the experience

unscathed, but heartbreak was certainly the lot of those who later attempted to copy the vase, including Josiah Wedgwood, as we will see.

It is not clear what Byers stood to gain from copying the vase. Perhaps there was some financial element to his arrangement with Tassie, whereby Tassie paid in order to have access to the mold made by Pichler, in the hope of recouping this expense with the sale of the resulting copies, but it cannot have been a particularly lucrative transaction for Tassie, considering that his nephew still had copies on his hands decades after his uncle's death, and Byres's stipulation that there should be no more than sixty copies would surely have limited his own profit. Perhaps Byers commissioned the mold so that he could retain a copy of the vase for his own enjoyment, because he certainly did not own the original for long. In a sense, he was never an owner of the vase—more a go-between—and he sold it not long after Pichler's mold was successfully produced. The buyer he found was not, as one might expect, a rich and powerful English aristocrat, but an antiquarian like himself, a man who would also, however regretfully, sell the vase. But—setting aside their mutual interest in the vase—it would be hard to find two characters more at odds than sour, displaced James Byres, and Sir William Hamilton, a man who made an art of living comfortably and who, as the most famous cuckold in history, became a byword for complaisance.

# SIR WILLIAM HAMILTON

WILLIAM HAMILTON WAS BORN to a Lady of the Bedchamber, an aristocratic courtier who was almost certainly mistress to Frederick, Prince of Wales. This meant that Hamilton was brought up at court, and was, if nothing more, at least a sort of foster brother to Frederick's son George, the future King George III. So Hamilton was well connected, but he was also a younger son with no fortune to his name, and he would have to make his own way in the world. Like many a younger son, he went into the army. He saw the end of the War of the Austrian Succession, and the beginning of the Seven Years War, but he played no great part in either; he later confessed to a friend that he suddenly realized that a soldier's life might not be for him when a bullet knocked off the tip of the short spear he carried as a sign of his officer rank. It is perhaps surprising that he stayed ten years with the colors, less so that in all this time he rose no higher than captain.

In 1758, in his late twenties, he left the army and sought another traditional recourse of younger sons: he married an heiress, Catherine Barlow, who possessed a small but comfortable fortune, including estates in Pembrokeshire. They settled near Piccadilly, into what appears to have become a genuinely loving relationship, despite the pecuniary motives that underlay it. Hamilton's old playmate was crowned king in 1760, and Hamilton was given a place at court. Hamilton began to collect pictures, but he spent more than he could afford and ended up selling two collections, one after another. Catherine suffered from "an asthma," and in the mini–Ice Age winter of 1762 her sufferings were severe. Hamilton feared that they would be forced to retire to Pembrokeshire, not a fate he contemplated with any enthusiasm; it was time to ask a favor of his royal patron. In 1763, the post of envoy to the Kingdom of the Two Sicilies (which at this time included much of southern Italy) became vacant; Hamilton applied for and was given the job. A year later, he and Catherine arrived in Naples. Horace Walpole, who now becomes something of a chorus to our story, warned the ambassador at Florence: "You have a new neighbour coming to you, Mr William Hamilton. . . . He is picture mad, and will ruin himself in virtu-land." By "virtu," he meant all the collectibles that Italy offered the connoisseur—pictures and antiquities—and his diagnosis of Hamilton's passion as a collector was barely exaggerated. That passion expressed itself almost immediately in vases.

Hamilton arrived at a time when the earth around Naples was giving up the most spectacular secrets. The two Roman towns of Pompeii and Herculaneum, buried and preserved by the catacylsmic eruption of Vesuvius in A.D. 79, were being excavated for the first time, constantly throwing up all sorts of marvels, from the uncannily well preserved belongings and bodies of the dead, to wall paintings and objects that would provide vital evidence for the dating of the vase. Hamilton observed the digging with great curiosity, and sometimes his reactions revealed a flicker of passions not merely antiquarian:

". . . at the last they have found a Theatre tho' I can not say it appears to me to be certainly so. In a room just by this building was found a Venus of marble coming out of a Bath & wringing out her wet hair what I thought most remarkable was that all her *tit bits* such as *bubbies mons veneris* &c are double gilt & the gold very well preserved . . ."

The area around Naples had been settled even before the Romans came, by ancient Greek colonists, and their tombs were now also being opened and ransacked. From these tombs came vases whose decoration preserved the artistry of the ancient Greeks, some of them made in Athens and Corinth in the fifth century B.C., during the heyday of those cities. Almost nowhere else had Greek painting been preserved; indeed, at this time hardly any of the highest Greek art had been discovered or recognized, and now these vases provided glorious examples of an ancient artistry that survived in no other form. Hamilton became obsessed by them. He bought from tomb robbers and dealers, and he also went in for a little treasure hunting and tomb opening himself. Before very long he had amassed a collection of several hundred ancient vases. He was quick to realize the importance of his collection, and he arranged to have it published. The first volume came out at the end of 1767: *Collection of Etruscan, Greek and Roman Antiquities from the Cabinet of the Honble. Wm. Hamilton His Britannick Majesty's Envoy Extraordinary at the Court of Naples.* Being himself only a gifted amateur, and conscious that his time in the army had denied him the chance to gain any real scholarly grounding, Hamilton approached Winckelmann to provide text to accompany the illustrations of his collection.

Hamilton had met Winckelmann in Rome, on a holiday from his duties in Naples. Though Hamilton had hired James Byres as a guide to the antiquities, he also called on the services of Winckelmann with whom, not surprisingly, he got on much better. They developed a

high degree of mutual respect—Hamilton for his guide's learning, Winckelmann for his pupil's taste.

Winckelmann understood the significance of Hamilton's collection, and he agreed to supply explanatory notes. He came to visit Hamilton in Naples, to view the vases. Unfortunately, not long after, Winckelmann was murdered by a piece of rough trade, as we might now say, whom he met on the waterfront in Trieste. He had been on the way to visit his homeland, but had lingered in Trieste, unable to tear himself away from the country he loved; and the delay proved fatal. Even without Winckelmann's contribution, Hamilton's book had an enormous impact. Josiah Wedgwood, in the process of opening his new factory in the English Midlands, began to produce copies of Hamilton's vases from the prints in the first volume. He described them as

> . . . truly Greek workmanship, and ornamented chiefly with Grecian subjects, drawn from the purest Fountain of the Arts; it is probable that many of the Figures and Groupes upon them, preserve to us Sketches or Copies of the most celebrated Greek paintings; so that few Monuments of Antiquity better deserve the Attention of the antiquary, of the Connoisseur, and the Artist . . .

This was the beginning of a relationship between Wedgwood and Hamilton that was to prove highly significant in the history of the vase.

In 1771, Hamilton and his wife, Catherine, returned to England on leave. Hamilton brought his vases with him. Horace Walpole viewed them and was suitably impressed. Hamilton needed to sell them in order to recoup the money he had spent on their acquisition and the elaborate publication. But Hamilton was not such a cold-blooded dealer as Byres; he wanted his vases to belong to the nation, and for

once the nation did the decent thing. The vases went to the British Museum, and Parliament voted more than eight thousand pounds in payment to Hamilton. After his return to Naples, one of Hamilton's friends, Dr. John Elliot, wrote to describe the impact of his collection. The whole country was now mad for vases:

> Your collection forms one of the greatest and most admired ornaments of the metropolis, even foreigners come to see it. I have with much satisfaction seen the advantageous manner, in which the inestimable remains of antiquity are arranged. I really think, that the national taste has received a rapid improvement from them; in place of the ponderous dull ornaments we formerly had, we have now the pleasure of seeing new embellishments daily rising up, where every thing is formed in the elegant manner of the Ancients. The Furniture of even the houses is already changed. These improvements are totally owing to that choice collection, which you have set before the publick. In the most ordinary houses . . . we see the chimney pieces and cabinets decorated with vases.

Hamilton and Catherine returned to Naples, and for another decade Hamilton pursued his interests there as before. Vesuvius was active at the time, and Hamilton, whose great virtue seems to have been an ability to take an eager interest in whatever was going on around him, became an expert vulcanologist, making dangerous forays to the lip of the crater, observing the phenomena of eruptions from a less-than-safe distance, and writing up his experiences for the Royal Society, who rewarded his efforts with a fellowship. His marriage seems to have continued to be a success. His wife certainly loved him; as her health failed in the spring of 1782, she wrote him touching letters:

I feel my weak, tottering frame sinking & my spirits fail me; my only regret in leaving this world is leaving you; was it not for that I should wish the struggle over. But my heart is so wrapp'd up in you that you are like the soul that animates my body. You never have known half the tender affection I have bourne you because it has never been in my power to prove it to you—forgive this effusion of my heart. I feel myself every day declining. . . .

Catherine's presentiment was entirely correct; she was dying. Did her husband return her love? When she wrote him this letter, he was in the process of buying a most expensive piece of "virtu"; it was not the only thing of beauty he would acquire over the coming months.

Hamilton visited Rome again in the summer of 1782. It is no surprise that he visited James Byres's showroom apartments; Hamilton was always on the lookout for something to buy, either for pleasure or profit, and here he found something that would satisfy both motives. He saw the vase, lately removed from the Palazzo Barberini, sitting among Byres's collection of busts and paintings, as one might say, in his shop window, and perhaps feeling that it had come down in the world a little. Hamilton described the moment in a letter that he subsequently wrote to Josiah Wedgwood:

> . . . the superior excellence of this exquisite masterpiece of ancient art struck me so much at first sight, that I eagerly asked, "Is it yours? Will you sell it?" He answered, "Yes; but never under £1000." "I will give you a thousand pounds"; and so I did, though God knows it was not very convenient for me at that moment, and the business was concluded in a moment.

Despite the fact that the "moment" is recollected in tranquillity, Hamilton's language conveys something of the excitement he seems to have felt when he encountered the vase for the first time. Byres,

who must have seen the vase-mad Hamilton as a hot prospect, leads him through the rich and tasteful displays, and casually arrives at the pièce de résistance; the mean-tempered, calculating dealer deftly hooks the enthusiastic dilettante, and Hamilton in gentlemanly fashion extravagantly refuses to haggle. But Hamilton was not a Croesus; his limited funds made him an unusual mixture of connoisseur and businessman. To say that "it was not very convenient for me at that moment" might suggest that like some modern tourist he had merely left his credit card in his hotel room; but it is in fact a wild understatement. The truth is he simply could not afford to pay a thousand pounds; he did not have such a sum of money in any form. Why, then, did he take the plunge? We know that Hamilton was capable of living beyond his means, but this was a serious act of financial recklessness. Did he just *have* to have it? Or was his overmastering excitement generated by the scent of a fat profit? Events at least bear out the latter theory: before long, Hamilton had sold the vase for nearly double what he paid for it. In order to carry out the transaction with Byres, Hamilton gave him a "bond," at 5 percent. Technically, Hamilton was not buying the vase at all, merely borrowing it; if he could not redeem the bond, then eventually it would return to its original owner, with interest.

In his letter to Wedgwood, while extolling the virtues of the vase, Hamilton made some extravagant claims for its provenance:

Except the Apollo Belvedere, the Niobes, and two or three others of the first-class marbles, I do not believe that there are any monuments of antiquity existing that were executed by so great an artist; and I have no doubt of this being the work of the time of Alexander the Great, and was probably brought out of Asia by Alexander, whose ashes were deposited therein after his death.

Hamilton may have been floating this exotic theory simply in order to raise the status of the vase, just as Pietro Santi Bartoli had been keen to associate it with the Emperor Alexander Severus. Despite the fact that there had already been some attempt to identify the figures as pertaining to the myth of Alexander's conception (by Zeus in the form of a snake with Olympias), to imagine that the vase was made in Asia at the time of Alexander was very wide of the mark, and it betrays Hamilton as a very poor scholar. Certainly his publisher, Pierre d'Hancarville, was deeply contemptuous of the existing attempts to identify the figures. Before we embark on the next interpretation of the figures on the vase, as supplied by d'Hancarville, it is worth reviewing the career of certainly the most bizarre and unconventional antiquarian ever to study and expound on it.

★ ★ ★

BARON PIERRE D'HANCARVILLE was a liar, adventurer, pornographer, and general all-round scoundrel. His title was almost certainly self-awarded (he was the son of a bankrupt French merchant). Like an antiquarian Barry Lyndon, he racketed through the courts of Europe, dazzling his interlocutors with his brilliance and learning. According to the Countess Albrizzi:

> His penetrating, voracious eyes, his flaring nostrils, his lips which barely touch each other are the outward signs of his longing to see everything; and then, having seen everything, having known everything, he wins you over with his learning and his prolific and imaginitive way of speaking.

His relationship with Hamilton is evidence of how tolerant and broad-minded (or how trusting and gullible) the envoy was. But both men—one by the standards of the age a decent and relatively respectable member of the establishment, the other an out-and-out

rogue—were brought together by their attraction to and sympathy for the past.

D'Hancarville started his career as a captain in the army of a German princeling. He was imprisoned for debt, but rescued by the Duke of Wurttemberg, who became mixed up with him in a major swindle involving the "sale" of the island of Corsica. He was arrested for the criminal business deal, but escaped again, this time apparently taking some of the duke's silver with him. Europe was, and doubtless still is, full of con men and tricksters of a like description. But d'Hancarville also found the time to publish a philosophical pamphlet that attracted the attention and praise of Voltaire, and, when his wanderings brought him to Italy, it was with a reputation for the brilliance of his learning as well as the elasticity of his morals. Winkelmann warned a fellow antiquarian: "When you show him your gems, keep a very close lookout to see what he is doing with his hands."

D'Hancarville lived on credit, and on the run, and surely some rumor of his reputation must have come to Hamilton's attention. But either d'Hancarville's silver tongue persuaded him, or he decided consciously to set aside the bad and see only what suited him—a world-class antiquarian. Because when Winckelmann was murdered, it was to d'Hancarville that Hamilton turned, to help him with his great endeavor—the publication of his collection of vases. In a way his trust was well placed. D'Hancarville was not only a brilliant scholar, he was also a book designer of genius, and under Hamilton's patronage he produced what has been described as one of the most beautiful volumes of all time. When, halfway through the publication of the four volumes, d'Hancarville was forced to flee Naples, Hamilton was ready to take his side:

> He has been sent out of Naples in a very rough manner indeed,
> so much so that I thought he must have been guilty of some state

crime—but his papers are untouched & no reason given for this violence but that it is the will of His Sicilian Majesty . . .

In fact, in order to supplement his income, d'Hancarville had decided to do a little publishing on his own account. He had already inserted some rather racy illustrations into Hamilton's volumes. Now he launched a couple of his own, purely pornographic works, purporting to illustrate the "private lives of the Caesars," and the "secret Cult of Roman women." This venture (which would, under other circumstances, have drawn no more than an amused smile from the worldly Hamilton) exemplifies d'Hancarville's dual nature. On the one hand, it was a bare-faced attempt to make a bit of money; on the other hand, it was evidence of d'Hancarville's radical and genuinely held beliefs about ancient art. He developed a theory that all ancient art originated in sexuality. That Hamilton knew and was influenced by this theory soon became apparent. But meanwhile, his faith in his collaborator was severely tried. D'Hancarville had taken refuge in Florence, and the plates for Hamilton's volumes had gone with him; indeed, d'Hancarville had pawned them, to satisfy his creditors, and he himself had gone into hiding in a convent. Hamilton had to set off in pursuit, and when he arrived in Florence, he found that d'Hancarville was in prison again. Not surprisingly, it took several years for the last two volumes to be completed, as d'Hancarville's creditors allowed him to consult the pawned plates only one by one, while he wrote a vast and rambling essay to accompany the illustrations.

At the end of the 1770s, d'Hancarville arrived in London. Here he managed to captivate another English dilettante—Charles Townley. Townley's patronage allowed him to complete the work in which he laid out his theories on ancient artists, and how they drew their inspiration from the initiation rites of the secret religions of the ancients, and from sexuality. This work—*Recherches sur l'origine,*

*l'esprit et les progrès des arts de la Grèce*—naturally confirmed his notoriety, but it also provided him with an opportunity to air his own views about the vase, and the meaning of its figures.

First, with a typically arrogant gesture, he took a sarcastic swipe at all previous theories. Using a simile designed to show off his own classical learning, he compared those who believed any existing explanation to the god Saturn. According to the myth, Saturn habitually ate his children to prevent any of them from supplanting him. When Jupiter was born, his mother gave a wrapped bundle to Saturn, who gobbled it down; the bundle contained a stone—and not the baby—but Saturn failed to notice; so to d'Hancarville, previous scholars were like Saturn because they would swallow anything. He went on to concoct a deliberate parody of an interpretation, by pretending that the vase was a piece of Christian symbolism. Figure C, the kneeling woman with the serpent, must be Eve; figure A, the young man to whom she holds out her hand, is therefore Adam. Figure D, chin on hand, is the Almighty, in the process of judging and punishing their behavior. The trees that frame the action are those of the Garden of Eden, and bear fig leaves that will become useful in a moment; the pillars, being Doric in style, the most ancient of orders, must surely be the gates to the earthly paradise. On the other side of the vase, the female figure with the extinguished torch is the Angel who guards those gates and carries a torch instead of the flaming sword described by Milton in *Paradise Lost*. Therefore, d'Hancarville concluded facetiously, the vase was made either at the time of Adam or Oliver Cromwell.

This would be more a more effective piece of satire if d'Hancarville's own interpretation were more strongly reasoned. Unfortunately, his irony rebounds on him, and only reinforces and continues the distinguished record of scholarly obtuseness. D'Hancarville declares that the vase shows the myth of Orpheus and Eurydice. Orpheus was the musician of supernatural power who fell

in love with the nymph Eurydice. They were married, but at the ceremony, the torch of the marriage god Hymen smoked instead of burning with a clear flame, and, soon after this unlucky omen, Eurydice was bitten by a poisonous snake and died. Orpheus, however, followed her down to Hades, soothing Cerberus, the monstrous guard dog of the underworld, with his music. Pluto agreed to restore Eurydice to life, and she was allowed to follow Orpheus back to the world above, on condition that Orpheus not turn to look at her; but he could not resist the temptation, and he lost his wife a second time. D'Hancarville declares that figure C, the woman with the serpent, is Eurydice, "who is constrained to turn her back, but holds out one arm to him, and he endeavours in vain to retain her; the aquatic serpent, from whom she received her mortal wound, is at her side." So figure A is Orpheus, while D is Pluto, looking on. Nothing violently unreasonable so far, although some sign of a musical instrument would have helped; it is the other side of the vase, however, that defeats d'Hancarville. Here he decides to bring in the Heavenly Twins, Castor and Pollux. Why he does this defies explanation; only a moment's inspection would be enough to ascertain that there are no male twins on the vase. But d'Hancarville gets round this with a suggestion as crazy as anything yet proposed: while figure E is Pollux, Castor, though not visible in human form, *is represented by the pillar* that stands beside the figure. Once again the scholar, sensing that his theory does not fit the evidence, adjusts the evidence accordingly.

★ ★ ★

LITTLE MORE THAN A MONTH after Hamilton acquired the vase he, like Orpheus, lost his wife. Catherine died in August 1782, and Hamilton, who rather prided himself on his stoicism, was surprised at the strength of his grief. After her death, despite all the beauties and distractions of Naples and of his collection, he was lonely, and the vase provided no consolation. But for him there could be no trip

down to the underworld; instead, he went home on leave, taking the vase with him and firmly intending to sell it.

Hamilton traveled home overland, staying in Rome and Florence, then heading for Innsbruck, Dresden, and so on, to London, but the vase was sent by ship. Hamilton had enough experience of transporting vases, but he must have organized this one with particular care, watching anxiously as the vase was packed up in straw, sealed into its case, and struck down into the hold. So the vase left Italian shores and took to sea, almost certainly for the first time in its life, and it was carried through the Mediterranean, the Straits of Gibraltar, the Bay of Biscay, and the English Channel. Saved from the terrible jolting of a journey across Europe, it risked instead a watery tomb.

The ocean voyage was no small danger. Indeed, Hamilton's next attempt to transport vases by sea was to end in disaster. In 1799, seventeen years after the vase's safe passage, he sent his last collection of vases home to England in order to save it from the inexorable advance of Napoleon's invading army; eight cases of vases, which he described as the cream of his collection, were stowed in the hold of HMS *Colossus*. In a gale off the Isles of Scilly, the *Colossus* dragged her anchor and ran onto a reef. The crew reached the shore safely, but the ship broke up, pounded to pieces by the terrible surf. There were reports that some of the cases escaped the destruction and were thrown up on the beach, but only one or two of the vases inside had survived their ordeal unbroken.

The commander of a nearby fort, a Major Bowen, sent a very strange account of attempts made to salvage the cases, describing how local fishermen took to their boats and found several of the cases marked with Hamilton's name drifting in the waves. With the gale still blowing and seas still high, the cases were too large and unwieldy to be hauled into the boats, and the fishermen tried to open them as they floated in the water, so that they might retrieve the contents.

The fishermen managed to get the cases opened, and saw inside them several large pieces, beautifully painted. However, when they tried to lift the vases out of the water and into their boats, the fishermen found that the vases had somehow softened in the sea, and fell apart in their hands, like dough. But ceramics do not soften in seawater, and this must be a fisherman's tale, perhaps told to account for the failure to recover the cases.

Whatever the truth of the matter, only a handful of vases reached Hamilton, who grieved bitterly for his treasures: "Never in this world will such a collection be made again. . . . The like were never seen, or ever will be." The disaster was also a serious blow to his finances, but he accepted it as best he could, and his stoicism was rewarded by the discovery, two years later, that cases sent in another ship contained, not as Hamilton supposed, the dregs of his collection, but nearly all of his finest vases, left on the quayside in Naples by mistake, then loaded into this second vessel.

Happily the vase escaped any such apocryphal melting, or the real threat of a watery grave, and docked safely in the filthy, crowded port of London in the summer of 1783. It had exchanged the blue Italian skies for a northern climate; from now on it would have to endure the damp English air, and its journey could be seen as a symbol of the millennia-long seesaw of power between the Roman and British Empires. Once reunited with his prize possession, Hamilton proudly presented the vase to the Society of Antiquaries, as one of its members recorded:

Sir Wm. Hamilton was pleased to produce, for the Inspection of the Society, a Vase singularly curious brought by him from Italy, & purchased there at great Expence. It is called, by way of Excellence and Distinction, the *Barberini Vase*, having been many years in possession of that Noble Family, & considered by them, & all Travellers of Taste and Judgement, as a Cimelium

of extraordinary Curiosity and Value. [A "Cimelium" according to the *Oxford English Dictionary*, is a treasure or thing "laid up in store as valuable."]

Hamilton also made a presentation to another group: the Society of Dilettanti. This was an altogether less formal body, a dining society founded as a convivial club for gentlemen who had traveled to Italy and had cultivated their taste accordingly. A dilettante being one who cultivates the arts for love rather than for any professional considerations, the minutes of the society declared: "Whoever shall descend to be serious in earnest thereby deviating from the Originall constitutional sense and spirit of the Society, shall be severely reprimanded." The vase, it appeared, was not the only curiosity in Hamilton's cargo. He had something else to show the Society of Dilettanti; a collection of "votive offerings."

Shortly before he acquired the vase, Hamilton had learned of another, rather more bizarre connection with the ancient world, in the remote town of Isernia. There, a church festival was dedicated ostensibly to Saint Cosimo. However, just as Hamilton became interested in attending the festival, it was suppressed by the bishop, and he had to construct an account for the society from secondhand sources. But he duly presented it to the society, and another member wrote up the findings and published them, together with plates of illustrations of the offerings themselves that he had acquired.

According to Hamilton's account, every year on the saint's day (September 27) local women would come into town and purchase votive offerings: "In the city, and at the fair, ex-voti of wax, representing the male parts of generation, of various dimensions, are publickly offered to sale." These offerings, referred to euphemistically as the saint's "Great toe," were then taken by the women to the church. "In the vestibule are two tables, at each of which one of the canons of

the church presides." A large basin for the reception of different offerings is set up here. "The vows are chiefly presented by the female sex." Hamilton's text describes how his source "told me also, that he heard a woman say, at the time she presented a vow (like that which is represented in Plate 1, fig 1), 'Cosimo, let it be like this' . . . The vow is never presented without being accompanied by a piece of money, and is always kissed by the devotee at the moment of presentation."

"Plate 1" is a drawing of four of the offerings heaped up together. "Fig 1" carefully labels by far the largest of these, and the only one in a state of tumescence. At the altar, the "oil of Saint Cosimo" was offered to the male congregation: "Those who have an infirmity in any of their members, present themselves at the great altar, and uncover the member affected; and the reverend canon anoints it."

This was all very interesting, and no doubt tickled the dilettanti, one of whom wrote to Hamilton: "I shall like to see our matrons handling the great toe of Saint Cosimo in the British Museum. I wish you would send me one for mine." But there was a serious point to the research; Hamilton believed that he had detected the survival of a pagan rite, seemingly derived from the worship of the phallic god Priapus. He had discovered a connection to the ancient Roman world, something still living, every bit as informative as a silent, inanimate vase. Hamilton's collaborator, who published the *Remains of Priapus*, certainly thought it worthy of serious study, and added a long essay on the worship of Priapus to Hamilton's account and the drawings of the offerings. But once the book was in print, he and the rest of the society experienced an attack of nerves; they grew apprehensive of the offense the images might cause and tried to restrict the circulation of the copies.

Hamilton may also have shown the society his vase in order to attract likely customers. He desperately needed to sell it—not only in order to pay off the bond he had given to James Byres, but also to

make a profit on the transaction, with which he could then pay off some of his many other debts. Fortunately, the right customer dropped into his lap. In London, now a lonely widower, he spent time with his young niece, Mary Hamilton. Hamilton's brother Charles was dead; Mary, Charles's daughter, was in her twenties, attractive and vivacious, and he enjoyed going about with her, in an avuncular fashion. By the happiest of accidents, Mary had developed friendly ties with the Duchess of Portland, who was as likely a potential customer for the vase as Hamilton could hope to find. She was richly endowed with great wealth and the still considerable power that the highest rank of the aristocracy possessed at this time, and she spent a sizable portion of her vast fortune on collecting curiosities. Horace Walpole characterized her as "a simple woman, but perfectly sober, and only interested in *empty* vases." Mary engineered an invitation to the duchess's country seat at Bulstrode Park, and so began a comedy of intrigue and maneuvering.

★ ★ ★

SCENE ONE: This comedy opens at Bulstrode Park. On a brief visit, accompanied by his niece, Hamilton figures as an exotic guest, deeply tanned from his sojourn under a foreign sun, perhaps even singed by his daring encounters with Vesuvius. He merely mentions the vase, one item in a stream of fascinating details and anecdotes, and it's just enough to pique the duchess's interest.

SCENE TWO: Whitehall, London. Hamilton and Mary visit the duchess again, this time at her residence in Whitehall. They are shown her private museum of natural and artificial curiosities. No explicit mention is made of how well the vase would sit as the centerpiece or crowning glory of this collection, but doubtless the implication hangs heavy in the air. The duchess says that she would *quite like* to see the vase.

SCENE THREE: Hamilton's lodgings. It's now the depths of winter,

and the cold weather has inflamed poor Mary's neuralgia. She records the action of this scene in her diary, beginning with the entrance of the duchess's old friend and confidante, Mrs Delaney: "Mrs. Delaney and the Duchess came to me, and we went to my uncle, Sir William, at his hotel in King Street. The Duchess saw the fine vase, etc, etc, stayed till half past three o'clock. The pain in my face continued very bad." The duchess herself was a martyr to neuralgia, and sometimes swaddled herself in six or seven cloaks and coats, and for Mrs. Delaney, it would seem Mary's distressing condition took precedence during the visit. In a thank-you note sent on New Year's Day, Mrs. Delaney mentions the vase only in passing. "Tell me how you do today my dear Miss Hamilton. I hope your goodness to me yesterday did not add to your teazing complaint. The calm, delightful society of yesterday, not forgetting the *vase*, did me more good than freezing fingers can express. I am impatient for Saturday. Ever yours, M.D."

SCENE FOUR: St James's Place, Saturday. The action reaches its crisis. Mary's diary again:

Went to Mrs Delaney's home in Saint James's Place. She took me aside to say she had a *secret message* for me from the Duchess. Then, under the cover of getting me to look for a book she took me to her bedroom and told me what the Duchess wanted me to do, viz—to purchase the vase of my uncle. Immediately sent a note to him, but learnt that he was not at home, because, quite by chance he had decided to call on Mrs Delaney and was *at that moment* announced! I took him down to the parlour under pretence of showing him the pictures, and then told him what the Duchess wished about the vase. When we came upstairs again they talked upon the subject. My uncle brought me home at ten o'clock. He told me he would think upon what the Duchess had said.

Scene Five: Hamilton's hotel. Hamilton analyzes in soliloquy the events of the night before, wrestles with the problem of how best to clinch the deal and what sum to name. In a letter he presents his tactics to his niece and go-between:

> My Dear Niece. I have been thinking much upon what passed last night and now I will open my mind freely to you on the subject, and you may make use of what I write as far as you think proper, and with your usual prudence. In first place, there is something in the act of selling that gives a disagreeable sensation, particularly when the value of the objects for sale can only be ascertained by what the French call *prix d'affection*. However, as the first proposal did not come from me, but from the Duchess, I shall at once make what I think a reasonable offer to her Grace. I am very sure I could directly get two thousand pounds from the Empress of Russia, but I cannot bear the thought of its going out of England now it is once safe here, for there is not such a monument to antiquity in the world. . . .

Scene Six: Whitehall. Mary goes to see the duchess. "To Mrs Delaney's again, to meet the Duchess. She and I went into Mrs Delaney's bedroom and I told her what Sir William had said about the *Vase*." She dutifully and tactfully passes on her uncle's position, his courteous willingness to sell, his ruthless play for a colossal price. Hamilton's threat to take the vase to Catherine the Great is a real one; the empress is herself a voracious collector with resources far beyond even the duchess's, and he will later attempt to sell her his Correggio. Hamilton has judged his victim well. The duchess *is* as rich as Croesus; and she is besotted with the vase and does not balk at the amount.

Scene Seven: Mary's diary: "Went to the Duchess of Portland's. My uncle came at the same time, and she shewed him many of her fine

things. He stayed till half past three; they talked over and settled the affair of the vase." In other words, they haggled. But not much; Hamilton accepted eighteen hundred pounds, and thus made himself eight hundred pounds clear profit, less whatever interest was owing on the bond he had given James Byres. The vase was the Barberini Vase no longer. From this time on, it would be the Portland Vase.

★ ★ ★

WHILE HAMILTON WAS PLAYING out this comedy with his niece and the duchess, he was also spending some time with his nephew, Charles Greville. Childless, Hamilton was happy to make time for both niece and nephew; he had a good relationship with Greville, who, like himself, was a younger son required to make his own way. He met Greville's teenage mistress, Emily Hart, and was smitten by her great beauty and charm. Hamilton arranged for Romney to paint her portrait, and then decided that this was not enough; she must sit for Sir Joshua Reynolds, too. His attentions were so marked that Mary began to gossip, particularly with Reynolds's niece, who, as she confided to her diary: "told me that my uncle William had been often at Sir J Reynolds lately; that he escorted my Cousin Chs Greville's Mistress, in a *Hackney Coach*, & that her Uncle was painting this Woman's picture for him to take to Naples. I shall make use of this intelligence to have some entertaiment in *plaguing Sir William.*"

When Hamilton's leave ended and he returned to Naples, he found, naturally enough, that he was lonely. Greville, who had per-haps already broached the subject before his uncle left, wrote to suggest a deal every bit as delicate as the sale of the vase. Just like Hamilton before him, Greville needed to marry well in order to secure a living. Two things stood in the way of this: Firstly, his young and beautiful mistress would hinder his search for a wealthy and respectable bride and must be disposed of; secondly, he must acquire some financial standing that would render him acceptable to eligible

young ladies in the marriage market. He proposed to kill two birds with one stone; Hamilton could have the lovely Emma and, by way of gratitude, could write a letter to Greville, officially making Greville his heir. This proposal was put forth with remarkable candor; Greville went so far as to describe Emma as a "modern piece of Virtu"—as it were, the living counterpart of the vase, and a fitting replacement as the finest object in his collection. In a way, his description would prove more accurate than he could have guessed, and, by degrees, Hamilton acceded to his request. He had doubts— the girl was almost young enough to be his granddaughter—and he took into account a fact that his nephew seemed able to ignore. Emma was very fond of Greville; in fact, she loved him. But in the spring of 1786, Emma was packed off to Naples, ostensibly for a holiday. Hamilton made no secret of his admiration for her, as she tells Greville in the first letter she sends home: "He . . . is constantly by me, looking in my face. He does nothing all day but look at me and sigh. I can't stir a hand, leg or foot; but he is marking as graceful and fine." From the first, however far it went subsequently, Hamilton's relationship to his young visitor was based on the simple pleasure of looking at her.

Friends and acquaintances jumped to amused conclusions, and in his letters James Byres made the same vase analogy as Greville: "Our friend Sir William is well. He has lately got a piece of modernity from England, which I am afraid will fatigue and exhaust him more than all the volcanoes and antiquities in the Kingdom of Naples." But things were not quite so straightforward. When it became clear to Emma that Greville had abandoned her, and that she was to stay with the uncle, at first she was heartbroken, and scribbled piteous notes to her betrayer: ". . . I do try to make myself as agreeable as I can to him. But I belong to you, Greville, and to you only will I belong, and nobody shall be your heir apparent."

Hamilton was wise enough not to press her. Over several months

he showed her off to the admiring Neapolitans, made sure she enjoyed herself, and continually commissioned artists to capture her beauty in paintings, statues, carved gems, and snuff boxes. However far she had come, Emma had certainly begun in life as a common prostitute, and she surely knew which way the cold winds of the world blew. Besides, Hamilton was a decent man, kind and loving, certainly more so than his selfish, calculating nephew. By Christmas she had capitulated, and she lay back to enjoy Hamilton's adoration, which still more than anything else seemed to involve making copies of his beautiful piece of "virtu." His unblushing celebration of her charms made even Emma coy: ". . . those beautys that only you can see shall not be exposed to the common eyes of all, and wile you can even more see the originals, others may gess at them, for they are sacred to all but you, and I wish the wos better for your sake."

She became a permanent fixture in Hamilton's exquisite Neapolitan lodgings, and she made him a happy man. He began to collect vases again, and a painter friend saw him one day, coming away from court in his full regalia, lugging along a basketful, having commandeered a street urchin to assist with the other handle. Artists were still queuing to immortalize Emma, but Hamilton hit on an even better way to display her "beautys." He discovered in her a talent for acting, specifically the ability to strike attitudes. She could hold a pose, be "in character." Perhaps it began as a bedroom game, or when she sat for Romney and Reynolds as "a Bacchante," or "Circe," but it quickly grew into something more theatrical. Hamilton taught or encouraged her to present in her poses characters from ancient mythology, to bring to life the figures on his vases. He had a black box constructed, which was to be the frame in which she stood; had dresses made for her that imitated the robes of the ancients; and experimented with lighting effects. As Emma's skills became more apparent, the act changed, becoming more fluid. Like an impressionist or a mime, Emma began to build up a repertoire of different character

poses, which she could run through one after another. By chance, one of the great literary figures of the age—Goethe—visited Naples at this time, saw her private performance, and jotted down a description of it.

She is very beautiful, her figure fine and pleasing. He has had a Greek dress made for her, which suits her wonderfully well. She undoes her hair, takes a couple of shawls and goes through such a changing succession of poses, gestures, looks etc, that really in the end you think you are dreaming. You see what so many artists would be glad to achieve, here perfectly finished in movement and change. Standing, kneeling, sitting, lying, serious, sad, teasing, extravagant, penitent, seductive, threatening, fearful, etc, one flows into and out of the next. She suits the folds of her shawl to every expression and with the same two or three of them can invent a hundred different dressings for her hair. The old lord holds the lights for it and has given himself wholeheartedly to his subject. He finds in her all the statues of antiquity, all the lovely profiles on the coins of Sicily.

Hamilton had the best of both worlds; conceiving a passion for the beautiful classical forms that decorated his vases, like Pygmalion, he contrived to animate these frozen figures, to metamorphose them into warm and yielding flesh and satisfy his passions both aesthetic and sexual in the worship of his lovely young muse. He had brought the vase to life.

Despite the vast differences in age and social status, he married Emma in 1791, but his idyll, of course, did not last. By the end of the decade he had been forced out of Naples by the advancing armies of the French Revolution; his health was failing, his debts were mounting, his second collection of vases lost in the shipwreck, and his wife was conducting a very public affair with the greatest British celebrity

of the time—Nelson, the hero of the Nile. Emma's infatuation with Nelson was notorious, she herself began to succumb to obesity, and all three were, in the eyes of the world, figures of fun—Nelson's victories notwithstanding. Stoical to the last, Hamilton gracefully accepted his wife's infatuation and lived with little or no complaint, often in the company of his wife and her lover, for whom he expressed a warm regard, dying two years before Nelson was killed in the moment of victory at Trafalgar.

Hamilton had always drawn inspiration from his study of the classical world, from his vases, and even from the Portland Vase itself. Toward the end of his life, it seems his studies gave him particular comfort.

My study of antiquities, has kept me in common thought of the perpetual fluctuation of every thing. The whole art is, really, to live all the *days* of our life; and not, with anxious care, disturb the sweetest hour that life affords—which is, the present! Admire the Creator, all his works, to us incomprehensible; and do all the good you can upon this earth; and take the chance of eternity, without dismay.

Meanwhile the vase, seemingly immune to the "perpetual fluctuation" of every other thing in the universe, had disappeared into the collection of the Duchess of Portland.

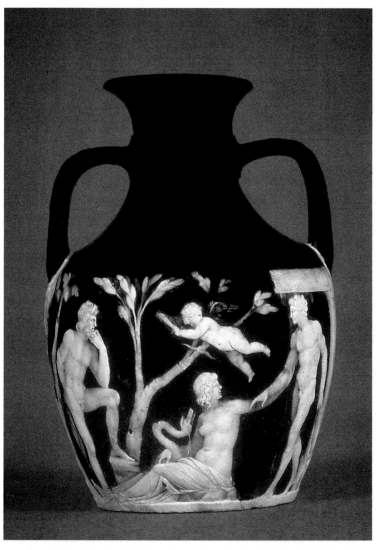

*Here and overleaf:* Three views of the Portland Vase: side I.

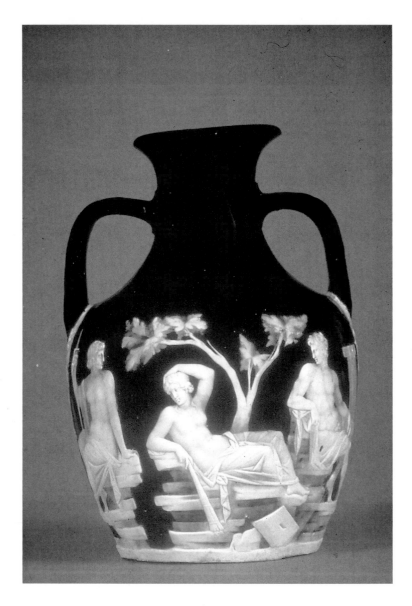

Side II.

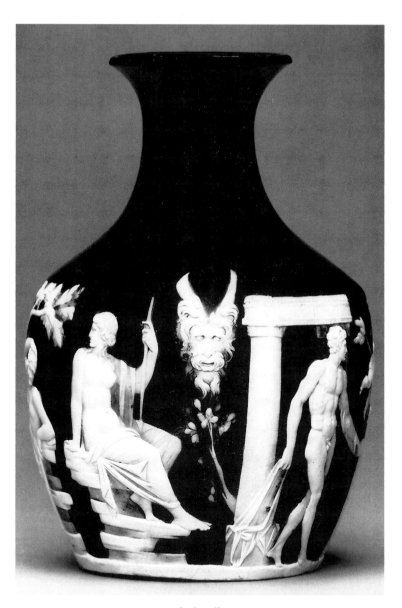

The handle.

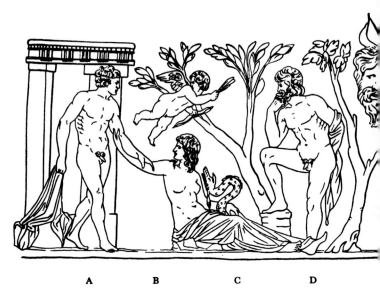

A        B        C        D

Line drawing of figures on the vase.

During modern restorations of the vase, the removal
of the base disk (shown here) has revealed that the
body of the vase was altered in order to
fit the disk. Under close examination, the rim of
the base is jagged, indicating that it has been
"grozed"—a process whereby glass is taken away in
tiny bites, using a small metal tool, to alter a piece
once it is in its hardened state. The consensus is that
at some point in antiquity, before the vase was
grozed and the disk added, the vase likely extended
downward, in an amphora-style shape.

E                 F                 G

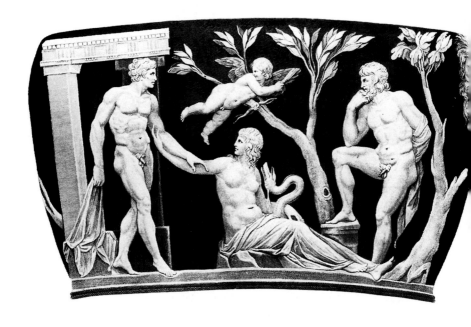

When ceramics genius Josiah Wedgwood produced his first satisfactory copy of the vase, his close friend and sometime poet Dr. Erasmus Darwin celebrated Wedgwood's achievement in verse. To accompany his poem Darwin wanted pictures of the vase, and his publisher suggested that a freelance engraver be commissioned for the task. So, by mere coincidence, in autumn 1791 the vase had an unexpected and remarkable encounter with one of the great visionary artists of any age—William Blake. (*Engraving of the vase: side I, by William Blake, 1791.*)

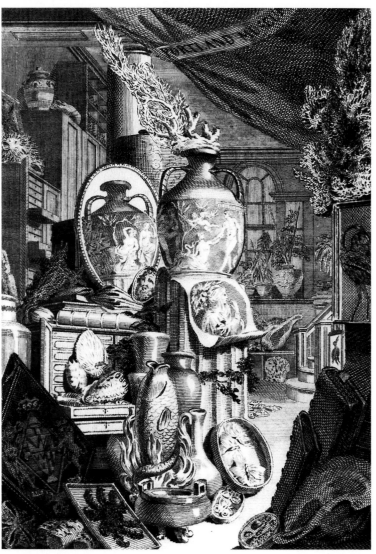

A year after the Duchess of Portland died, her treasures were put up for sale at auction—chief among them the vase. The frontispiece engraved for the catalog was meant to evoke a glimpse of the duchess's museum, and it has been suggested that the objects were portrayed in the engraving not according to their actual size but rather to the prices that they might realize. (*Engraving by Charles Grignon, 1786.*)

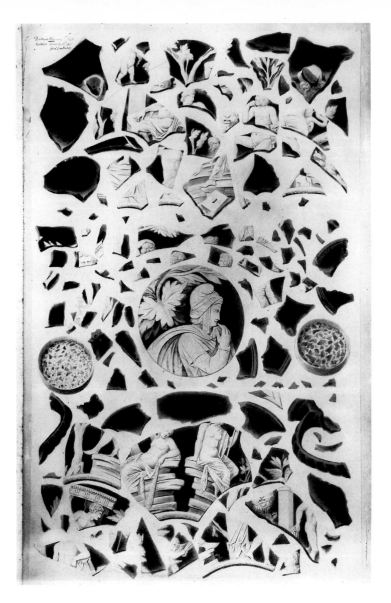

In February 1845, thanks to the violent act of one William Mulcahy, the vase lay in fragments. The painstaking task of putting the two-hundred-odd pieces back together was entrusted to John Doubleday. His first act was to commission a watercolor of the fragments, to stand as a record of the enormousness of his task. Doubleday's would be the first of three restorations that the vase has since undergone. (*Watercolor by T. Hosmer Shepherd.*)

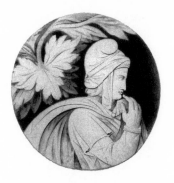

# THE DUCHESS
# AND MRS. DELANEY

HORACE WALPOLE could stand as the patron saint of this book;
he was a strong advocate of tracing and recording the history of
objects, and in his letters he provides us with an invaluable commentary on the career of the vase during the second half of the eighteenth century. Horace was quite literally a man of letters; he
decided when he was still a precocious teenager that he would make
his bid for literary fame through his correspondence. He was the son
of Sir Robert Walpole, one of the most successful politicians in
English history, who virtually invented the office of prime minister,
and used it to dominate the English political scene during the reign
of George II, and also to markedly increase his personal wealth. So
Horace had money and connections, but he was still an outsider, perhaps by temperament and certainly because of his homosexuality.
With his resources and a good degree of detachment, Horace became

a waspish, brilliant observer and recorder of his contemporaries' foibles. Moreover, he cultivated a taste for antiquities and curiosities of all sorts, with which he stocked his greatest curiosity of all, his Gothic villa at Strawberry Hill. It has been said that Horace revolutionized the taste of the entire nation with this folly: a fantasy concoction of monastic vaults and stained glass, but all on a cozy, domestic scale. He invented a literary genre to complement his architectural trendsetting; in the summer of 1767, he wrote *The Castle of Otranto*, the first Gothic novel, an absurd but strangely compelling mix of the sensational and the supernatural, involving secret passageways, mad monks, abducted heroines, and a generally preposterous plot. It spoke to the suppressed urges of the civilized mind, spawned a whole industry of imitators, and has never been out of print since.

Horace made the Grand Tour when he was in his early twenties. His was the dog eaten during the crossing of the Alps—much to his distress—but by the time he arrived in Rome he had recovered from the shock of his pet's demise and was too busy chasing the other object of his affections, the ninth Earl of Lincoln, to pay much attention to the antiquities there. However, he did acquire a bust of Vespasian, for which he paid twenty-two pounds at Cardinal Ottoboni's sale, and a medal of Alexander Severus. His tastes were, to say the least, eclectic. Over the years he filled Strawberry Hill with a grotesque mélange of objects: curios and valuable paintings, keepsakes and souvenirs, knickknacks and gewgaws. Visitors were led round four at a time (tickets were free but had to be prebooked), and they tiptoed about, so as not to disturb the author at his desk, while they admired his possessions in their unique setting—a lock of hair belonging to Edward IV, a pair of ancient Roman earrings, a phallic object or two, a silver teakettle, contemporary works by the lesbian sculptress Ann Damer, and works by the notorious divorcée Lady Diana Beauclerc, from whom Horace had commissioned a series

of her "soot paintings" (watercolor and charcoal) to illustrate his erotic drama *The Mysterious Mother*. These paintings and the manuscript of the play (which dealt with the theme of incest) were hidden together in a tower, screened by a curtain, and revealed to only a few special guests.

Horace made a catalogue of his collection. Fearing that some might regard the cataloguing of one's own works as rather self-regarding behavior, he felt the need to defend his actions; those who came after him, he argued, and wished to buy or sell these objects, would greatly benefit from a knowledge of their history and provenance. Each individual history operated like a family tree or a bloodline: "Such well-attested descent is the genealogy of the objects of virtu—not so noble as those of the peerage, but on a par with those of racehorses. In all three, especially the pedigrees of peers and rarities, the line is often continued by many insignificant names."

Horace plays the role of observer and recorder in the story of the vase; he knew Sir William Hamilton, and he was friend and adviser to the Duchess of Portland. When he wrote that the peerage contained "insignificant names," he was not thinking of his friend Margaret, Duchess of Portland. After all, the new owner of the vase would, in the course of time, by association pass her name on to the vase. Horace himself generously assisted at the enlargement of her collection, of which the Portland Vase was to become the centerpiece. He wrote to a friend in the 1750s: "My evening yesterday was employed—how wisely do you think? In what grave occupation! In bawding for the Duchess of Portland, to procure her a scarlet spider from Admiral Boscawen."

Margaret Cavendish Holles-Harley had been born not with a silver, as much as a platinum, spoon in her mouth. She was the daughter of the Earl of Oxford, and on the death of her parents she inherited the family fortune, which included Welbeck Abbey and an income of twelve thousand pounds a year. She was already an heiress when she

married the rich and handsome second Duke of Portland in July 1734, and the union of their fortunes made them colossally wealthy.

The duke himself was kindly, but retiring. He was a fellow of the Royal Society and a Knight of the Garter, but he took no part in politics, or in much else except family life. He was a loving husband who sired six children and was beside himself with grief and worry when four of them came down with smallpox (all survived). After her marriage Margaret referred to him as her "Sweet William," and confided to a friend, "I wish you knew more of the flower; for I am sure you would be delighted by it." The flower reference is highly indicative of the duchess's interests. Indeed, flowers seem to have played a more important part in her life than the duke himself.

Like her husband, Margaret enjoyed the life of gilded privilege and pleasure, but within the confines of her palatial houses she seems to have been altogether more active. As an anxious mother who had to see her children through all their illnesses, she became something of an amateur physician, and she developed a cure for whooping cough that involved rubbing the spine with rum. She was susceptible to the cold and habitually dined in a cloak and hood; sometimes she would wear as many as five layers of coats and cloaks. She was vivacious and witty; indeed, her friend Mrs Delaney sometimes described her as "provokingly so." All her friends and acquaintances were given nicknames: "Pipkin," "Mrs Sullen," "Long Nose," "Wild Beast," and "the Quilted Petticoat." She liked men of ability, and they seemed to return the sentiment—explorers, artists, and men of letters, all sorts answered her invitations. She lionized the actor Garrick; and the poet and clergyman Edward Young, author of "Night Thoughts," a religious poem popular at the time, though now largely unread.

The duchess also had letters from no less a person than the French philosopher Jean-Jacques Rousseau, who stayed with her once on a visit to England and kept up a correspondence with his hostess. She

spent most of her time at the duke's country seat, Bulstrode Park, which she took pains to beautify. She spent time and money on the gardens at Bulstrode and stocked a menagerie of rare and unusual creatures. She was intensely interested in botany and commissioned the painter Ehret, now considered to be one of the finest botanical artists, to paint more than three hundred pictures of exotic flowers. The Reverend John Lightfoot, a highly distinguished botanist, was retained as family chaplain, and set to work cataloguing the duchess's rarities. So broad-reaching was her patronage of botantists that a shrub growing in the foothills of the mountains of Jamaica is named *Portlandia grandiflora*. She invited the naturalist Sir Joseph Banks to Bulstrode soon after that famous scientist had returned from his voyage with Captain Cook.

As a woman of leisure, the duchess also pursued several more frivolous hobbies such as "turning," the shaping of pieces of wood and ivory on a lathe. Her confidante Mrs. Delaney, in a similar spirit, designed decorations from seashells. She developed her skills on cornices, painted to resemble carving, and then was given the task of designing and decorating an entire grotto on the grounds of Bulstrode. But it would be a mistake to view these two women's own pastimes as merely trivial, domestic, and amateurish. They both harbored grander passions: the duchess for curiosities, and Mrs. Delaney for the art of collage. The duchess's interest led her, eventually, to the vase; but the end of Mrs Delaney's endeavors is, in its way, equally remarkable, and the results are, like the vase, now visible in the British Museum.

★ ★ ★

MRS. DELANEY WAS A DAUGHTER of the aristocracy who, against the wishes of her family, married a clergyman of comparatively modest means and lived happily with him near Dublin. William Hogarth taught her painting, she showed great skill with the needle, and she

had developed a love of collages in her childhood. Though childless, she had a long and happy married life. When she was sixty-nine, her husband died, and she went to stay at Bulstrode with her friend the duchess, who was then in her mid-fifties.

Mrs. Delaney enjoyed a comfortable and companionable existence with the duchess. They liked to wander the park at Bulstrode, with food for the animals and the peacocks, sketchbooks tucked under their arms, and eyes peeled for good botanical specimens. Above all, they indulged their love of flowers, and for Mrs. Delaney, this was no mere distraction; the beauties of Bulstrode took on a moral importance:

> Surely an application to natural beauties must enlarge the mind? Can we view the wonderful texture of every leaf and flower, the dazzling and varied plumage of the birds, the glowing colours of flies &c., and their infinite variety, without saying, *"wonderful and marvellous art thou in all thy works!"* And this house, with all belonging to it, is a *noble school* for contemplations!

In 1772, at the age of seventy-three, Mrs. Delaney started something new. She wrote to her niece, Mary: "I have invented a new way of imitating flowers, I'll send you next time I write one for a sample." She later recounted how, one morning, she was sitting in her bedroom at Bulstrode when she noticed the similarity in color between the petals of a geranium in the room and a piece of colored paper that lay on the table. On a "whim of my own fancy," she picked up her scissors, cut out shapes of petals, found other colors for the leaves and stalk of the plant, and constructed a picture of the plant in collage. The resulting image was greeted with enthusiasm by the duchess, and Mrs. Delaney began to wield her scissors in earnest. She was inventing her own art form—the creation of flower pictures by

collage. She may have been intending merely to imitate pressed flowers, but she went much further. She had already spent decades practicing embroidery, and in particular the embroidery of flowers. She had spent hours in the company of the duchess, listening to her interrogate her botanical visitors, and quietly absorbing a great deal of knowledge. She had developed extraordinary skill with scissors; she could cut silhouettes and had a sharp eye for detail. She had already made pictures of birds from cut paper, with astonishingly intricate work on the feathers, as many as eighty-six cuts to an inch of paper, and in her seventies she still retained the dexterity and unimpaired eyesight that enabled her to create her collages.

They are incredibly detailed and extremely beautiful. Her White Flowered Accasia has 584 tiny leaves on its delicate spray, and 120 stamens. The pictures have to be seen in the flesh to be properly believed; even when looking at sumptuous color illustrations, it is almost impossible to conquer the impression that one is looking at a painting and not a collage. In fact, to begin with, Mrs. Delaney did apply shading and other detailing to her collages with watercolor. But as she refined her methods, she abandoned this technique and used only strips and shapes of paper, hundreds of them for each picture. The petal of a rose, for instance, would be represented by many different pieces of paper—each shape denoting a change in shade— as the light fell across the folded surface of the bloom. The stems and buds of the flowers were built up in the same way, using several strips of paper of different shades to create the effects of light playing on the surfaces and of three-dimensional form.

She used colored paper imported all the way from China, or sometimes dyed the paper to the desired shade herself. She designed her works like professional botanical illustrations; the specimen displayed in splendid isolation on a black background, with all its elements shown off to their best advantage. Close up, the work reveals an astonishing complexity and skill; step back, and the illusion is complete.

Some regarded Mrs. Delaney's work as merely the amusement of an old and idle woman. She herself played down her "Paper Mosaicks": "I can't boast of any useful employments," she wrote to her niece, "only such as keep me from being a burthen to my friends, and banish the spleen." Nonetheless, she had admirers. King George III and his Queen were frequent visitors to Bulstrode; indeed, the king had the disconcerting habit of strolling unannounced into the sitting room, and, as she recounted proudly in a letter to her niece, even they honored her efforts:

> The King asked me if I had added to my book of flowers, and desiring he might see it. It was placed on a table before the Queen, who was attended by the Princess Royal and the rest of ye ladies, the King standing and looking over them. I kept my distance, till the Queen called me to answer some question about a flower, when I came; and the King brought a chair and set it at the table, opposite to the Queen, and graciously took me by the hand and seated me in it, an honour I could not receive without some confusion and hesitation: "Sit down, sit down," said her Majesty, "it is not everybody has a chair brought them by a king."

The king and queen became good friends of Mrs. Delaney, and when she reached her eighties, her keen eyesight began to fail at last. After the duchess died, they housed her and looked after her at Windsor. Mrs. Delaney's flower pictures are now kept and displayed by the British Museum, and are regarded—like the vase—as a part of its treasures.

★ ★ ★

THE DUCHESS INHERITED her passion for collecting from her father. It was his cabinet of curiosities, bequeathed to her, that

formed the nucleus for her own collection. This famous piece of furniture, made of ebony and decorated by the artist Polemberg, was known as the "Ten thousand pound Cabinet" because of the supposed value of the precious rarities it contained. These included a dagger once belonging to Henry VIII, set with "jacinths" (gemstones like sapphires, yellow or blue); an emerald seal belonging to Charles II; and an antique vase of agate, decorated with a relief of rams' heads. To these, the duchess added another curiosity inherited from her husband's family: a pearl earring worn by Charles I at his execution. This had been given by King William III to her husband's grandfather, the Earl of Portland, with whom, as we shall see, King William was more than just good friends.

The duchess, botanist and menagerie owner, was interested in rarities of natural history, as much as those of antiquity. The catalogue to her collection lists: "Shells, Corals, Petrifactions, Spars, Ores and Chrystals," "Fishes and parts of ditto," "English Insects," and "Exotic Insects." Walpole, in an account of the duchess's collecting written after her death, describes how her passions developed as her collection swelled inexorably from one ebony cabinet to fill an entire private museum: "At first her Taste was chiefly confined to Shells, Japan & old China, particularly of the blue & white with a brown Edge, of which last She formed a large Closet at Bulstrode; but contenting herself with one specimen of every pattern She could get, it was a collection of odd pieces." When the duchess inherited her mother's substantial income, she spent part of it on her flower garden and menagerie at Bulstrode, and the rest

in indulging her taste for Virtu, sparing no expense to gratify it for about thirty years, her own purchases costing her not less than threescore thousand pounds. . . . The Duchess began to buy pictures, which She did not understand, & there & in other instances paid extravagantly, as well as for other articles

to her taste. Latterly she went deeply into natural history, & Her collection in that Walk was supposed to have cost her fifteen thousand pounds.

In the 1780s, according to Walpole, "She checked her purchases; but some months before her Death she was tempted by the celebrated Barberini Vase."

Though she closed her bargain with William Hamilton in February 1784, it was several months before it was delivered. Part of the delay was to allow Hamilton to commission a memento of the vase. For the task, he hired Cipriani to make drawings of the vase, and Bartolozzi to engrave the plates. These two Italian artists lived together in Golden Square, and there the vase stayed for some time while the work went on. The drawings were completed in July, while Hamilton was away in Scotland, and in his absence Cipriani delivered them to Mary, as she records in her diary entry for July 13:

> At 12 o'clock Cipriani and another man brought my Uncle's fine Vase, to deposit in my care. He shewed me the Drawings he had made from it which are indeed inimitably executed. . . . As soon as he left me I sent for a person to make a Box to contain this precious work of Art.

So the Vase joined and took pride of place in the exotic jumble of the duchess's cabinet of curiosities. Her museum was a very private affair, as indeed was the transaction between Hamilton and herself. No word of the purchase got out to the world at large. According to Horace Walpole, not privy to the secret, the vase had "disappeared with so much mystery." Only the duchess and her closest circle could enjoy it, as it sat, in pride of place, among her collection, beside another altogether less distinguished vase of agate, and Henry VIII's jewel-encrusted dagger, and Charles I's final choice of earring. We

have no record, unfortunately, of what the duchess thought of the vase, but the colossal amount she uncomplainingly paid for it speaks eloquently enough. She must have shared Hamilton's opinion that "there is not such a monument of antiquity in the world," and she certainly gave it pride of place in her collection and had no intention of ever parting with it. It was hers, to gloat over in private, and gloat she surely did.

But to the rest of the world the vase had disappeared. It seems impossible to us, in an age of public galleries and color supplements, that such a thing might happen, but the art world was vastly different at the end of the eighteenth century. Hamilton told his niece to convey the vase to the duchess "secretly," and so successfully did she carry out this commission that even the duchess's own family were not aware that she had acquired it. The vase saw the light of day only after her death, two years later, when with the rest of her treasures it was exposed to the calculating gaze of the auctioneer.

# JOSIAH WEDGWOOD

WHEN THE DUCHESS DIED, her will revealed that she had left the contents of her museum to her younger son, with a suggestion to sell the collection to compensate for the fact that the bulk of her vast estate would go to the eldest, the third Duke of Portland. Her treasures were put up for auction the year after her death, in more than four thousand lots, and chief among them was the vase. A drawing was made, engraved as a frontispiece for the sale catalogue, intended to evoke a glimpse of the duchess's museum. The picture shows a jumble of rare and valuable objects heaped together in glorious disarray like the treasures of Tutankhamen's tomb. Among the china, books, coins, and shells, the vase has pride of place, sitting center stage on a plinth. A mirror is propped behind it to show off the side of the frieze that would otherwise be hidden from view. Hanging from the foot of the vase is a drawing of the decoration on its base; sticking out of its mouth is a large frond of coral, as though

it were wearing an outré cocktail hat at a rather jaunty angle. The drawing is not to scale; the size of the vase is greatly exaggerated, so that it appears to be the largest item in the collection. It has been suggested that the objects were portrayed in the engraving not according to their actual size but rather to the prices they might realize. Copy for the catalogue was provided by the same Reverend John Lightfoot who had overseen the duchess's botanical collections. His entry for the vase gives us a good idea of the mixture of fact and misconception then surrounding it. He described it as

> The most celebrated antique VASE, or SEPULCHRAL URN, from the Barberini Cabinet at Rome. It is the identical urn which contained the ashes of the Roman Emperor ALEXAN-DER SEVERUS, and his mother MAMMAEA which was deposited in the earth about the year 235 after Christ, and was dug up by order of POPE BARBERINI named URBAN VIII between the years 1623 and 1644.

With the excitement of the saleroom on him, Lightfoot let himself go a little:

> The materials of which it is composed emulate an onyx, the ground a rich transparent dark amethystine colour, and the snowy figures which adorn it are in bas relief, of workmanship beyond all encomium, and such as cannot but excite in us the highest idea of the arts of the ancients.

And, it was to be hoped, the highest bids.

Horace Walpole attended the sale, and gleefully anticipated a knockdown price: "It will not, I conclude, produce half of what it cost the Duchess." He was not quite correct. The sale lasted for six weeks, and the vase came up on the penultimate day: June 7, 1786. It

went under the hammer for £1,026, making up nearly a tenth of the overall proceeds of the sale. It was sold to a "Mr Tomlinson," but he was undoubtedly acting as an agent. At first the *Gentleman's Magazine*, chief organ of society, decided that the mystery buyer was the Duke of Marlborough, but a few weeks later it discovered and revealed the true identity of the vase's new owner:

> The famous vase lately belonging to the Duchess of Portland is said to have been sold to a Mr Tomlinson for one thousand and twenty-six pounds. Readers may not be apprized that Mr T was a bidder for the Duke of Portland, and that his grace is the present owner of the curious relic of antiquity.

So the duke, who had decided to keep the vase in the family, had bid for it at the public auction and, in effect, bought it from his brother. But the duke had a rival bidder, someone with the resources to compete in the auction room and an obsession with vases that went far beyond the duke's own. There is a story that the duke prevented his rival from bidding against him only by agreeing to lend him the vase for a year after the auction. This rival bidder was Josiah Wedgwood, the potter, and while the story of his threat to bid may be apocryphal, there is no doubting his desire to possess the vase. Wedgwood and the Portland Vase were made for each other.

Wedgwood first heard about the vase in February 1794, when the sculptor John Flaxman saw it in London and wrote to Wedgwood.

> I wish you may soon come to town to see William Hamilton's vase. It is the finest production of Art that has been brought to England and seems to be the very apex of perfection to which you are endeavouring to bring your bisque & jasper; it is of a kind called "Murrina" by Pliny, made of dark glass with white enamel figures. The vase is about a foot high and the figures

between four and five inches, engraved in the same manner as a cameo and of the grandest and most perfect Greek sculpture.

Flaxman and Wedgwood had already collaborated on ceramics that look as if they had been directly inspired by the vase itself, and this before they had ever laid eyes on it. Flaxman expected that Wedgwood would be excited by the vase, but he can hardly have known how much of an obsession it would become, or that he himself would soon be spending so much time and effort diligently recreating these "most perfect" figures.

Wedgwood had commissioned Flaxman to create the ornaments for his own vases, and, in 1778, Flaxman produced his most important bas-relief design for Wedgwood, the Apotheosis of Homer. The resemblance to the Portland Vase is striking—white figures in bas-relief on a blue background. But this is not a coincidence—the link with Hamilton was already established. The design for the Apotheosis of Homer came from another ancient vase that had been acquired by Hamilton, and which he had sold, along with the rest of his first collection of vases, to the British Museum in 1772. Wedgwood studied both the prints from d'Hancarville's publication and the vases themselves, and their influence on him was considerable.

Wedgwood was making his vases of "jasper," which Flaxman refers to in his letter. Jasper was Wedgwood's great invention, an entirely new kind of ceramic body, the most important innovation in ceramics since the invention of porcelain by the Chinese nearly a thousand years earlier. Wedgwood is a sort of superhero of ceramics. He developed the highest technical skills of the potter, he had a frightening appetite for hard work, a canny commercial instinct, and the inspiration of a true innovator. His energy was demonic—he would throw himself into a project until his health was endangered to the point of breakdown, and then bounce back, eager for the next

challenge. During the building of his new factory, he "overworked" an injured knee while walking over the site. He had been lame since a childhood attack of smallpox, and now decided with typical ruthlessness to solve the problem of this injury by having his right leg amputated. (At this time, one must remember, anesthesia was rudimentary, to say the least, and antisepsis not yet understood.) Miraculously, three weeks later the stump was almost healed, as Wedgwood reported to his business partner Thomas Bentley: "The wound is not quite 2 inches by one and a ¼, I measured it with the compasses this morning when I dressed it. Yes, I dressed it, for I have turned the Surgeon adrift and Sally and I are sole managers now."

"Everything gives way to experiment" was one of Wedgwood's favorite principles, and he brought the same fascinated, detailed attention to his work in the potteries as he did to his own healing stump. At the beginning of the 1770s, Bentley was asking Wedgwood for something new for their London showroom. Wedgwood was producing dark, austere vases that imitated natural stone—agate or basalt. Bentley considered these rather masculine and asked for a "finer body," something that would appeal to "the Ladies" in the neoclassical style. So Wedgwood and Bentley decided to produce cameos that accorded with the fashion, as dictated by the Adam brothers, for pastel shades—blue, green, pink, yellow.

Neoclassical—that is to say, design influenced by the works of ancient Greece and Rome—is a modern term that Wedgwood would not have recognized. He called it the "true" or "correct" style. In part, it was a reaction against heavily ornamented rococo. The neoclassical style had strong political overtones because it appealed to the emerging middle classes, and it became a symbol of their struggle against the ruling landed aristocracy who were desperately trying to keep them in their place. As the archetypal self-made man, and a radical thinker, Wedgwood was a natural champion of the neo classical style. At this time he also began to collaborate with James Tassie.

Tassie supplied Wedgwood with molds of cameos and intaglios taken from antique gems that portrayed the gods and heroes of the classical world, and Wedgwood replied with molds from his own stock. They were both catering to the growing demand in Britain for all things classical, and, to begin with, their relationship was one of friendly rivalry. But Wedgwood began to voice to Bentley anxieties about the relative merits of their work, and Tassie, if he had known, would surely have been deeply flattered: "Mr Tassie and Voyez, between them, have made terrible depradations on our Seal Trade. The former by making them more beautifull, and the later by selling them cheaper."

"Voyez" (tellingly not given the honor of a prefix), was Wedgwood's other rival, and an altogether more malign bugbear. A sculptor and modeler, Jean Voyez had been taken on by Wedgwood in 1769. Six months after his arrival at the works he was convicted of stealing "11 Models of Clay val 5£., 15 Moulds of Clay val 50s., and 15 moulds of Plaister val 50s. Goods of Josiah Wedgwood." He was sentenced to transportation for seven years, but the sentence seems later to have been remitted to five months imprisonment and a public whipping. This was unfortunate for Wedgwood because Voyez was not engaged in petty theft; he was an industrial saboteur of the most dangerous type. Only a year later Wedgwood discovered to his dismay that Voyez was now in the employ of a rival potter, Humphrey Palmer, and supplying exactly the know-how that Palmer needed in order to compete with the Wedgwood wares. Wedgwood even contemplated paying Voyez a pension in order to protect his business: "The Selling of a single Vase less per week through such competition would be a greater loss to us than paying him his wages for nothing." Then he discovered that Voyez was marking his seals with the "W&B" mark of Wedgwood and Bentley's products. Wedgwood, understandably, was inclined to resort to the law, but his legal advisers assured him that an action would fail, because a rustic Staffordshire jury, untutored in

the wicked ways of the commercial world, would not be brought to understand the seriousness of the offense. Fortunately, after a few years, Voyez, who was not perhaps the kind of man to settle down anywhere, left England, and Wedgwood must have breathed a sigh of relief.

Despite these anxieties and distractions, at the beginning of the 1770s, Wedgwood replied to Bentley's request for something new:

> I have for some time past been reviewing my experiments, & find such Roots, such Seeds as would open and branch out wonderfully if I could nail myself down to the cultivation of them for a year or two. And the Foxhunter does not enjoy more pleasure from the chace, than I do from the prosecution of my experiments when I am fairly entered into the field.

It took Wedgwood four years of secret experimentation to perfect his new medium, all the while running his successful manufactory at Etruria, and raising a family of seven—not counting those who did not survive infancy—with the help of his formidable wife, Sally.

> If I had more time and more heads I could do something—but as it is I must be content to do as well as I can. A man who is in the midst of a course of experiments should not be at home to anything or anybody else but that cannot be my case. . . . I am almost crazy."

Wedgwood was using barium in his new mixture, but he did not fully understand the nature of this ingredient. When fired, the pieces would blister and crack for no apparent reason. The overlaid bas-reliefs would crack off. The whole process was very costly. After five thousand experiments over three years, he was still unable to predict the outcome confidently, and vases always collapsed after firing. But

Wedgwood persevered relentlessly to perfect his invention. He developed a secret technique of casting vases in a coarser form of the jasper, which was then given a thin coating of the finer ware—a piece of chicanery that has only recently been discovered, and which made possible the project of "the vase."

When the Portland Vase arrived in London, jasper was already on its way to becoming the most successful ornamental ware ever produced, and Wedgwood was ready, as ever, for a fresh challenge. When the vase disappeared into the duchess's private museum, Wedgwood had an illustration to study, while the idea of copying the vase germinated. It must have "opened and branched out wonderfully." Soon after the auction, once Wedgwood had arranged to borrow it from the duke, the vase set out on its travels once more.

Perhaps Wedgwood transported the vase personally, clutching the straw-filled box to protect the precious contents as he bumped along the turnpike. Or perhaps it went by water, on a horse-drawn barge, along the canals and waterways of England, through the flat green fields of the Midlands to the new factory Wedgwood had named Etruria. Water transport was essential to Wedgwood's business—the appalling condition of the roads in eighteenth-century England made it almost impossible to transport fragile goods of any description except by water. Wedgwood had dug a canal to his factory to link it to the waterways, and without it he would not have been able to distribute his wares.

The very name of Wedgwood's factory made explicit his intention to use the factory to reproduce the vases of classical antiquity. Etruria was the area of Italy inhabited by the ancient Etruscans, and Wedgwood shared his contemporaries' misapprehension that ancient pottery excavated in Italy was Etruscan, rather than Roman or Greek. This was in part caused by the confusing historical accident that some of the finest surviving Greek vases were found in Etruscan tombs. Despite its classical name, Wedgwood's Etruria factory was

thoroughly modern, even ahead of its time. Water provided not only the crucial transport links but also power from a waterwheel. As well as its good location and practicality of design, the factory had housing for the workers, who enjoyed the unheard-of advantage of a sick-leave benefit scheme. It might have seemed to Wedgwood as though the whole edifice had always been awaiting the arrival of the vase.

Once the vase was at the factory, and in Wedgwood's hands—literally—it's clear that touching and holding it stirred up the conflicting passions that drove him. After a fortnight's careful study, he wrote to Sir William Hamilton—Wedgwood the middle-class entrepreneur adopting the obsequious tone of shopkeeper to wealthy patron:

> Sir. I thank you for your very obliging letter, and shall ever retain a grateful sense of the kind partiality with which you have been pleased to honour my weak exertions. I cannot but feel myself flattered by the approbation of so exquisite a judge, who has himself introduced among us that pure taste, these elegant forms, which my humble studies have been in propagating and rendering permanent. You will be pleased, I am sure, to hear what a treasure is just now put into my hands, I mean the exquisite Vase with which you enriched these islands, and which, now that we may call it the Portland Vase, I hope will never depart from it. His Grace has generously lent it me to copy, and permitted me to carry it down to this place, where I stand much in need of your advice and directions.

Wedgwood's previous study of the illustrations of the vase had encouraged him to imagine that he could successfully copy the designs. With the vase now in his hands, its true nature was apparent, and it was an unpleasant surprise. In a letter to Hamilton he frankly confessed how daunted he felt by the quality of its workmanship:

Now that I can indulge myself with full and repeated examinations of the original work itself, my crest is much fallen, and I should scarcely muster sufficient resolution to proceed if I had not, too precipitately perhaps, pledged myself to many of my friends to attempt it in the best manner I am able.

He realized that, working in ceramic rather than glass, he would not be able to re-create the exquisite effects achieved by the original craftsman. His jasper could not be cut as thinly, or produce the effects of transparency.

It is apparent, that the artist has availed himself very ably of the dark back-ground, in producing the perspective and distance required, by cutting the white away, nearer to the ground as the shades wanted were deeper, so that the white is often cut to the thinness of paper; by which means he has given to his work the effect of painting as well as sculpture. That hollowness of the rocks, and depth of shade in other parts, produced by cutting down to the dark ground, and to which it owes no small part of its beauty, would all be wanting, and a disgusting flatness appear in their stead. It is here that I am most insensible of my weakness.

But Wedgwood seems to take an almost masochistic pleasure in the problems to be faced. His insight, honesty, and enthusiasm are impressive.

I dare confess to you sir, that I have at times wrought myself up to a certain degree of enthusiasm, in contemplating the beauties of this admirable work; and in those paroxysms am ready to cry out, that this single piece is alone a sufficient foundation for a manufactory, and that of no small extent; and then I begin

to count how many different ways the Vase itself may be copied, to suit the tastes, the wants, and the purses of different purchasers.

Wedgwood called together his best craftsmen and artists to begin the process of reproducing the ornamentation on the vase. Chief among them was John Flaxman, who had originally called Wedgwood's attention to the vase. The son of a plaster-cast maker near Covent Garden, Flaxman came from a poor family, but he showed a precocious talent for modeling and drawing. He enrolled in the newly established Royal Academy Schools and soon made a name for himself. His reputation reached Wedgwood in his manufactory in the English Midlands, via a visitor called Freeman, as Wedgwood reported to his partner, Bentley:

> He is a great admirer of young Flaxman and has advised his Father to send him to Rome which he has promised to do. Mr Freeman says he knows young Flaxman is a Coxcomb, but does not think him a bit the worse for it or the less likely to be a great Artist.

Flaxman does not seem to have been too much of a "coxcomb." The contemporary artist Joseph Nollekens called him "Little Flaxman," not just because of his stooped figure—he suffered from curvature of the spine—but because of "his fixity of ideas, his imaginitive poverty, his tendency to lapse into the sentimental or melodramatic." But perhaps Nollekens envied him his exceptional talents, for Flaxman became one of the most influential artists of his day.

The head of the ornamental department at Etruria was Henry Webber, the son of a Swiss sculptor, who had just signed a seventeen-year contract with the company. Wedgwood also involved his chief modeler William Hackford, known as "the ingenious boy," who was

especially gifted in fine modeling, and who stayed in service of the Wedgwood firm for sixty-three years.

Closely supervised by Wedgwood himself, and by his son Josiah II, under the fingers of these men the figures began to take shape. By June 1787, they were completed, and molds were created in which the ornaments could be reproduced and applied to the surface of the vases. Wedgwood was already planning to send Webber and Flaxman off to Rome to view the antiquties at firsthand "for the purpose of making Models, Drawings and other improvements in the Arts of Modelling and Designing." But the body of the vase was proving to be much more of a problem. Jasper was still a capricious medium. He confided his troubles to Hamilton:

> I must depend on an agent, whose effects are neither at my command, nor to be perceived at the time they are produced, viz. The action of fire on my compositions; a little more or a little less fire, and even the length of time employed in producing the same degree, will make a very material difference in this delicate operation.

Despite all his previous experiments and hard-won success, Wedgwood still could not predict what would happen to his trial pieces once they went into the kiln. He created a new color for jasper that would match the dark blue of the vase. He had recently invented a pyrometer, an instrument that measured the high temperatures used during the firing process. Before this invention successful firings depended on the skill of the kiln master, who would estimate the temperature in a kiln simply from observing the color of the fire. Wedgwood was elected a fellow of the Royal Society for this achievement, and it helped him greatly in his attempts to copy the vase. Nevertheless, he could not get his new medium to behave itself. Once in the kiln the vases that had been so carefully and laboriously con-

structed from the unfired jasper would blister and crack and collapse.

Copying the vase was proving to be the most laborious and infuri-
ating undertaking Wedgwood had ever embarked upon. The old syn-
drome asserted itself. He drove himself toward ill health and had to
consult his doctor, complaining of pains in his head and "a general
weakness." The physician prescribed a holiday, which Wedgwood
agreed to take "as soon as the Portland Vase is complete." The vase
itself had gone back to the Duke of Portland after a twelve-month
loan, but its remote, cool perfection must have been ever present to
Wedgwood's mind, mocking his frustrated endeavors.

A letter to his son, Josiah II, gives us a glimpse of the obsessive
attention that Wedgwood gave to the task:

> I wish you to look at the left leg of Pluto between the calf and
> the ancle the latter of which is not seen, & compare it with a
> cast taken out of the mould taken from the vase itself which
> you will find in one of the drawers of the cabinet closet, this
> part is said to be too broad. If so, it must be narrowed a little.

It had become an affair of honor. He had orders for copies of the vase
from his patrons, but he himself insisted that the subscribers should be
able to refuse the copies if they were not satisfied. The care he took
over the state of mind of his craftsmen gives us a hint of his own churn-
ing emotions: he urged his son not to tell the men that twenty orders
had been placed for copies, so as not to put them under any pressure.

Three years after he had begun, "gently and steadily" or not,
Wedgwood's experience, skill, and sheer stubborn perseverance
finally paid off. In September 1789, he produced a copy that satisfied
his own perfecting standards. "The prospect," he wrote, "brightens
before me." In the spring of 1790, he was ready to give his copy its
first public outing. Having a good understanding of the relationship
between publicity and celebrity, he went straight to the top. In May,

his vase was shown to Queen Charlotte herself, who had first estab-lished Wedgwood's reputation by commissioning from him at the beginning of his career a service known as "Queen's ware." The vase "pleased her very highly." It was then displayed in a private exhibi-tion at the house of Sir Joseph Banks, the president of the Royal Society. The *Gazeteer* and *New Daily Advertiser* breathlessly recorded the event.

On Saturday night last there was a numerous conversatione at Sir Joseph Banks's, Soho-square, when Mr Wedgwood produced the great vase, manufactured by himself, in imitation of that superb one about four years ago exhibited in the Museum of her Grace the Duchess Dowager of Portland. It is most exquis-itely finished, and allowed by all present, in point of look to be at least equal to the original, which was valued at two thousand five hundred pounds. The whole of the above vase is a composi-tion of the most beautiful transparency, and does infinite credit to the artist. Beside Sir Joseph and a numerous company who attended on the above occasion, there were present Sir Joshua Reynolds, the Hon. Horace Walpole and several members of the Royal and Antiquarian Societies.

Sir Joshua Reynolds, president of the Royal Academy, signed an official certificate to approve the vase as "a correct and faithful imita-tion both in regard to general effort and the most minute detail of parts."

Hamilton did not see the vase until a year later, but he then com-municated his reaction to Wedgwood: "The sublime character of the Original is wonderfully preserved in your Copy & little more is wanting than the sort of transparency which your materials could not imitate. . . . In short I am wonderfully pleased with it."

Hamilton's double-edged praise highlights the flaw in the whole project that Wedgwood could never eradicate: however many experiments he made, his chosen medium, jasper, was opaque and could not reproduce the beauty of the original glass. Moreover, the enterprise could in no way be considered a commercial success. Selling the few copies he made—only about thirty were produced during his lifetime—could not possibly compensate for the time and money he had spent. Wedgwood's son was sent on a promotional tour of Europe, during which the Princess of Orange admired his vase but did not buy it. In fact it seems that Wedgwood sold only ten copies, and he began to make disappointed remarks about the fact that his sales were not going to cover his costs.

But these first copies of the Portland Vase were his masterpiece, the last and finest chapter in a remarkable career. They are still regarded as among the greatest technical achievements in English ceramics. They became the hallmark—literally—of Wedgwood quality. No other manufactory had ever attempted, let alone achieved, such a difficult commission, and these copies brought the name of Wedgwood lasting fame. The Portland Vase gave Wedgwood something to measure himself against, something that called forth all his abilities and qualities; it was his greatest challenge.

The Wedgwood factory continued to produce copies of the Portland Vase throughout the following century, but none came near to the standards achieved by Wedgwood himself. The statue of Josiah that stands outside the modern Wedgwood factory and museum in Barlaston holds the distinctive shape of the vase, to symbolize this most lasting, most important association. If imitation is the sincerest form of flattery, then Wedgwood must be the Portland Vase's greatest admirer.

★ ★ ★

WHEN WEDGWOOD PRODUCED his first satisfactory copy of the vase, the first person to see it was his friend Erasmus Darwin, the doctor and—the term must be used loosely—poet . Darwin immediately celebrated his friend's achievement in verse:

> *Etruria! Next beneath thy magic hands*
> *Glides the quick wheel, the plastic clay expands,*
> *Nerved with fine touch, thy fingers (as it turns)*
> *Mark the nice bounds of vases, ewers and urns;*
>
> *And pleased on WEDGWOOD ray your partial smile*
> *A new Etruria decks Britannia's isle.*
> *Charmed by your touch, the kneaded clay refines,*
> *The biscuit hardens, the enamel shines,*
> *Each nicer mould a softer feature drinks,*
> *The bold cameo speaks, the soft intaglio thinks.*
>
> *Whether, O Friend of Art! your gems derive*
> *Fine forms from Greece, and fabled Gods revive;*
> *Or bid from modern life the portrait breathe,*
> *And bind round Honour's brow the laurel wreath;*
> *Buoyant shall sail, with Fame's historic page,*
> *Each fair medallion o'er the rocks of age.*

These lines are from Darwin's long and ambitious poem "The Botanic Garden," a mammoth work of over two thousand rhyming couplets. It was intended "to induce the ingenious to cultivate the knowledge of Botany, by introducing them to the vestibule of that delightful science." The poem was divided into two sections. In the first, "the physiology of plants is delivered; and the operation of the elements, as far as they may be supposed to affect the growth of vegetables." The second section dealt with the "loves of the plants" and

particularly "the Sexual system of Linnaeus." Although now merely a literary curiosity, at the time it was a great success, and in Darwin's defense it must be said that while he was producing these absurd and bombastic verses, his tongue was often in his cheek. The lines above come from a section of the poem concerning the natural products of the earth in general, and pottery in particular. Having introduced pottery, and his friend Wedgwood, Darwin embarked on a lengthy digression concerning the vase itself. When Wedgwood sent Darwin his first successful copy of the vase, he had hinted that it "might furnish even a minor poet with subjects for a few lines; what effect must it have then on a fancy and genius of the first order?" Darwin took the bait, and steered his poem into speculation "O'er the fine forms on PORTLAND's mystic urn."

Darwin's metaphysical interpretation of the figures on the vase was further explained in an eleven-page footnote, the gist of which was that the vase showed the journey from life to death of all mankind. Fortunately in the poem itself this was more economically expressed:

> *Here by fall'n columns and disjoin'd arcades,*
> *On mouldering stones, beneath deciduous shades,*
> *Sits HUMANKIND in hieroglyphic state,*
> *Serious, and pondering on their changeful state.*
> (This refers to figures E and G, as it were, male and female representatives of the human race.)

> *While with inverted torch, and swimming eyes,*
> *Sinks the fair shade of MORTAL LIFE, and dies.*
> (This is figure F.)

> *There the pale GHOST though death's wide portal bends*
> *His timid feet, the dusky steep descends;*
> (This refers to figure A.)

*With smiles assuasive LOVE DIVINE invites,*
*Guides on broad wing, with torch uplifted lights:*
(This is Cupid.)

*IMMORTAL LIFE, her hand extending, courts*
*The lingering form, his tottering step supports;*
(This is figure C.)

*Leads on to Pluto's realm the dreary way,*
*And gives him trembling to Elysian day.*
(Figure D, therefore, is Pluto.)

The identification of figure C as "Immortal Life" is supported in the footnote—" by her fondling between her knees a large and playful serpent, which from its annually renewing its external skin has from great antiquity. . . . been esteemed an emblem of renovated youth." Darwin also supplies an interpretation for the figure on the base disc:

*Beneath, in sacred robes the priestess dress'd,*
*The coif close-hooded, and the fluttering vest,*
*With pointing finger guides the initiate youth,*
*Unweaves the many-coloured veil of Truth,*
*Drives the profane from Mystery's bolted door,*
*And Silence guards the Eleusinian lore.*

Darwin's theory is at least refreshingly different, and it is certainly the only one to be formulated in rhyming couplets. Wedgwood himself took it up, and added a few refinements of his own; he pointed out that the column standing behind figure E "with its capital thrown down at the feet of this emblem of death may denote that the person deceased was the head of a great family, as so costly an urn would only be purchased by persons of the first rank." He speculated

that the staff held by figure G might "be an emblem of the authority of the deceased." He was particularly taken with the interpretation of figure A as the soul entering the next world: "The timidity with which the new guest takes his first steps out of this portal, his holding fast to his garment, beautifully denotes the reluctance with which he puts off his corporeal existence."

Darwin wanted pictures of the vase for his epic footnote—four of the eleven pages were to be plates illustrating his theory. He knew that the vase had been drawn by Cipriani and engraved by Bartolozzi, and he asked his publisher if he could use the resulting plates. Darwin's publisher, Joseph Johnson, was worried about copyright: "It is not the expence of purchasing Bartolozzi's plates that is any object; they cannot be copied without Hamilton's consent." But Johnson had another suggestion concerning one of the engravers who worked for him on a freelance basis: "Blake is certainly capable of making an exact copy of the Vase, I believe more so that Mr Bartolozzi, if the Vase were lent to him for that purpose, & I see no other way of its being done." So, by mere coincidence, in the autumn of 1791 the vase had a most unexpected and remarkable encounter with one of the great visionary artists of any age: William Blake.

The vase was now famous, an A-list celebrity of classical art. Blake was a nobody who lived out his life in obscurity and often penury, his poetic and artistic genius unrecognized, but he was no stranger to the vase. He had long been influenced by the artworks of the classical past. As a child, he attended a drawing school on the Strand, run by Henry Pars. Pars's brother William had been commissioned by the Society of Dilettanti to sketch ancient statues and buildings in Greece and Asia Minor—his *Ionian Antiquities* was published when Blake was in his second year at the school, and the fragments and ruins it portrayed sank into Blake's mind. He studied casts of famous classical statues and acquired copies. Some of these

subsequently turned up in his work—Hercules as "Giant Despair" in his illustrations of Bunyan, for example. He began to buy prints and engravings, and discovered a predilection for Raphael.

In 1772, at the age of fourteen, he was apprenticed to an engraver, James Basire. Basire was working on commissions from the Society of Antiquaries, and had collaborated with Pars. Under him, Blake learned the arduous trade of the engraver, and helped with his master's commissions, including illustrations for the publication *Archaeologia: Or Miscellaneous Tracts Relating to Antiquity.* Shortly before the vase came into Blake's hands, two learned antiquarians aired their opposing theories concerning the figures on the vase in this very work. J. G. King linked his theory to Alexander Severus; for him the figures A to D were "an allusion to the birth of Alexander the Great under which is typified the birth of Alexander Severus." Figure A was Alexander the Great and/or Alexander Severus. Figure C was either or both of the mothers of these two; Olympias and/or Mammea, and figure D was Jupiter. On the other side of the vase, King fancied he detected a reference to Alexander Severus's building projects; figure E is the emperor again, and the rocks on which he sits are a "bath," to symbolize the Roman baths built during the reign of the emperor. Figure F is Mammea again, though King resists the temptation to suggest that her up-ended torch is in fact a loofah, and figure G is "Constancy." This is arbitrary enough, but it sounds like pure reason compared to the theory then put forward in the same publication by a fellow antiquarian named Marsh. For the first side of the vase, Marsh followed his colleague, but the second side was, he decided, a satire on "scattered features of well-known history, satyrically sketched out." This "satire" compared Alexander Severus with his predecessor, Elagabalus: "to lash a luxurious emperor, addicted to the most shameful vices, and to praise a virtuous one." Elagabalus— figure E—"sits with his garment loose, in attitude slothful, obscene and libidinous." It never seems to cross his mind that all the male fig-

ures on the vase, and indeed all classical statues, behave with rather less "modesty" than trouser-wearing modern man. "At his feet female or connubial love" (figure F) "lies sorrowful." Marsh is referring to Elagabalus's homosexuality, but he can't quite bring himself to state the matter openly. But figure F might represent "a most beautiful woman, rejected and repudiated by that monster of impurity; and we know the causes of that repudiation." Figure G is "a female monitor, divination, revolving many things in her mind, fixed in purpose, leaning firmly, perhaps, on an augural lituus, just going to give a response to the tyrant, or, like another Syrian priestess, ready to denounce his death."

Blake also acquired a copy of Winkelmann's *Reflections on the Painting and the Sculpture of the Greeks*, and was influenced by his ideals. In 1779, he joined the Royal Academy, which founded its teaching on classical art. Key textbooks at the academy included William Hamilton's publication of his vases, as designed by d'Hancarville, and Montfaucon's *L'antiquité expliquée*, which included his interpretation of the figures on the vase as referring to the myth of Leda and the Swan. In the same year, Blake met fellow artist John Flaxman. Both were Londoners, and the sons of tradesmen. Flaxman was already working for Wedgwood and would collaborate on his copy of the vase, and would become the most celebrated artist of his day—a stark contrast to Blake's fate. But despite this, and despite Blake's prickly, highly eccentric nature, they remained on friendly terms for many years.

The works that Blake studied stimulated a love of the ancient world, and his imagination responded powerfully, delighting to project itself back over the vast stretches of time to a remote antiquity. Blake's biographer Peter Ackroyd suggests that his love of the deep past was linked to a preoccupation with death. Ackroyd sees "a connection between his interest in the past and his interest in mortality—was there, perhaps, some sense in which he wished to lose him-

self in antiquity?" In 1789, Blake's youngest brother died, probably of tuberculosis. He was Blake's beloved favorite, and Blake had been training him as a draftsman. Blake sat beside the deathbed for a fortnight as Robert struggled through the ghastly final stages of the disease, and at the end he saw Robert's spirit rising through the ceiling, "clapping its hands for joy." After Robert's death, Blake began to read the works of Emanuel Swedenborg, whose philosophy included a firm belief in a resurrection of the dead in spiritual but also perfect human form.

Blake had taken up engraving to earn a living while still studying at the academy. It was drudgery, but once it became his trade he stuck to it, to support himself and his wife, Catherine. However, after Robert's death, he used the technical knowledge of his trade to create an entirely new medium. Just before he met the vase, he produced *Songs of Innocence*, the poems and illustrations all etched directly onto the engraver's plate, to form an unprecedented whole. This technique was, according to Blake's early biographer, Alexander Gilchrist, inspired by Robert. "His brother Robert stood before him in one of his visionary imaginations, and so decidedly directed him in the way in which he ought to proceed that he immediately followed his advice by writing his poetry and drawing his marginal subjects of embellishments in outline upon the copper plate. . . ." It was the beginning of a burst of creativity, and soon after, he produced *Songs of Experience*, including "Tyger, Tyger," the poems drafted out in the back of Robert's notebook, which was carefully preserved and reused.

In between these two early masterpieces, Blake undertook his commission from Johnson and engraved the vase. What did he think as he examined the first figure on the frieze, the perfect figure of the young man who was—according to Darwin's interpretation—a ghost entering the afterlife? He may have disapproved of the "reluctance" with which the ghost "puts off his corporeal existence." But other-

wise Darwin's interpretation must have appealed to him, bound up as he was with his brother's spirit journey to the next world. As he sharpened his needle or burin, rested his copper plate on its leather cushion, gazed at the frieze and began his work, he was at least able to compare the scenes on the vase with his own extraordinary visions.

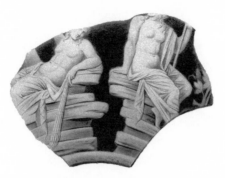

# THE DUKES OF PORTLAND AND
# THE DUCHESS OF GORDON

I N 1786, THE VASE came fully into the possession of the third
Duke of Portland, having been bought by "Mr Tomlinson" at auc-
tion at the premises of Skinner and Co. in Aldersgate Street in July
1785, then loaned to Wedgwood for a year. Now it began to be known
by the name it bears today, and what one might call its "maiden"
name of Barberini fell out of use. The origins of the dukedom that
gave its name to the vase lie in the affections of King William III.
When William was Prince of Orange, an obscure if determined player
in the seventeenth-century European conflict between Protestants
and Catholics, his page was William Bentinck, a fellow Netherlander.
In 1675, the young Prince William contracted smallpox, and during
this potentially fatal and highly contagious illness, Bentinck nursed
his friend and master. This early proof of devotion cemented a
thirty-year friendship, and rather more than that; it was the begin-

ning of a serious relationship. The Prince of Orange and William Bentinck were lovers.

When the increasing unpopularity of the catholic King James II prompted ambassadors from England to offer the crown to the Prince of Orange, Bentinck was the trusted confidante given the task of negotiating. He helped to arrange the strategic marriage between Prince William and Mary Stuart, daughter of James II, and he oversaw the detailed planning of the invasion of England by troops loyal to William and the Protestant cause. This virtually bloodless and entirely successful coup put William on the English throne, and one of his first acts as king was to make his friend Groom of the Stool, First Gentleman of the Bedchamber (never was the title more fittingly given or held), and Earl of Portland. The measure of the favoritism William displayed toward Bentinck can be detected in the jealous animosity it stimulated. His closeness to the king made Bentinck distrusted and disliked by those denied the royal ear:

*The King thinks*
*The Queen tells*
*The Princess eats*
*Prince George drinks*
*Lord Portland takes—all things.*

This was a piece of envious doggerel current at the time, and apart from commemorating the various foibles of the royal family, it demonstrates how great King William's generosity to his friend was. The more jealous and suspicious the English aristocracy showed themselves, the more the king favored his friend who, he knew, had his interests at heart. They fought together at the battle of the Boyne, and at Landen. (William was not a very successful military commander, but there is no doubting his courage and persistence. On one occasion, when wounded on the battlefield in sight of his troops,

instead of quietly retiring to seek medical attention he stayed on the field, taking off his hat and waving it vigorously to prevent the spread of alarm and despondency in the ranks.) Bentinck was instrumental in frustrating an assassination attempt on William, and was rewarded with yet more grants of land.

Bentinck was honest, direct, devoted, but he was a long-term boyfriend, not a courtier, and he could not cope with the arrival at court of young Arnold Joost van Keppel, who became the king's new favorite. Keppel was all youthful charm and high spirits, and the king doted on him; Bentinck was stricken with jealousy. He retired from court in a sulk that lasted for years, and he was reconciled with William only as the king lay on his deathbed. Summoned to his side, by the time Bentinck arrived his master was beyond speech, but the king took Bentinck's hand and pressed it to his heart, in a touching gesture of forgiveness and love.

The Bentinck family took root in the many acres of English soil granted them by King William and flourished. Bentinck's son was made a duke by King George I. He was also offered the govenorship of Jamaica, a less comfortable gift, and one he was induced to take only after having lost significant amounts of money in the South Sea Bubble. Englishmen had a habit of dying young in the West Indies, and the first Duke of Portland was no exception; he lasted four years in the job before being carried off by the yellow jack, or some other scourge of the colonial constitution, at the age of forty-four. His son, the second duke, thus inherited the title while still a teenager. He was very handsome, and was eventually elected a fellow of the Royal Society, but, most important, he married Margaret Cavendish Holles-Harley in 1734, avid collector of curiosities and subsequent purchaser of the vase, and he retired into a quiet domestic rural existence with her. It was his son, William Cavendish-Bentinck, the third Duke of Portland, who bought the vase at auction after his mother's death and became its owner for the next twenty-five years.

William Cavendish-Bentinck had a traditional career as a young aristocrat. He went up to Oxford and took his M.A. He did the Grand Tour and spent nearly three years in Italy, although unfortunately there is no evidence that he ever visited the Palazzo Barberini to view his future acquisition. He learned to drink like his peers—that is, to excess—and by the age of twenty-six he was consuming two bottles of claret daily and, perhaps not surprisingly, suffering the first twinges of gout. On the death of his father in 1761, he inherited the dukedom and took his place in the House of Lords. He had love affairs, first with Maria Walpole, Countess of Waldegrave, a niece of Horace Walpole. Maria was a beautiful widow, but she had her sights set on an even higher prospect than William; she soon threw him aside for the Duke of Gloucester, brother to King George III, to whom she was subsequently married in secret. William had another romantic entanglement with a married woman, plaintive Anne Liddell, Duchess of Grafton, who was ill treated by her husband (he neglected her in favor of his own notorious mistress) and poured out her woes to her confidant. News of William's engagement gave her a "Confusion of Sentiments," but she tried her best to be pleased for her "friend."

William married another Cavendish, Dorothy, daughter of the fourth Duke of Devonshire. It was a good marriage from the dynastic point of view, but it also proved successful on purely personal terms, because it was long and happy. William began to take on the business of overseeing his extensive properties. He took his responsibilities seriously and was soon engaged in correspondence dealing with rents, leases, tithes, roads, livestock, crops, buildings, and even mines, of which he owned several. The expenses of his estates always seemed to swallow up the income.

William had a younger brother, Edward, a classic black sheep and ne'er-do-well, whose nickname, "Jolly Heart," perhaps explains his elder brother's constant indulgence. William remonstrated with him: "I have always been bred to think that society has its claims," he

wrote to his brother, but as far as Edward was concerned, the race course had its claims, too, and that was that. Edward sank into bankruptcy and fits, and William continued to pay his bills. Horace Walpole condemned him for having "too great compassion for an idle and worthless younger brother," but Horace was a late addition to the Walpole family, eleven years younger than his father's other children, and he never loved his siblings. William's generosity was almost as damaging as his incompetence; he nobly excused a friend from honoring a debt of thirty-six thousand pounds, a truly colossal sum. William, despite his best efforts and the vast resources at his disposal, was not good with money. He had run up debts at Oxford, prompting some anxious letters from his mother the duchess, and continued to do so. Now, in the 1770s, they began to quarrel; he had power of attorney, but she insisted on issuing orders. And all the while, she was spending her own substantial income on her curiosities and menageries, culminating in her most extravagant purchase made in 1783: two thousand pounds on one vase.

William and his mother also fell out over politics. Having been "bred to think that society has its claims," William took his seat in the House of Lords, and had an active part in its doings and the eternal debate between the Whig and Tory Parties. William joined the Whigs, as was only natural; they were an oligarchy of the landed interest. But their power was eclipsed by the arrival of George III on the throne; he was determined to put down party politics, and claw back power to the monarchy. His greatest ally in Parliament was the Count of Bute (a pompous idiot, but entirely trusted by the king), whose wife happened to be best friends with the Duchess of Portland. The duchess followed her friend rather than her son, and was not amused by his Whiggish tendencies. She wrote accordingly: "I must desire you will inform me if you intend to support the King's measures or join the Opposition. If your Connections or Engagements induce you to that resolution I can only say I am sorry

for it." But he did, and she was. Indeed by 1782, he was leader of the Whigs, having served his party to the best of his ability and earned the respect of its leading lights.

These leading lights were, specifically, Charles James Fox and Edmund Burke, and their differing reactions to the French Revolution split the Whig Party. Fox greeted the Revolution with enthusiasm. Burke, in his famous *Reflections on the French Revolution*, condemned it. William, who was deeply under the spell of Fox's brilliance and charm, but felt instinctively that Burke was right, was divided along with the party. In 1792, with the Revolution now descending into a chaos of massacre and war, representatives of the party came to William to demand that he separate himself and the party from the friend and political ally he admired beyond all others: Fox. One of those present described William's pained and painful reaction:

> To all this, strange as it may appear, the Duke of Portland replied nothing, neither would he answer a word. . . . I, although I have often seen him benumbed and paralysed, never saw him or anyone else, so completely so before. All was one dead silence on his part; he seemed in a trance, and nothing could be so painful as these two hours, for our conversation lasted as long as that, reckoning intervals of ten and fifteen minutes' silence.

In these days of professional politicians, never at a loss for a well-turned sound bite, there is something striking about this picture of a man, thrust mainly by an accident of birth into a position for which he does not seem to have been fully qualified, struck dumb by contending thoughts and emotions and his own embattled integrity. In the end, William bowed to the inevitable, broke with Fox, and led his followers over to help the Tory government in the bloody struggle with revolutionary and then Napoleonic France. He gained office as

secretary of state, and eventually became first lord of the Treasury. In 1807, in his seventies and now a sympathetic friend of the ailing king, William was prime minister, although for the entire length of his premiership he never so much as opened his mouth in Parliament. He died in 1809, leaving behind a reputation of, in Horace Walpole's words, "a proud though bashful man." He also left debts of half a million pounds, and, of course, the vase.

It is not clear exactly where the vase lived during its ownership by the third duke. It stayed in his keeping for twenty-three years, and although it was not kept so secret as it had been in the duchess's museum, nevertheless it led a very private life. It may have been at Bulstrode or Welbeck, or on show at the duke's London house, where it would be most admired by his political cronies and the society of the capital. What is known for certain is that at some point during William's ownership of the vase, it was cracked. There is no record of exactly when or how this happened, but the culprit was named by a fleeting reference in the *Gentleman's Magazine:* Jane, Duchess of Gordon. Jane was a political enemy of William, a staunch and active Tory, but they were both part of the small social circle of the ruling class, and there is no reason why Jane would not have been a guest in the duke's home. How, while there, she damaged the vase is not known; but knowledge of Jane's character and background does go some way to explaining why she might be responsible for the carelessness, clumsiness, or high spirits that resulted in its damage.

★ ★ ★

UNTIL NOW THE ACTORS in the story of the vase have fallen, as described earlier, into two main categories: those who owned it, and those who studied it. But there is a third category—those who damaged the vase. Chief among these is William Mulcahy, but he is not alone. Between the time the third Duke of Portland came to possess the vase and the present day, no less than four people have, for very

different reasons, been responsible for violating to a greater or lesser extent its fragile form, and the Duchess of Gordon was merely the first of these. Exactly what she did—whether she dropped it—or pushed it over, or knocked against it, is obscure. The damage was relatively minor, and cannot now be distinguished from later cracks. The fracture affected the base of the vase, which came right off and had to be fixed back onto the body. Perhaps it was nothing worse than an unlucky accident, but the duchess had a reputation for wild and extravagant behavior, which was founded during her childhood in genteel poverty, fostered by a romantic story of star-crossed love, and cemented by an adult career of great ambition and political influence.

The Duchess of Gordon was born plain Jane Maxwell, daughter to a baronet with little money or position. She was brought up in a small flat in Edinburgh, where underclothes hung drying in the dark passages, or were slung out of the window on a pole. She and her sister Eglantine fetched water for the teakettle from the communal pump in the courtyard. One of their favorite occupations of childhood was to ride on the backs of pigs, which were still allowed to browse the streets of eighteenth-century Edinburgh. A contemporary records how "an old gentleman who was their relation told me that the first time he saw these beautiful girls was in the High Street, where Miss Jane was riding upon a sow which Miss Eglintoune thumped lustily behind with a stick." What characterized the Maxwell girls, apart from their poverty and high spirits, was their good looks. Jane was especially blessed, with dark, expressive eyes, regular features, and a peculiar grace. While still a teenager she was celebrated as "the Flower of Galloway" and a popular song was written for her—"Jenny of Monreith." Unfortunately, the tragic events of her early adult life sound as though they were drawn from the most hackneyed ballad. She fell in love with a young officer who was posted overseas. When word came that he had been killed, Jane was devastated. In grief and despair, she went through with a loveless but otherwise ideal wedding

to the Duke of Gordon, who was not only wealthy but also one of the handsomest men of his day. Then, during the honeymoon, Jane received a letter from—oh horror!—her lost love, to say that he was alive and well and was on his way home to claim her. Distracted, she fled from her husband—whether into a raging storm or deep snow the story does not relate—collapsed, and was found clutching the letter.

The marriage does not seem to have properly recovered from this romantic but rocky start. Jane dutifully produced seven children, but the duke fathered another nine outside the marriage. Apart from this impressive fertility, he was "a man of easy habits and mediocre abilities," who preferred to spend his time on his country estates, engaged in rural affairs, field sports, and the breeding of deer hounds.

But Jane's natural hog-thumping, vase-cracking high spirits were not extinguished by her marriage to the duke; rather, they seem to have been exaggerated to an almost demonic level, as she sought to forget her cares in gaiety and excitement. Her behavior was wild; according to a contemporary, "Her conversation bore a very strong analogy to her intellectual formation. Exempted by her sex, rank, and beauty from those restraints imposed on women by the generally recognised usages of society, the Duchess of Gordon frequently dispensed with their observance." She became a socialite, a hostess, an "empress of fashion," as Horace Walpole described her, and he marveled at her frenetic pace:

I heard her journal of last Monday. She first went to Handel's music in the Abbey, then she clambered over the benches and went to Hastings's trial in the Hall; after dinner, to the play, then to Lady Lucan's Assembly; after that to Ranelagh, and returned to Mrs Hobart's faro-table; gave a ball herself in the evening of that morning into which she must have got a good way; and set out for Scotland the next day. Hercules could not have achieved a quarter of her labours in the same space of time.

Having had her own romantic ambitions destroyed, Jane was determined to secure advantageous marriages for each of her daughters. She became notorious for her quest to find them all suitable husbands, and "eligible bachelors" would go into hiding when she made her visit, trembling in the knowledge that she would stop at nothing to ensnare them. When she was attempting to arrange a marriage for her fourth daughter, who had sadly not inherited her beauty, the father of the bridegroom, Lord Cornwallis, objected to the union on the grounds that the Gordon blood was tainted by madness. This was not unfounded; Lord George Gordon's increasingly bizarre behavior had sparked the anti-Catholic Gordon Riots; it now manifested itself in conversion to Judaism, a floor-length gray beard, and the name Israel Abraham George Gordon. Jane efficiently resolved this problem by confidentially informing Lord Cornwallis that "Louisa has not a drop of Gordon blood in her veins." This is perhaps fair enough, when the duke's extramarital record is taken into account; in any case it seems to have satisfied Lord Cornwallis, for the marriage went ahead.

Her eldest daughter Charlotte married the Duke of Richmond. Susan became the Duchess of Manchester. Georgina was engaged to Francis, the fifth Duke of Bedford, but when he died from "an overexertion at tennis," Jane secured a transfer to his brother, the sixth duke, and Georgina duly became the Duchess of Bedford a year later.

Not content with her domestic success, Jane went into politics, taking the Tory side in the war with the Whigs, and in the battle between the Tory prime minister William Pitt, and his great Whig rival, Fox. Jane worked as unofficial whip for her chosen party, using her charms to rally supporters to Pitt's government, and if charm failed she was not above bullying and intimidation. Her most remarkable achievement in the political field was her relationship with Prime Minister Pitt himself, which—without being scandalous—grew very close. She became his familiar and eventually even his confidante. It gave her real political influence at a time when

members of her sex rarely had access to power of this sort, and it is perhaps the most telling tribute to her extraordinary nature.

It has been suggested that the vase went to the British Museum partly because of Jane's carelessness; that it was deposited there after the death of the third duke, in order to protect it from the kind of casual damage that it suffered while in the duke's private house. But the move may have had more to do with the rising fortunes of the British Museum. When the third duke of Portland died in 1809, the vase became the property of his son, William Henry, now the fourth duke. Only a year after he inherited it, William Henry loaned the vase to the British Museum, and it arrived there just after the Rosetta Stone and just before the Elgin Marbles. The museum was in a great period of expansion, with treasures flowing in from all over the world as British adventurers, ambassadors, explorers, and archae-ologists quartered the globe, armed with the confidence and wealth of a growing empire. The Department of Antiquities had been opened in 1807, and the vase immediately became a star attraction in it. But the vase was only a loan; William Henry retained his owner-ship, and he viewed the vase as an important part of his inheritance, otherwise he would certainly have sold it. He had no compunction, for instance, about selling Bulstrode, so beloved of his grandmother the duchess and her companion Mrs. Delaney. He was making heroic efforts to pay off the gigantic debts of his improvident father, and it is greatly to his credit that he did not automatically seize on the vase as a way of providing at least a small part of the half a million pounds he needed in order to put himself back in the black.

Fortunately, William Henry was significantly more successful with money than his father, and he had luck as well as judgment; as London swelled to monstrous proportions with power, population, and money, he watched the rental value of his extensive holdings in Marylebone go through the roof. He was not a miser, or a slave driver; he looked after his tenants and his flocks, and they all increased and

multiplied. He tended his forests, improved the drainage in his meadows, introduced progressive farming techniques, and invested in coal mines and railways. In a remarkably short time the debts were paid. William Henry also found time to pursue other interests just as vigorously and successfully. He became obsessed with shipbuilding, and championed the cause of a ship designer, Symonds. By funding the construction of a vessel on Symonds's principles, and offering to race it against the navy's best, he persuaded the admiralty to take notice of Symonds's ideas. His ship, the *Pantaloon*, beat the crack naval frigate *Barham* hands down, and Symonds's went on to build the last generation of the Royal Navy's sailing vessels before the advent of steam. William Henry's other favored pastime was the turf. He frequented Newmarket in a wagon specially fitted with a telescope through which he could follow the progress of the race, although— perhaps with uncle "Jolly Heart's" awful example before him—he never laid a wager. He owned a derby winner—Tiresias—and built the Portland Stand at Newmarket.

He lived on into his eighties, still vigorous, alert, kindly, and careful with money, insisting that no more than a hundred pounds be spent on his funeral. He died in 1854, on the day that Britain declared war on Russia and the Crimean debacle began. William Henry could be regarded as a figure of continuity, order, and progress, of tradition and good management; one who was settled, solid, and safe. So it is perhaps ironic that it was during the period of his ownership that the vase suffered its worst. It was William Henry who received the letter from the trustees, notifying him of the "lamentable occurrence" in 1845, when the vase was smashed, and wrote back with such forbearance, dissuading the trustees from pursuing Mulcahy's family for "an act of folly or madness which they could not control."

# JOHN DOUBLEDAY
# AND THOMAS WINDUS

IN FEBRUARY 1845, the vase lay in fragments; but after—so to speak—the dust had settled, and these had been carefully gathered up and examined, the possibility of restoration looked slightly less than hopeless. Some of the figures had only been broken into large pieces, with unsplintered edges. The base disk was almost unharmed, although the handles were in a bad state. All in all, the museum considered it worthwhile attempting a restoration, and the duke gave his consent.

The museum entrusted the work to one of their in-house craftsmen, John Doubleday. His first act was to commission a watercolor of the fragments, which would stand as a record of the enormity of his task. The two hundred and more pieces were arranged in a rectangular frame. In the center lay the base disk, unharmed. Below it were laid the larger, less damaged pieces from the side of the vase

showing the figure of the reclining woman—indeed that figure is clearly distinguishable—and above were laid the more fragmented pieces from the other side of the vase, of which only a hand or face is recognizable here and there. Between these two, flanking the disk, a host of tiny fragments were carefully positioned, many of them from the base of the handles, and on either side of these were placed two small circular containers, in which were hundreds of tiny splinters. A more intimidating jigsaw puzzle could scarcely be imagined, but by September of the following year Doubleday had completed his task to such good effect that the vase was once more put on show in the museum. The *Gentleman's Magazine* lauded "the cleverness with which he has in a great degree contrived to render imperceptible the innumerable lines of conjunction" and hailed Doubleday as "the prince of restorers." The museum awarded him a bonus of twenty-five pounds. There is a photograph of him, a marvelous "before and after" composition, in which he sits in front of the watercolor of the fragments, while the restored vase perches beside him on the corner of a table. He stares with narrowed eyes and beetling brows at the watercolor, as though still calculating how he will solve the giant puzzle, but has his arm round the restored vase in a gesture of conquest.

★ ★ ★

THE DUKE OF PORTLAND might have accepted the destruction of the vase with fortitude and a spirit of forgiveness, but readers of the *Times* were less forbearing. One wrote in to suggest the return of the stocks, and another, identifying himself only as "F.S.A.," prescribed "public whipping" for Mulcahy and his ilk. This latter correspondent was almost certainly Thomas Windus, fellow of the Society of Antiquaries, who had just published a monograph on the vase: *A New Elucidation of the Subjects on the Celebrated Portland Vase*. After the destruction of the vase he printed an addendum to this work, giving

further voice to his outrage. Like the duke, he was concerned about keeping Mulcahy's identity secret: "In common charity and good feeling let us drop tears on the catastrophe, and blot out the name of the perpetrator for ever." Despite these fine words, his motive for concealing that name was less charitable than the duke's:

> Suffer it not for the sake of notoriety to be handed down to posterity as that of Eratostratus, the Ephesian, who burnt the famous temple of Diana, at Ephesus, on the day of the birth of Alexander the Great. The infliction of a severe public flagellation for injuries committed on the fine arts would tend much to cauterise these phrenological mischievous sensations from breaking out into active violence.

Windus was the sort of man for whom the phrase "pompous ass" could have been invented, and one instinctively pities any wife or children, but perhaps he was harmless and lovable. He had already written in to the *Gentleman's Magazine* to tell the world "what I conceive the best mode of restoring it partially to its original character and shape." He suggested acquiring a copy of the vase and scraping off the figures. "It will then be in a proper state and size to receive the original fragments remaining, which can be easily secured with cement." He had also finally, so he fondly believed, hit on the correct interpretation of the figures on the vase: "The whole allegory blazed on me at once in union with my favourite hypothesis—the sexes correct—and all the attributes . . . from the excitement I exclaimed with all the ardour of Archimedes, EUREKA! EUREKA!"

Windus decided that figure D on the vase had "a medical appearance." Unfortunately he does not specify what ancient equivalent to the stethoscope or white coat convinced him of this, but having laid his foundations in the sand, he researched the biographies of ancient

physicians and went on to build a tall but shaky structure. He decided that figure D was Galen, a famous doctor of second century Rome, and the scenes on the vase celebrate Galen's cure of the daughter of the Emperor Marcus Aurelius.

According to the story, the princess was suffering from a mysterious and incurable malady until Galen, summoned by the desperate emperor, determined that she was merely lovesick. She had conceived a passion for a rope dancer called Pylades, and as soon as he was introduced into the sickroom she made a miraculous recovery. Figure F on the vase is the princess, pining for her dancer, while the imperial parents sit anxiously on either side. Figure C is the princess recovered, fondling "the gyrating Hygeian Serpent, emblem of healing." Galen, figure D, looks on with professional satisfaction, while figure A, the rope dancer, advances toward his admirer. Once you imagine that figure A is indeed a kind of circus performer, it is absurdly possible to detect in his posture something of the acrobat, moving with balanced steps toward his love as though on a tightrope.

At least, as Windus points out, his theory successfully accommodates the sexes of the figures, and this alone puts him ahead of some of his predecessors. But there is one fatal flaw in his theory: the vase was in fact created two hundred years before Galen made his reputation and the princess fell in love.

In 1854, after the death of the fourth Duke of Portland, the vase was inherited by his son John, who duly became the fifth duke. John kept up the loan of the vase to the British Museum. The damage to the vase did not adversely affect its reputation—quite the contrary. As the new museum building was successfully completed, more and more visitors flowed in to view the treasures. When the British Museum first opened in the eighteenth century, visitors had been allowed only in small groups, which would then be led around on an enforced guided tour. Now the floodgates were opened, and the hordes poured in, much to the distaste of Frederic Madden, no doubt. In 1851, only five years after

the restored vase was put back on show, 2.5 million people visited the museum, and a large proportion of them must have seen the vase. It was one of the most popular exhibits, and a mold from which casts of the vase were taken to sell to visitors was eventually worn out by the demands of its fans, and had to be replaced.

As its fame spread among the culture-hungry Victorians, so the interpretations of the figures proliferated. Indeed, spinning theories about the frieze was the perfect task to occupy a classically educated clergyman over the long weekdays in his study at the rural deanery. During the second half of the nineteenth century, several more interpretations were published, and the pace was only just picking up. After 1900, almost as many interpretations would be devised and proclaimed than had appeared during the previous two and a half centuries, eventually reaching a total that now stands at nearly fifty.

In 1849, W. Watkiss-Lloyd took up Winckelmann's earlier interpretation of the first scene as being the marriage of Peleus and Thetis. He was the first to draw attention to the verses in Catullus that embody the romantic, nonviolent version of their courtship. The following year, a German scholar, C. T. Pyl, writing about the story of Medea, claimed the vase for this myth. According to Ply, figure F was Medea, and figure E was Jason. Medea had helped Jason to win the golden fleece; as for the figure with the upended torch, she was perhaps mourning for the younger brother she had dismembered and scattered on the waves, in order to delay their pursuers when she fled with Jason from the palace of her father. Otherwise, there does not seem to be the slightest evidence to support this theory.

But while the vase grew in fame, open to the gaze of the ever-growing hordes of visitors, its owner courted obscurity. To say that the fifth duke was a recluse is to put it mildly. In his attempt to minimize contact with the outside world, he created a reputation for eccentricity that, without quite crossing the border into outright insanity, is unrivaled in the annals of the crack-brained English aris-

tocracy. John was not a lunatic. He never ran amok, flinging precious heirlooms right and left, convinced that he was Napoléon or that a Rosicrucian conspiracy had designs on his life. He does not appear ever to have lost his grip on reality. But these facts make his behavior only harder to account for; in all its long life, the vase never had an owner more strange.

# JOHN, FIFTH DUKE OF PORTLAND, AND JOHN NORTHWOOD

JOHN, FIFTH DUKE OF PORTLAND, had a mother who showed signs of reclusiveness. She hid from visitors to Welbeck, and even her servants learned to make themselves scarce when she approached, understanding that she did not like to be seen. It was perhaps at the behest of his mother that John was educated at home, but sooner or later he had to go out into the world; he joined the dragoon guards, and he made a tall, good-looking cavalryman, with a reputation for fine horsemanship. He loved to hunt, and over the winter of 1820 to 1821, for instance, he went out with the hounds every single weekday, except when the frost was too hard. He traveled on the Continent, fell for an opera singer, Adelaide Kemble, daughter of the actor Charles Kemble, and proposed to her. Perhaps his affliction dates from her rejection; at about this time he began to complain of ill health—sud-

den losses of memory, an irritation of the skin—things that could, perhaps, be attributed to a "nervous disposition."

Gradually, he shrank from the world. Welbeck became his home and his castle, and he entrenched himself there, quite literally. First he dug the garden, laying out kitchen gardens over twenty-two acres, surrounded by high walls, with embrasures for braziers to warm and ripen the fruit. He built greenhouses, hothouses, and forcing houses for pineapples, peaches, and grapes, but he had no company to eat them with. He built an immense riding house, more than a hundred meters long, lit by four thousand gas jets and a glass roof. Then he went underground; the duke began to tunnel.

A tunnel was built from the house to the riding school, a thousand yards long, and wide enough for several people to walk abreast. Tunnels also extended from the house to the park gates; these were brick-lined and, wide enough for two carriages to drive down. One, more than a mile long, led to the nearby town of Worksop. An underground chamber was excavated beside the house, a subterranean great hall, fifty meters long and painted pink. Armies of bricklayers, carpenters, and plumbers were employed, with fleets of carts and traction engines, and hundreds of thousands of pounds were spent on the works. John stipulated that the workers on the estate should be provided with donkeys to carry them from their encampment (known as "Sligo" because of the Irish nationality of those employed) to their work, and with umbrellas to protect them from the weather. The duke himself wore an exceedingly tall hat and carried his own large umbrella as he watched the work, but employees were ordered to ignore him, not to address him or even acknowledge his presence. There is a story about one worker who was dismissed for merely touching his hat to the duke, but this seems out of character; the duke appears to have been unfailingly kind and thoughtful in his way, treating his staff with consideration as he pursued his unfathomable schemes.

Inside the house he could shut himself up entirely. He communicated with the outside by a system of letter boxes, two in each door, one for outgoing and the other for incoming messages. His were mostly addressed to his valet, who became his intermediary with the world. Boxes of clothes would be left outside the door, and plain, simple food brought in. John ate one chicken a day; half at noon, and half for his evening meal. Under these circumstances it is hardly surprising that stories sprang up; the duke was insane, suffering from a serious malady, hideously deformed, a bluebeard, a syphilitic, a monster. But he was none of these things, and no such simple explanation can account for his behavior. Certainly he was a hypochondriac, a recluse, and, given his vast wealth, at liberty to indulge his whims. One of his own favorite phrases, oft-repeated in his letters was, "Can anything be more absurd?" Absurd it certainly was: the wealthy aristocrat trundling down his broad tunnel, past the hissing gas lamps. But who knows what lonely melancholy brooded behind the thick curtains of his carriage, or why the duke felt such an overwhelming need to go underground.

When John died he had, of course, no offspring, and the dukedom passed to a young male relative, who thus became the sixth duke. He had little idea what to expect when he came into his inheritance. His sister Ottoline, later Lady Ottoline Morel, patroness of the Bloomsbury Group, was then a small child and described the scenes that met them when they arrived at Welbeck just before Christmas of 1879. Welbeck was a chaos of building work, and they reached the front door only with the aid of planks laid across the workmen's rubble. Apart from the small apartment in which the fifth duke had lived, all the rooms were bare and painted pink, and empty of all furnishings and fittings, except for a "convenience" plumbed into the corner of each, which was not hidden in any way. The furniture was found piled in one large vaulted hall, and the pictures were stacked in the riding school, uncatalogued and without their frames. The fifth

duke's apartment was filled with his collection of wigs, fine shirts, and handkerchiefs. Tapestries were found and unrolled, cabinets were stumbled across, and in one, Ottoline remembered her brother finding a secret drawer, in which were hidden snuff boxes, watches, miniatures, and a green silk purse containing two thousand pounds' worth of banknotes.

So it is surely just as well that the vase, safely ensconced in the British Museum, escaped the consequences of the fifth duke's neglect; it might otherwise have been buried for ever in a moldering pile of cabinets underground. Instead, shortly before the fifth duke died in solitude and seclusion, the fame of the vase received a further boost at the hands of an individual, also called John, whose origins lay at the very opposite end of the social scale from the vase's distinguished, eccentric owner.

★ ★ ★

JOHN NORTHWOOD WAS BORN in the 1830s, in a village on the road between Stourbridge and Wolverhampton. His father kept the village shop at the bottom of Glass House Hill; the area was aptly named because the English Midlands was a center of glass manufacture, established by Huguenot refugees who settled there in the seventeenth century. Northwood was one of seven children, but only he and two brothers reached adulthood. He grew up in the "hungry forties," a decade when, during the ruthless progress of the Industrial Revolution, famine and unemployment devastated the laboring classes, and, despite the fact that his father sold groceries, he knew what it was like to go short of food. He had no education, and he was put to work at the age of twelve in Richardson's Glass Works, where his natural talents began to manifest themselves; Northwood was not the kind of boy who would be left to sweep the floor. He learned painting, gilding, and enameling, and soon it became clear that he had a talent for drawing.

However able, Northwood was still at the bottom of the heap, and when the glassworks shut down temporarily, he was forced to go to work for his elder brother as a building laborer. He exchanged the delicate brushes and tools of his trade for the saw and chisel and learned woodworking. Perhaps he would have resigned himself to the life of a carpenter, a footsoldier in the army of Victorian artisans, but Richardson's Glass Works reopened, and Northwood returned to his first calling. Once again his talent showed itself. He learned to paint on glass, and worked so much more quickly than his older colleagues that he was forced to take a cut in his wages, so as not to cause resentment by earning more than the older and more experienced craftsmen.

At the age of twenty-four Northwood had thought out a new way to etch decoration into glass using hydrofluoric acid. Glass could be coated with a layer of wax, the design could be drawn onto the surface with a steel point, and the piece dipped in acid, which would then eat into the glass, following the marks of the design. If this sounds fairly straightforward, think for a moment how difficult it is to make a sharp point go where you want it to on the smooth, hard, curving surface of a piece of glassware. In Northwood's own understated words: "It is an art of its own, and takes some considerable time and practice before one becomes sufficiently skilled to be able to make a correct and satisfactory pattern."

At about this time, according to Northwood's son, who dutifully recorded his father's life story, Northwood overheard his employer, Mr. B.—or "Uncle Ben"—talking about the Portland Vase. Richardson had been thinking, as the proprietor of a glassworks might, about making a copy of the Portland Vase in glass. He had acquired one of the Wedgwood copies of the vase, and he brought it into the glassworks to show his craftsmen. "There is a thousand pounds," he announced, "for him who can produce that in glass." This challenge, as intended, fired Northwood's imagination. Was it just the

money? A young man with no education, little knowledge of the world, but an awareness of great ability, needs a goal. The Portland Vase became Northwood's.

True to the entrepreneurial spirit of the age, Northwood set up in business for himself, with the help of a member of the Richardson family, and with his brother to do the books. They built a little factory with etching rooms, workshop, and a plant for the difficult and dangerous business of manufacturing the acid. His son later described what it was like to work with the acid bath.

> In these days there were no fume extractors or ventilating fans and one had to have his acid-vat out in the open air, in bad weather under an open shed, and with no heating whatever the climate. The article could not be left in the bath of acid which was very strong, but had to be kept continually on the move. Our faces and hands used to suffer from the fumes. [A wooden handle was fixed to the bottom of each object in the bath.] We had to keep removing the scum formed on the glass where acid was acting to prevent it eating down in an uneven way. To do this we had sticks of wood with a pad of cotton wool tied on the end which we called a "mop." The operation was to stand over the vat and whilst moving the article in the acid with one hand, we rubbed the mop over the surface of the glass with the other. So you see we could not get very far away from the fumes. It was always an unpleasant job and no-one wanted it.

The enterprise was a success, and Northwood became what a contemporary might have described as a "warm man"—someone to watch. Northwood refined his process and devised new ones: he invented an etching machine, which used a template to mark out the design mechanically; and he developed a technique that involved using a weak compound of the acid to attacked only the top-most

surface of the glass, and could be used to create shading effects. The business flourished.

For the first time in his life, Northwood had leisure, and he used it to visit London and see for himself the work of craftsmen who had gone before. He wandered through South Kensington and Bloomsbury, where the Victorians, with their burgeoning wealth and acquisitive energy, were busy piling up the treasures of the ages. He filled sketchbooks with what he saw. He gazed for the first time on the vase itself, and he felt thoroughly depressed. How could he hope to emulate the dazzling achievement of the ancient masters?

The parallels between John Northwood and Josiah Wedgwood hardly need to be pointed out, but this is perhaps the most telling similarity: like Wedgwood, when Northwood saw the vase itself he was utterly crestfallen. Both men hoped to emulate the ancient masters, and both, once confronted by the masterworks themselves, by the appalling difficulty of the task, initially despaired. But they also both possessed near superhuman amounts of dedication, energy, and courage that enabled them to overcome their doubts and devote themselves to fine work on fragile objects.

The Elgin Marbles became the inspiration for Northwood's first conscious attempt to produce a masterpiece of glass carving. He embarked on the decoration of a large glass vase, which he called the "Elgin Vase," because it was to be decorated with figures copied from the Elgin Marbles. Granted, he had a successful business to run, and could work on the project only in his spare time, so it took him nine years—nine years of snatched moments that represented an awesome amount of concentration on one fragile piece. There were accidents: at one point he dropped his carving tool on the foot of the vase, and it was some time before he could bring himself to look down to see if he had broken the glass—he hadn't. Then, when he was carving the handle of the vase, the point of his tool broke off in the junction between the handle and the body, and after several days of struggling to get it

out, he was forced to remove it by carefully dissolving it with acid.

Northwood finished his Elgin Vase in 1873. According to no less an authority than the *Worcestershire Daily Gazette*, it was the most important work of its kind since the Roman era. But in a way it was a trial piece, a preparation for Northwood's attempt on the Portland Vase. The Elgin Vase was carved in clear, transparent glass; the Portland Vase, with its layers of blue and white, was yet another, altogether more difficult matter.

First the basic uncarved body of glass had to be produced. Philip Pargeter, Richardson's nephew, and a friend and colleague of Northwood, volunteered for this task, and also offered to finance the cash prize once promised by his uncle. "We had failures, as might have been expected, and I had to be very firm with the men," remarks Pargeter, showing the authentic Victorian attitude to labor relations. Northwood's son described the process Pargeter followed. First, a "cup-shaped article of opal white glass" was produced. "This cup, while in the hot state, is completely filled up solid with molten, transparent, coloured glass gathered on the end of a glass blowing iron." This was then rolled on an iron plate, called a "marver," in order to weld the two different glasses—the white and the blue—together. It was then reheated in the furnace, to keep it "in a soft and ductile state for the glass-blower to blow the solid mass into a hollow-shaped ball. The finisher or workman takes charge of it at this stage, and by his skilful manipulation, forms it into the shape and size of the article desired." It was then "annealed"—gradually cooled from its hot state—by being placed in an oven.

Having successfully produced a workable blank, Pargeter handed it over to Northwood so that he could begin his epic task. As a humble artisan Northwood wasn't at first allowed any special access to the vase—he could only peer at it as it sat in its display case in the British Museum. He noticed that the white glass that formed the outer layer of the vase only reached up to its shoulder; it did not

cover the neck. This meant that while the lower end of the handles rested on white glass, the upper end rested on blue. As a glassworker he speculated about the reasons for this. When the blue glass was dipped in white, was there not sufficient white glass to cover the whole piece? Or did the ancient craftsman deliberately leave the neck uncovered in order to lessen the strain created by the tiny differences in expansion of the two layers of glass?

Northwood knew from practical experience that expansion is the primary difficulty when producing a piece out of two different layers of glass—that when the glass is taken from the furnace it is at its highest expansion, and as it cools it contracts. Different layers will inevitably contract at different rates and degrees; a state of tension could be set up within the vase. This tension might not show itself at once. It could lurk invisibly, waiting for some trigger to release it.

Northwood's first step was, in a way, to cheat: he drew the design onto the outer, white layer, painted over it with a varnish made from bitumen, and dipped the piece in his acid bath, using his own process to give himself a flying start. The acid removed the white glass from around where the figures would be, letting large areas of blue show through, thus saving a great deal of work. But once this basic step had been taken, he had to begin carving.

This exceedingly practical experiment is perhaps the best opportunity we have of understanding how the original vase was carved. Northwood's equipment was homemade and simple in the extreme. His carving tool was a finely tempered steel rod, sharpened to a point, and held in a wooden surround, like a pencil. As he worked he dipped the point in paraffin, to cool it and give it bite. As time went on he developed a device that resembled a propelling pencil, with jaws on the wooden handle that allowed the rod to be fed through as the point wore away. He sharpened the point by rubbing it on an oilstone. As he worked, the glass rested on a pad made of moleskin filled with bran.

Northwood worked long hours, and he must have felt an enormous

amount of pressure. To say that he needed to concentrate is something of an understatement. He could not afford to make a single false step; once the glass was carved away, it could not be put back, so any glass removed in the wrong place would destroy the work. If he had been working on an original design, a mistake of this nature could perhaps have been incorporated into it, and no one would have been the wiser. But copying the vase removed even this recourse, and it made the task that much harder.

He had a small room built within the larger workshop, partitioned off to protect him from the noise and bustle, and he worked away steadily for several years. Despite the demands of his flourishing business, he put aside significant amounts of time for the project, demonstrating a passion for the vase that bordered on the obsessive. As he worked he constantly studied the vase, both the original and a Wedgwood copy. He had no access to photographic equipment, and he could not, like Wedgwood, take the vase back to his workshop and gloat over it. He had nothing but the skill of his own hand and eye, and he relied on his own sketches, made during repeated visits to the British Museum. Sometimes he would take his vase with him to London, so that he could compare his work in progress with the finished article. Edwin Grice, one of Northwood's craftsmen, made a special wooden box lined with velvet and set up so that the work in progress fitted perfectly into it. Even so, how nerve-racking such a trip must have been for Northwood—jolting over the rail line into Euston Station, threading through the busy streets of the capital with his precious burden. He made careful drawings of the different figures in the frieze, and when he returned to his workshop, he would set to work while the sight of the original was fresh in his mind. During daylight hours, he worked on the smaller, more detailed parts; when it grew dark, he would carve by the light of the largest, most powerful oil lamps, passing the rays of the lamp through a globe of water to focus the light.

Northwood had become something of a celebrity—his ambitious projects stimulating the public imagination like the record-breaking attempts of athletes or yachtsmen. The works yard would fill up with the carriages of visitors come to view the sport, and so Northwood had to contend not only with the difficulties and dangers of his work, but also with the gentry breathing down his neck and pestering him with questions. The press published bulletins on the progress of the work, and this would make it all the more humiliating when disaster struck; which it did, at the very last moment. After several years, the vase was nearly finished. Northwood decided to take it to London to compare it one last time with the original, to confirm that his copy was as perfect as he could make it. The museum had given him permission to take the Portland Vase itself out of its case in order to measure it and compare it with the nearly completed copy. According to one account, before he went, he decided to wash the vase in warm water, and this simple act triggered the disaster. But Edwin Grice told a different story:

> Before we started early for London we had a terrible mishap. The night had been very frosty, and when the vase was being lifted carefully into the box something went crack. We afterwards found that the holding of the vase in warm hands had caused uneven expansion, producing a fracture. It put a damper on our spirits, as you may guess. (*Stourbridge County Express*)

As Northwood had carved away at the white outer layer, the tensions within the vase, set up by the initial cooling process, had changed. Now the vase was more sensitive to a change in temperature—any change that would affect the existing tension. The crack ran right up the body of the vase.

It seems that the original makers of the vase displayed more technical expertise than their Victorian successors. Close examination of

the Portland Vase itself reveals that it has been ground on the inside. Tiny horizontal lines run around the inside of the vase, and these were almost certainly made during its manufacture, but for what purpose? Perhaps the grinding was undertaken to thin the walls of the vase and make the dark-blue glass more translucent, but no such effect has been achieved, indeed the blue glass is almost opaque; only if you bend down and look up so that your gaze passes through the shoulder of the vase and out of the mouth—in other words through only one wall of glass—can you detect any transparency at all. It is also fairly obvious that very little glass was removed by this grinding. An alternative explanation has been suggested by two modern glass experts, William Gudenrath and David Whitehouse. They hypothesize that the grinding was related to the tensions set up within the vase; if there was stress between the inner and outer layers of the vase, this would exhibit itself most powerfully on the inner surface. Gudenrath and Whitehouse went so far as to demonstrate this theory by blowing a glass vessel, and then, instead of cooling it gently in an annealing furnace, plunging it straight into cold water. This savage cooling set up tensions within the vessel. They still managed to grind the outside of the vessel without producing any ill effects, but when they only gently abraded the inside, the vessel shattered. Their conclusion was that the vase was subjected to the internal grinding process before work began on the carving, in an attempt to discover and alleviate any internal stresses. There is no evidence that Northwood knew of or followed this technique, and it may have led to his downfall.

Northwood's actions were phlegmatic. He stuck the pieces back together and carried on. Grice described how the vase was glued: "We strapped the vase round with rubber bands and other things, put it on the boiler side for a fortnight to keep it warm, and at the expiration of that time it took a very sharp eye to detect that it had been cracked at all."

The vase was "finished"; the evidence of the disaster covered over as well as could be; the commission fulfilled to the apparent satisfaction of all concerned, and the long promised thousand pounds was paid. If Northwood's copy had flaws, these, after all, only brought it closer in sympathy to the original, now webbed with cracks. Indeed, Northwood's vase was displayed to great acclaim, and it single-handedly inspired a sudden demand for cameo glass. Manufactories rushed to fulfill the desires of their customers for these costly novelties. For another fifty years, Northwood and his descendants and rivals catered to the demand that his copy of the Portland Vase had stimulated. Oddly enough, the trend disappeared as quickly as it had arisen, either because of the decline in the economic fortunes of the leisured classes or a change in taste, or perhaps both. In this respect, the late-Victorian craze for cameo glass may have mirrored the original burst of creativity under the Caesars, which seems to have been similarly short-lived.

In 1879, as the vase passed from the ownership of the fifth to the sixth duke, another scholar, W. Klein, connected the vase with a story about Theseus, involving a journey beneath the sea that he undertook to retrieve the ring of King Minos from Neptune. Klein proposed that the first side of the vase is actually an underwater scene. Figure A is Theseus, figure C is the sea goddess Amphitrite, and figure D is Neptune. The tree that grows between these two figures is perhaps a sturdy frond of seaweed, and Cupid is not flying, but swimming through the water, his torch burning magically without air.

Repaired and restored, its reputation enhanced to notoriety by its adventures, the vase lived out the nineteenth century as a famous highlight and fixture in the British Museum. No one could have guessed that it was about to set out on its travels again.

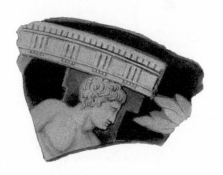

SIXTEENTH FRAGMENT

# CHRISTIE'S

IN 1929, NEARLY 120 YEARS after it had first been loaned to the
British Museum, the vase was put up for sale by the sixth Duke of
Portland, apparently without any consultation with its guardians at
the museum, though, of course, there was nothing they could do to
stop him. The director of the museum, Sir Frederic Kenyon (who
was the grandson of Edward Hawkins, the Keeper of Antiquities
responsible for prosecuting William Mulcahy), wrote a letter to the
trustees of the museum, alerting them "that announcements have
appeared in the press of the sale at Christies on May 2nd of the
Portland Vase." Kenyon was referring to a news item in the *London
Times* printed on March 7, which quoted from the catalogue for the
sale. "Messrs. Christie announce that they will sell at their rooms, 8,
King-street, St James's-square, on May 2nd, 'the world famous and
historic vase of antique glass' known as the Portland or Barberini
Vase."

The *Times* reminded its readers that the vase was "not a national possession, but merely on loan to the British Museum." The newspaper hinted that it had, unlike the trustees, some prior knowledge of the sale: "It was known some months ago that the sale of the Portland Vase was within the range of possibilities." It speculated excitedly about the sum that the vase might fetch: "The word 'priceless' is often carelessly applied to pictures and other objects of art. But we may well ask is this, one of the greatest and most beautiful specimens of ancient art, going to fetch under the hammer?" The *Times* refrained from making its own estimate. Instead, ever the champion of the haves over the have-nots, in an editorial the paper stoutly defended in editorial the duke's decision to sell what, after all, was his own property: "There will be sore hearts to-day among the lovers of the beautiful. . . . Even so, grief may justly be tempered with gratitude; for it is much that successive generations have been able to see and admire the vase." The thunderer went further; it was the common people's fault that the vase was to be sold, as the duke, "it can be safely assumed, has been driven to reclaim his possession only by pressure at the hands of the same public which has up to now enjoyed it as if it had been its own." In other words, if you tax the rich, you wretched selfish socialists, look what happens: precious objects vanish.

> Necessary as high taxation may be, the nation cannot expect to be able to impose it in increasing doses and indefinitely to enjoy favours from the victims. The disappearance of the vase from its familiar pedestal is bound to alarm the conscientious who keep their eyes open. There are pictures in public galleries of a tenure equally precarious; and outside the world of art there are many privileges of access and usufruct which the public is apt unthinkingly to regard as perpetual.

So hands off our aristocracy, or you'll regret it!

The reappearance of the vase in the news prompted Professor Frank S. Granger, of University College Nottingham, to write a long letter to Christie's three weeks after the initial announcement of the sale, containing yet another interpretation of the figures on the vase, the first to make it into print in the twentieth century.

Professor Granger, braving the displeasure of Henry Stuart-Jones, reasserted the connection with Alexander Severus, but with a Neoplatonic twist. In his interpretation, figure C is Mammea, the mother of Alexander Severus, and figure A is Alexander the Great. So here Alexander the Great assists at or inspires the birth of the emperor; this accords with the very first theory considered, which was put forward by Girolamo Teti way back in 1642. On the other side, figure F, the female figure reclining with upended torch, is Mammea again, and figure G, Professor Granger decided, is one of the Fates. The three Fates sat beside Pluto in the underworld; Clotho spun the thread of life from her spindle of raw wool, Lachesis twisted it to make it stronger or weaker, and Atropos sat ready with the shears to cut it off at the appointed time. Granger suggests that figure G is Clotho, and that the staff she holds is the spindle from which the threat of Mammea's life is wound. The frieze as a whole, therefore, serves to commemorate the life and death of Mammea.

Like some of his predecessors, Granger was either unable or unwilling to closely examine the vase. He suggests that the square block lying at Mammea's feet "may, perhaps, be a book." He is more certain about the figure on the base of the vase; this is "probably Orpheus on his mysterious errand, the descent into Hell. Him an imaginative reader might well identify with Christ" (who also went down to Hell after his crucifixion, to release the souls kept there since the fall).

Granger thus detects a theme—Birth on the first side, Death on

the second, and immortality on the base. Alexander Severus, he asserts, showed such tolerance to the early Christian Church that "it is possible to regard their joint rule. . . . as the first Christian Government known to the world." The emperor himself seems to have had leanings—Christian images were found in the imperial chapel. So to Granger the figures on the vase can be approached "in the light of early Christian art combined as it so often is with the use of classical symbols." After having dragged in an entire new iconography, however, Granger meekly retires: "These suggestions are made with no claim to certainty; but in the light of the whole circumstances of the Vase, they seem to me exceedingly probable."

At the beginning of April, a letter arrived from the duke's solicitors—Baileys, Shaw, and Gillett—asking the trustees to hand the vase over to Christie's "at 10.30am on Wednesday, 17th April." The duke wrote personally to Frederic Kenyon "to say how very deeply and sincerely I regret to be obliged to sell the 'Portland Vase' owing to the exigencies of the present times." The duke recorded the "pleasure and satisfaction" that the loan to the museum had given him. He offered "an expression of my gratitude to you and the Trustees for the care they have so long taken of my Family property." This statement seems to have been made without irony, despite the fact that when his ancestor had first lent the vase to the museum it had been in one piece, and now was in about two hundred, albeit glued together. The duke even repetitiously expressed "my regret to you, to the Trustees, and to the Public in general that I am obliged to come to this regrettable decision."

Kenyon's reply was equally formal and fulsome; he informed the duke that "the Trustees will appreciate highly your kind words with regard to them, and to the long period during which they have been custodians of this remarkable monument of ancient craftsmanship," and thus tacitly thanked the duke for overlooking the regrettable incident involving the Irish student and the lump of basalt. Kenyon

reassured the duke that the trustees "have never doubted that it is only with the greatest reluctance that you have decided to withdraw the Vase from the Museum, and to offer it for sale by public auction. Naturally they share your regret, but they recognise the decision is one they cannot question . . ."

This correspondence was published in the *Morning Post*, on April 10, under a extensive and eye-catching headline:

PORTLAND VASE SALE
DUKE OF PORTLAND'S DEEP REGRET
LETTER TO MUSEUM DIRECTOR
SIR F. KENYON AND AUCTION ROOM
COMPETITION.

The last two lines of this refer to a muted cry for help which Kenyon made, in the knowledge that the correspondence would be published; "If means could be found for preserving this famous work of Art for the Museum, I need hardly say that the Trustees would gratefully welcome it; but they have no available resources at their own disposal to meet the competition of the auction-room." But no rich benefactor stepped forward with an open checkbook, and the fateful day arrived when the vase had to leave the museum.

In all the vase's wanderings, the trip it made from the British Museum in Bloomsbury to Christie's auction house on King Street—a journey that one can make on foot in twenty minutes—must be one of the shortest it ever took; but it is by far the most well documented. Two London papers, the *Morning Post* and the *Evening News*, both devoted extensive column space to the event. They seemed unconcerned with the weak gestures of the League of Nations, or the parlous state of the German economy, but they were utterly fascinated by the local movement of the vase.

The *Morning Post* was the more upmarket of the two newspapers,

and its correspondent was allowed into the museum, and actually accompanied Christie's courier, "Mr T Rogers, of Mason's Yard, who for upwards of forty years has been employed by Messrs. Christie for the packing and transport of priceless works of art." The *Morning Post* saw Rogers's specially prepared packing case, which was taken to Kenyon's office, where the vase was now waiting. The vase was already packed inside a smaller case "which had been especially constructed for the safety of the Vase during the war." This case was opened for Rogers's examination, and then the smaller case was carefully lowered into the larger. While this was going on, the secretary of the museum and the Keeper of Antiquities chatted confidentially to the *Post* reporter, voicing their regret at its loss, and "the slight hope that it may be purchased by some patriotic Englishman, who will lend it once more to the nation."

The correspondent of the *Evening News*, an organ a closer to the gutter, was not offered the opportunity to hobnob with the highups; he was kept out on the street, with the crowd. But as befitted his station by the curb, his style was rather punchier. A melodramatic headline set the tone:

PORTLAND VASE IN A PLAIN VAN
Hush Hush Departure from the British Museum
MYSTERY

The *Evening News* staked out the museum and quizzed the warders, who "flatly stated that it had been removed shortly before 10 o'clock. But this statement lacked conviction, since I had been watching the courtyard of the British Museum since half past nine. I had not seen anything like a packing case carried out." Eventually, having penetrated as far as the entrance to the Gold Room, which was now roped off from the general public, the watchful eye of the *Evening News* was rewarded:

Suddenly there was a quick patter of feet, and round the corner from the private offices of the Graeco-Roman antiquity department, a man came hurrying, swinging in his hand what looked like a big leather-covered box with a strap handle. He scurried across the room in which the crowd had gathered; a panel slid aside in the further corner of the room; he vanished through the opening; the panel slammed after him and that was that.

The *Evening News* reporter then renewed his vigil in the courtyard, which was eventually rewarded with a glimpse of the vase, now repacked in Mr. Rogers's wooden case, "with a light padlock," being carried down the steps to a waiting van. "We all held our breath, while two men lifted it into the back of a plain green van, and settled it comfortably in the corner. One of the old men in charge"—presumably Mr. Rogers himself—"seated himself—yes he actually seated himself—on the box containing the Portland Vase, lit a pipe, and was driven away. . . ."

The indefatigable reporter flagged down a taxi—"Follow that vase!"—and gave chase as the van drove down Great Russell Street and then onto Shaftesbury Avenue. He confessed himself thrilled at the thought of the priceless object weaving its way through the Wednesday morning traffic "with all the crowds of ordinary Londoners going unconsciously about their business all round it. The aged retainer sat on his box and smoked imperturbably the whole way." But then no one seemed to be quite as excited by the proceedings as the newshound himself. The vase reached Christie's, unmolested by armed gangs or car wreck, and was conveyed down into the strong room, where it awaited the day of the sale.

The auction took place on May 2, and drew one of the biggest crowds ever seen at Christie's. Armed with their lunchboxes, members of the public queued for hours. Photographers swarmed through

the throng. The bidding was started at ten thousand pounds, and went up by the thousands. Two or three bidders ran the total up to nearly thirty thousand pounds. But this was apparently well below the reserve placed on it by the duke. The *Morning Post* had not sullied its pages with vulgar speculation about how much the vase might fetch, but the *Evening News* had not been so restrained. "Anything between £50,000 and £100,000" was their guess, and the lower figure may not have been so wide of the mark, at least as far as the duke was concerned. Thirty thousand pounds was certainly not enough for him; the bidding had not reached the reserve price that he had set. The auctioneer "bought in" the vase by making a bid himself. The whole anticlimactic process took only a couple of minutes, and some in the crowd were not aware of what had happened. A female voice cried, "The British public demands to know who has bought it!" But no one had bought it; the auctioneer's bid remained, and no one was prepared to go any higher.

The duke, not prepared to sell the vase for as little as thirty thousand pounds, took it back into his own keeping, where it remained for the next three years. If during this time he intended or actually attempted to find a buyer prepared to pay a price he considered worthy, he met with no success. The "exigencies" that had prompted him to try to sell the vase were not so pressing that he was prepared to settle for less, and, by 1932, it seems they were no longer threatening to the ducal finances. The duke wrote to the trustees of the museum, offering to renew the loan, on condition that he could take it off and sell it whenever he chose. They, having paused to consider whether they needed to renew their stock of postcards of the vase, then out of print, gratefully accepted. In April 1932, almost three years to the day since the vase had left the museum, it was handed back to the Keeper of Greek and Roman Antiquities, and placed on view in the same position in which it had stood before the auction. Perhaps this was a homecoming, and perhaps the vase itself might have hoped that a

peaceful existence now lay before it, but if so, its hopes would soon be dashed. Only a few years later, when the vase was in the process of acquiring a new owner, bombshells—the real high-explosive kind rather than the metaphorical—were raining down on the British Museum, and the vase was once again to be smashed into hundreds of pieces.

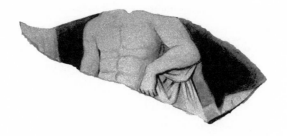

# RESTORATION

IN SEPTEMBER 1940, at the beginning of the Blitz, two bombs fell on the British Museum. They fell in almost exactly the same spot, the second coming through the hole made by the first, but fate seemed to be looking after the museum; both bombs failed to explode. In October, an incendiary landed on the roof of the Round Reading Room, in the center of the building, but the interior did not catch, and the blaze was extinguished. Then one night in May, at the height of the bombing, the museum's luck ran out. Seven hundred tons of bombs were dropped on central London in the course of the night of the May 10, and thousands of fires started. The museum was hit by a stick of incendiaries, some of them penetrated to the attic space between the copper roof and the plaster ceilings, and this time the fire took hold, doing immense damage before it was brought under control by firefighters. A whole range of galleries on the southwest side of the building were lost. The museum building then

housed collections belonging to the British Library, and 150,000 books were destroyed, some by flames, some by water. Researchers in the British Library today may still be informed that the book they have found in the catalogue is unavailable, having been "destroyed by enemy action."

The first-floor gallery, which houses the Greek and Roman collection, was left a blackened shell, open to the sky. Its floor was sealed to protect the galleries below, and after a while, rainwater produced a large internal lake, across which stepping-stones were laid to allow the staff to traverse what was left of the gallery.

Fortunately, the vase escaped the inferno. It had been removed before the outbreak of hostilities, along with the rest of the treasures of the museum, to safekeeping outside the capital. But unlike its crated companions in exile, its fate was still uncertain. In 1943, the sixth Duke of Portland died, and a year later, the seventh duke let it be known that he was also of a mind to sell the vase. The trustees decided that they might dare to inquire about the price. For some time nothing was done; the fight for national survival was something of a distraction, and the Keeper of Antiquities himself, Bernard Ashmole, was on war service. But Ashmole's stand-in, Allen, made a strong case for purchase in a report to the trustees, based firmly on the fame of the vase:

> The general public cannot imagine the British Museum without the Portland Vase. During its long sojourn in the Museum it has acquired a celebrity—or notoriety—which has added considerably to its market value as a unique work of art. The ordinary tax payer will not grudge the purchase of an object which he has always considered one of the national treasures, and which has always had a fascination for him.

In 1944 the seventh duke revealed that he would part with the vase for as little as five thousand pounds. Compared to the sums bandied

around at the Christie's sale, this was surely a bargain. The museum made an offer, having found the money in a timely bequest, but another year went by and the war in Europe was dragging to its close before the duke replied to accept. On the day before Armistice Day, a formal receipt was issued to the duke, and the vase had changed hands for the last time.

Now the vase was finally the property of the museum, or at least so it was assumed, but an unusual donation revealed that not all of it was in safekeeping. Unknown to those responsible for it, part of the vase had been missing for a hundred years. In 1948, Bernard Ashmole, Keeper of Antiquities, now safely returned from the war, received a box containing thirty-seven tiny chips of glass. They had been brought in by a Mr. Crocker of Putney, who didn't know what they were but thought the museum might be able to identify them. The museum could; they were splinters from the Portland Vase. What the museum couldn't at first understand was what on earth they were doing in the possession of Mr. Crocker, but gradually the story was untangled.

The glass splinters were Doubleday's leavings; pieces he had been unable to find a place for in his reconstruction of 1845. When Doubleday died, a colleague had taken these fragments to G. H. Gabb, a box maker, so that a suitable container could be constructed with little compartments to hold the splinters. This colleague then also died, and it seems that the commission died with him. Gabb duly made the box, in which he placed the splinters, but simply forgot to return it. Decades passed, Gabb himself died, and his executrix, Miss Reeves, found the box among his effects. She passed it on to Crocker; he took it into the museum.

To Ashmole, the fragments represented an opportunity: Why not restore the vase again? Doubleday's work was a hundred years old, and the glue he had used was decaying and discolored and had become unsightly. The cracks were literally showing. Techniques had

improved over the last century, and now the museum's restorers could make a better job of it. Ashmole also admitted to curiosity; he wanted to know whether the base of the vase really belonged to it or not, and restoration would give him a chance to find out. In November 1948, one of the museum's restorers, J. H. W. Axtell, was given the task. But first, of course, he had to take it to pieces. Doubleday's glue was removed, and once again the vase was reduced to fragments, laid out in an intimidating jigsaw. The event was witnessed by Ashmole and assembled experts, who were invited to handle the pieces. One of them recorded his excitement at this historic experience:

> This seemed an occasion unlikely to recur, like the seeing of the King's College windows at inches distant on the ground. As some of the fragments passed, amid guarded silences, through my fingers, there came into my head the title of the Ambrose Bierce collection Can Such Things Be?

The freshly restored vase was back on show by spring of the following year, and all agreed it looked much improved. Ashmole established to his own satisfaction that the base disk did not belong to the vase originally, but was a later addition, though how much later was not certain. But the splinters themselves proved a disappointment. In the restoration, Axtell had found a place for only three of them, and the rest continued their exile, languishing in the box made by Mr. Gabb.

★ ★ ★

ALTHOUGH THE VASE MAY NOW have been restored and secured, controversy surrounding the interpretation of its figures did not abate. New theories sprang up like dragon's teeth, thick and fast and somewhat fantastical. Study of the vase involved an ever more dizzy-

ing whistle-stop tour through the major events of Greek mythology. In 1964, D. E. L. Haynes restated the Peleus and Thetis argument, but perversely insisted that figure C was not Thetis, but her mother, or even her grandmother. In 1965, H. Mobius joined the Theseus-at-the-bottom-of-the-sea clique, with the added insight that figure F was Ariadne, lying disconsolately on the Isle of Naxos.

Ariadne, daughter of Minos, had slipped Theseus the ball of thread by which he made his way through the Labyrinth, and thus helped him defeat her father's monster, the Minotaur, but she was then abandoned by the ungrateful hero on Naxos. In 1966, F. L. Bastet came out in support of this, but he insisted that the whole frieze referred to the story of Theseus and Ariadne, and that figure C was Ariadne as well. In 1967, Bernard Ashmole himself weighed in with a theory, and its combination of detailed study, impressive learning, and slight eccentricity makes it well worth examining in greater detail.

Ashmole brought to the task not only the fruit of a lifetime's study of antiquities, but also the ample time during his tenure as Keeper of Antiquities to examine the vase. He had even been present during its restoration, and had handled the separate pieces. This certainly put him one step ahead of those who were not even able to correctly identify the gender of some of the figures.

He began his account by making an important point; that the Romans were in the habit of using subjects of Greek mythology to convey more than one meaning; the scenes from Greek mythology that decorate the sides of many Roman sarcophagi—including the one in which the vase itself was supposed to have been found—were not there by chance, they were present because the Romans considered the stories these scenes illustrated to be allegories of the afterlife. Sometimes portraits of those for whom the sarcophagi were intended were superimposed on the bodies of the gods and heroes. Ashmole thus maintained that meaning intended to be conveyed by

the figures on the vase might be highly esoteric. Knowledge needed to decode this meaning might have belonged to the "initiated," and as this knowledge was lost, any interpretation of the vase might now be impossible. This was a brave attempt to swim against the current; one thing Ashmole's predecessors had in common was a belief that the vase could be decoded—by them. But of course Ashmole then immediately made his own attempt to provide an interpretation.

Ashmole started with side I, heartily agreeing that it represented the Peleus and Thetis myth. To him, the identification of figure C as sea nymph Thetis with her sea serpent; of figure A reaching out to her but looking anxiously over her head at figure D; and Figure D himself, brooding over the union being effected in front of him, perfectly fitted the story. Neptune's desire for Thetis gave way to the dangerous prophecy, and he grudgingly gave permission for the marriage of lovely Thetis to the mortal Peleus. Ashmole strengthened this interpretation by reassessing the masks below the handles. According to many previous scholars, these are of Pan, thus identified because of his goat horns. But close examination of the masks reveals that these horns are an illusion; they are simply strips of uncarved white glass running round the join between the handle and the vase. The masks do not have horns, and they do have fleshy, fishlike lips. They are, maintained Ashmole, the face of the god Oceanus, grandfather of Thetis. Oceanus was the fount of life; on his stream, so the Romans believed, the souls of the dead were carried to the next life, and his face is commonly seen on Roman sarcophagi. Ashmole's interpretation of side I of the vase, combining the strongest elements of previous interpretations together with fresh insights, is highly convincing—perhaps the most convincing of all those yet proffered. The story fits the picture; the relationship of the figures, the action, and their attributes are all accounted for.

However, Ashmole's stab at the second side of the vase is significantly less well supported. In interpreting this side, Ashmole focuses on the reclining female figure, and specifically on her breasts. He admires these enthusiastically, but his admiration does not stem merely from personal predilection. These magnificent assets are a giveaway, an identifying feature that can belong to none other than Helen of Troy, the Marilyn Monroe of Greek mythology. Ashmole quotes chapter and verse on Helen's breasts from the highest authorities. When Troy fell, and Helen's husband, Menelaus, discovered his runaway wife, he gave chase in a vengeful fury. According to the myth, Aphrodite intervened to save her by merely arranging for her disordered dress to reveal her breasts as she fled. A character in Aristophanes' play *Lysistrata* mentions the incident: "Menelaus, when he somehow saw the breasts of Helen naked, threw away the sword I think." The mere sight of her charms was enough to utterly and abruptly quench ten years of bloody, brooding anger. This central figure then, is Helen, and the figure on her left, figure E, is Achilles, with whom, according to one version of the myth, Helen ended up in the Isles of the Blessed, feasting and drinking in the afterlife. Achilles, greatest of all Greek heroes, was the offspring of Peleus and Thetis, and his union after death with Helen brings the whole history of the Trojan War to a close. The two sides of the vase are thus related; they show the beginning and end of the entire saga of the Trojan War. Figure G, Ashmole maintains, is the goddess Venus, who presided over so many events in that story. The identification of Achilles is, to Ashmole, confirmed by the pillar beside him; this is his grave stele, or marker. Ashmole's theory is interesting, but it fails to deal with the torch that figure F is holding. This torch may symbolize death, but it hardly accords with the blissful afterlife implied by the myth. Nor, logically, should Achilles be sitting by his grave, if he has been magically transported elsewhere to enjoy the company of the beautiful Helen.

Over the next twenty years, nine more theories were published. Writers began to find it increasingly necessary to deal with their predecessor's theories first—positioning themselves in the continuing debate—before going on to make their own diagnosis, which was often just a recombination or reconfiguration of two or more previous attempts. Many agreed that figure C was Thetis, although one theorist introduced yet another set of mythical characters by deciding that figure C was actually Andromeda.

Andromeda was presented as a sacrifice by her parents to the sea monster then ravaging their kingdom, and was rescued by Perseus, who happened to notice her plight—chained to a rock, the monster greedily approaching—as he flew home from slaying the Gorgon, wearing the winged sandals that had been lent to him by the god Mercury. According to this theory, figure A is Perseus (despite any sign of sandals or Gorgon's head), and the sea monster is rearing its ugly though rather diminutive head between Andromeda's legs. Interpretations of side II varied still more widely. At the end of the 1970s, John Hind, happy to accept the Peleus-and-Thetis theory for side I, came up with another entirely new and perfectly plausible explanation for side II. Hind remarked that in order to be considered valid, any interpretation ought to account for all the obvious attributes of all the figures. This is a very sensible point, and Hind does his best to adhere to it by referring to the story of Aeneas and Dido.

Fleeing Troy after its destruction at the end of the Trojan War, Aeneas arrived in Carthage, a city still rising at the behest of its beautiful and widowed queen, Dido. Dido fell in love with the Trojan prince, and, according to a famous passage in Virgil's *Aeneid*, they consummated their love in a cave in the forest, having been forced to take shelter from a storm while out hunting. Unfortunately, Aeneas's fate lay elsewhere; his destiny was the foundation of Rome, and he was forced to leave Dido, who committed suicide in despair, throwing herself on her own funeral pyre. Hind detects something restless in

the seated pose of figure E; he argues that the bent leg and slight angle of the torso suggest that this figure is on the point of rising— that is, going away and thus deserting figure F. Figure E is Aeneas, and figure F, then, is Dido, reclining in despair, the torch that symbolizes both her burning love and her self-lit funeral pyre hanging from her fingers. Above them arch the trees of the forest, and below them the rocks, together representing the forest grotto where the lovers lay together. Figure G is the goddess Venus, who presided over the fate of Aeneas, and who sternly bade him leave the fleshpots of Carthage in order to fulfill his destiny. Hind therefore concludes that the theme is war; while on side I the marriage of Peleus and Thetis sets in motion the events that will lead to the Trojan War, side II commemorates the symbolic beginning of the Carthaginian Wars, during which the youthful Roman republic and the sea power Carthage fought to the death for control of the Mediterranean.

After Hind, during the 1980s at least four more theories were published, involving in various combinations of nearly every character from Greek and Roman myth: Theseus, Apollo, Perseus, Achilles, Augustus, Romulus, Atia, Andromeda, Thetis, Iphigenia, Julia, and so on. Meanwhile, as the decade drew to a close, the controversy continued unabated, and the scholars dissected one another's hypotheses, the vase itself was once again pulled apart.

<p style="text-align:center">★ ★ ★</p>

IN 1985, A NEW ROMAN GALLERY was being prepared at the British Museum, and in this the Portland Vase was, of course, to be the lead attraction. Prior to the opening of this new gallery the vase was inspected by the museum's conservators, and found to be in poor shape. Either the Department of Conservation had grown harder to please, or the work of the 1940s was not holding up as well as Doubleday's earlier effort. Less than forty years after J. H. W. Axtell had made his restoration, the adhesive he had used was yellowing and

brittle, and the filling shrunk and disfigured. The conservators put the vase under the microscope. This revealed that Axtell had added a blue pigment to his adhesive, in order to hide the joins, but the pigment had a weakening effect. In some places the adhesive was starting to fall out. A less technical experiment was also undertaken to determine the vase's condition: tapping the vase—gently—with a fingernail did not produce the ringing sound associated with a happily cohering vessel. Nigel Williams, head of the Ceramics and Glass Section of the Department of Conservation, officially declared the vase to be in unstable condition, and proposed a third restoration. The vase was booked to take a leading role in a temporary exhibition entitled "Glass of the Caesars." After this, it would be starring in the new Roman Gallery, but between those two gigs it might take a sabbatical for a few months, while the work was carried out.

Williams's first task was to investigate the techniques of his predecessors. He found little on Doubleday, but after nearly a century and a half this was no surprise. He was more taken aback by a complete lack of documentation of the restoration work of Axtell, who had still been employed by the museum when Williams joined the staff in 1961. Williams wanted to know what kind of adhesive Axtell had used, because he was going to have to remove it in order to reduce the vase to its constituent parts before building it up again. Unable to find any written records, Williams was reduced to canvassing his colleagues for their recollections; the results were conflicting: epoxy resin, shellac, animal glue, or a mixture of these were all confidently put forward by different individuals.

To begin the process of dissolution, the vase was wrapped in blotting paper overlaid with dental plaster, inside and out, further reinforced by flexible plastic clamps. Thus mummified, the vase was placed in a bowl of water. Solvents were added, and after three days, one of the handles was gingerly prodded. It moved. The vase was taken out of its softening bath, and gradually the plaster-lined paper

was peeled off, starting at the rim. As the paper was pulled away, the fragments could be picked off one by one. After a day's painstaking disassembly, during which each piece was numbered and its position on the vase recorded, the vase was in pieces—189 fragments. Each one was put under the microscope so that the remains of the adhesive (which turned out to be an early epoxy resin) could be scraped off with a surgical scalpel, and then washed in warm water. The vase clearly needed a wash; it was very dirty, and the pieces came out of their bath markedly improved in appearance. The washing process allowed the conservators to begin to familiarize themselves with the individual pieces, and plan how they would be put together again

The fragments were all laid out, reproducing Doubleday's watercolor jigsaw, and Williams and his team now confronted the most daunting aspect of their task. Williams confessed that he well knew "how terrifying it can be to have one of the world's most famous object in pieces, and how doubts begin to creep in as to whether it will ever fit together again." To make matters worse, a camera crew stood at his shoulder, recording every move for a BBC television documentary. Williams not only had to suffer this extra scrutiny, but also felt under pressure to complete his work in order to fit in with the documentary maker's deadline.

As expected, sticking the vase back together certainly proved more difficult than pulling it apart. The most long-lasting, powerful, and up-to-date epoxy glue had been chosen, but it took days to dry, and as it did so, fragments of the vase would slide out of place. Those undertaking the restoration devised a complicated process whereby they used a secondary, faster-acting glue—a sort of "superglue" that dried in seconds when subjected to ultraviolet light—on one small section of one of the surfaces being stuck together. This would hold the pieces together in that section until the stronger glue took effect. So the technique was perfected, and the process of reconstruction could begin.

The placement of each piece had to be planned carefully; there is a risk when fitting together fragments of any object that if the pieces are stuck together in the wrong order, subsequent pieces will not be left room to fit in snugly. In order to avoid this problem—called a "trap out" in the restoring business—construction of a fragmented vessel like the vase is usually begun from a large piece, or a base piece, to which other pieces can then be added. Two areas of the vase were made up of fragments with obvious, close-fitting joins, which could be easily built into large sections. These sections provided a foundation, and gradually the vase began to grow round them. The most problematic areas were the neck and shoulder of the vase, which had taken the force of Mulcahy's blow and were the most badly shattered. At first, no satisfactory alignment could be found for the myriad tiny slivers in this portion/area. The upper part of the vase was assembled, taken apart, and reassembled as various configurations were tried and rejected for several frustrating weeks until finally a solution was found, and the last piece fitted into the rim of the vase. The vase was now left for three weeks to allow the adhesive to harden and set.

There were still small holes in the vase, places where the original glass was entirely missing, and these needed to be filled. The first step was to create a backing to these holes; strips of wax were laid across the inside of the vase, and then a colored resin was brushed into the holes, and slowly built up to just above the surface of the vase: the excess was then wiped away. Once hardened, this resin was polished and shaped until it closely resembled the glass around it, without being completely undetectable, so that the attentive visitor can still see what is original, and what has been added. The entire process took nine months, then Vase went back on show, taking center stage in the new galleries.

While the restorers refurbished the vase itself, scholars who concerned themselves with its dating and provenance were similarly

enhancing its reputation. Gradually during this time, the emphasis shifted; as academics studied the political iconography of the Augustan period, they began to realize that the figures on the vase might not simply depict a well-worn story from mythology, but might rather have a much closer relationship with whoever commissioned it. Over the last few decades of the twentieth century, an entirely new theory began to emerge, one that gives the vase a place of the highest honor in the Roman world, associating it directly with the Emperor Augustus himself.

# THE EMPEROR AUGUSTUS

GERMAN ACADEMIC Erica Simon studied the vase in the 1950s, and she came up with an entirely new theory, supported by Roman historian Suetonius, in his work *The Twelve Caesars*, which contained his account of the life of the Emperor Augustus. At the end of this account Suetonius discusses, in his wonderfully gossipy style, portents and omens that were said to have accompanied the birth of the future emperor, including one he found in a book: "called Theologumena, by Asclepias of Mendes." It is, in essence, the story of a divine rape:

> Augustus's mother, Atia, with certain married women friends, once attended a solemn midnight service at the temple of Apollo, where she had her litter set down, and presently fell asleep as the others also did. Suddenly a serpent glided up, entered her, and then glided away again. On awakening, she

purified herself, as if after intimacy with her husband. An irre-
movable coloured mark in the shape of a serpent, which then
appeared on her body, made her ashamed to visit the public
baths any more; and the birth of Augustus nine months later
suggested a divine paternity.

This story provided Simon with the key to her fresh interpreta-
tion. She decided that both sides of the vase refer to this myth: fig-
ure A is Apollo; figure C is Atia, with Apollo in the form of a serpent
popping up between her legs, before or after the act of impregnation;
figure D is Chronos, prophet of the good times to come under the
rule of Augustus, the result of this union. On the second side, figure
E is Apollo again; figure F is Atia again—falling asleep at the temple,
perhaps—and figure G is Venus, presiding over their fruitful
encounter. Simon referred to several images of a sleeping woman
with her arm raised to her head, being approached by a snake, which
are found in artworks created during Augustus's reign, associated
with his birth, and considered to be works of propaganda for his
cause. The masks beneath the handles represent Capricorn, the con-
stellation under which Augustus was born, as Suetonius mentions
again, in another story concerning portents of Augustus's greatness.
The historian tells how Augustus reluctantly accompanied his friend
Agrippa to visit an astrologer called Theogenes. Agrippa got such a
glowing prophecy that Augustus hung back, not willing to submit
himself to something he assumed would be rather less exciting:

> Yet when, at last, after a deal of hesitation, he grudgingly sup-
> plied the information for which both were pressing him,
> Theogenes rose and flung himself at his feet; and this gave
> Augustus so implicit a faith in the destiny awaiting him that he
> even ventured to publish his horoscope, and struck a silver coin
> stamped with Capricorn, the sign under which he had been born.

Simon's theory was also prompted by the efforts of modern scholars to date the vase; their findings, as we will see, put the likely date of the vase's construction during the reign of Augustus, and Simon's overall conclusion is that the vase was a piece of propaganda in Augustus's campaign to legitimize the power he had seized during the last, bloody struggles of the civil war.

Augustus was first of the Roman emperors. His given name was Octavius—"Augustus" was a title conferred later. Octavius was born into the merchant class, but as his mother was a niece of Julius Caesar, the seventeen-year-old Octavius was given a post on Caesar's staff, who was then campaigning in Spain. Julius Caesar liked and admired his nephew, and made him his heir. When Julius Caesar was murdered, young Octavius capitalized on the political opportunity. He established himself up as an equal to Mark Anthony, who was Caesar's right-hand man and political successor. Together they hunted down and killed Julius's assassins and other enemies of the Julian faction; after decades of civil war, there were many. A reign of terror was instituted, the "proscriptions," during which lists of thousands of political opponents were compiled, for summary execution. Still only nineteen years old, Octavius seized control of several Roman legions and marched on Rome itself. Then Octavius and Mark Anthony agreed to divide the Roman world between them. But a rivalry between the two had already begun, and with it a propaganda war. Even the marriage of Mark Anthony to Octavius's sister could not prevent the inevitable clash, and when Mark Anthony abandoned his wife for the charms of Cleopatra, Octavius was provided with his pretext for war. The two opposing forces fought a decisive sea battle at Actium, and Mark Anthony was defeated by Octavius's lieutenant Agrippa. (Octavius, no general himself, had a habit of falling sick before battles). At the age of thirty-three, Octavius had made himself absolute ruler of the known world, and the senate hailed him as Caesar Augustus.

Augustus was faced with a problem: His uncle Julius had been assassinated because he had too openly flirted with the role of absolute monarch. Therefore, Augustus needed to sell himself as a man who respected the republican virtues and tradition. In the senate he pretended to give up his power. "I am mild by nature," he told the senate, "and have no wish to dominate. Allow me to live out my life in peace."

Officially Augustus resigned from almost all offices; he wanted to create an illusion of a return to constitutional government. He would be just a humble administrator, albeit a rather successful one. He initiated building projects on a massive scale. According to the Roman historian Strabo, "the Romans and their allies have never enjoyed such peace and prosperity as that provided by Caesar Augustus." He presented himself as simply the hardworking, pious, modest, clean-living servant of the people, and at best merely the "first among equals."

To keep up the façade, Augustus initiated a propaganda campaign, orchestrated by Augustus's friend Maecenas. Maecenas had at his command a significant sample of the greatest writers in Roman literature—the poets Horace, Virgil, and Propertius. All eagerly embraced the myth of Augustus, either out of political necessity or because they genuinely welcomed it after so much bloodshed. Horace wrote effusive odes in praise of Augustus and Agrippa. Virgil prophesied a "golden age," presided over by the benign and godlike Augustus, and penned an epic in which his protagonist, the Trojan prince Aeneas, fled the ruins of Troy to found the city of Rome. (The poet Ovid, who did not toe the line quite so assiduously, found himself banished to the Black Sea—the ends of the earth as far as he was concerned—and he spent the rest of his life writing abject letters to the emperor begging to be allowed to return home.)

Augustus carefully cultivated the image of a simple man; he lived frugally, sleeping in the same simply furnished room, wearing fine

clothes only on state occasions, eating plain food, and even advocating plain speech. He championed a return to the "traditional values" of the republic; morality laws were passed, and louche behavior punished by the state. An actor called Pylades was made an example; when a member of the audience hissed at his performance, Pylades responded with "an obscene movement of his middle finger"; for this he was banished from Italy. But this was all a show; Augustus was careful to accumulate and keep all real power, in particular the command of the legions, and he controlled the vast financial resources of the empire. As for the pious chastity of the republic, Augustus was sexually voracious, with a predilection for deflowering virgins. He was a serial adulterer who defended his actions to his friends by explaining that he slept with the wives and daughters of his enemies in order to discover their plans. His daughter Julia ran out of control in wild promiscuity, laying the basis for the subsequent reputation of the Roman orgy, and even, according to Suetonius, living out a courtesan fantasy by selling her body to the highest bidder. (There is yet another theory concerning the figures on the vase that identifies Julia as figure F, reclining in disgrace on the island to which she was banished.)

In his youth, before he decided that in order to wield power he must dispense with its trappings, Augustus had felt the urge to collect. He liked curiosities of all sorts. He amassed a collection of ancient weapons and skeletons, and had a particular weakness for vases. During the proscriptions, graffiti appeared on the base of his statue, referring to this, along with his father's mercantile background:

*I do not take my father's line;*
*His trade was silver coin, but mine*
*Corinthian vases.*

There was a rumor that he added to the list of those to be killed names of the men who owned vases that he coveted so he could subsequently confiscate them for his collection. After he defeated Mark Anthony and marched into Alexandria, ransacking Queen Cleopatra's palace, he kept nothing for himself—the policy of public self-denial was already in operation—except for a "murrhine," or glass vase.

★ ★ ★

THE THEORY THAT THE FIGURES relate directly to Augustus's myth is underpinned by the dating of the vase and its attribution; recent research has revealed not only a possible date for the creation of the vase, but even a tentative identification of the craftsman who carved it.

In an article written at the end of the 1980s, Kenneth Painter and David Whitehouse elaborated on Simon's interpretation of the figures on the vase. Figure C was certainly Atia, the mother of Augustus, and figure D was Neptune, the god of the sea, by whose favor the battle of Actium was won and Augustus's rule begun. The date of the battle was also, by pure coincidence, the date of Augustus's birthday, and thus the most significant in his myth. According to Whitehouse and Painter, side II showed the birth of Paris. In the myth, Paris's mother, Hecuba, Queen of Troy, dreamed that she gave birth to a burning torch that set fire to the whole city, a portent of the havoc her son would cause. This was why the child was exposed to die on a hillside, but was rescued by shepherds, with whom he lived, and among whom Jupiter spotted him when he was looking around for some unsuspecting mortal to decide which of the three goddesses—Juno, Minerva, or Venus—was the fairest.

So figure F is Hecuba, E is Paris himself, and G is Venus, to whom Paris gave the prize, and who rewarded him with mortal Helen, thus precipitating the Trojan War, and neatly fulfilling the prophecy. The rocks upon which Hecuba lies, as she clutches the ill-omened torch of

her dream, represent the ruins of Troy, as does the fallen capital at her feet. So the two sides of the vase show the ruin of Troy and the birth of a new, Augustan Rome. Figure A, claim Whitehouse and Painter, seeing a resemblance between this and other depictions of the emperor, is none other than Augustus himself.

Whitehouse and Painter draw attention to another resemblance between the workmanship on the vase and that of an engraved gem in the collection of the Duke of Devonshire. This gemstone, a carnelian less than two centimeters high, is carved with the figure of the Greek warrior Diomedes. The face, hair, musculature, and pose of this figure are all strikingly similar to those of figure A on the vase, so much so that the assumption could be made that they were both carved by the same hand. The obvious conclusion is that the gem and the vase were both the work of a single craftsman. But unlike the vase, the gem is signed, in Greek letters, with the name Dioskourides. The fame of Dioskourides has lasted. He is known to have carved portraits of Julius Caesar, and one of Augustus himself. Did he also, therefore, carve the vase? Did he carve it for his imperial patron?

Augustus enjoyed—insisted on—propaganda to further his cause. He had a predilection for glass vases, and the resources to commission the finest work that craftsmen could produce. It is conceivable, therefore, that the Portland Vase was for his personal pleasure, to celebrate the myth of his divine origins. It is possible that the Portland Vase belonged to the Emperor Augustus himself.

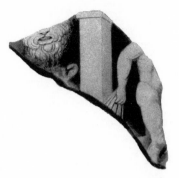

# JEROME EISENBERG
# AND SUSAN WALKER

I T MIGHT APPEAR THAT, barring accidents, the story of the vase
is over. It sits comfortably in its case in the Gallery of Roman
Antiquities, and we may be certain that its fame will ensure it a per-
manent place among the highlights of the collection. The British
Museum has given the vase a home for a couple of centuries, and it
has owned it outright for sixty years. It will not now part with one of
its most celebrated treasures, and unless the vase is the victim of
another accident, deranged attack, or "enemy action," the most it
can expect is to be carefully taken apart and put back together again
in another hundred years or so, when the current restoration has
aged, and another generation of restorers begin to look at the records
of their predecessors to discover what adhesive was used way back in
the twentieth century. Presumably the vase will stay in the museum
until civilization, or London, or both, come to an end.

But even in the foreseeable future, the story of the vase is far from over. The controversy over the significance of the figures on the vase continues to rage unabated; indeed, it rages hotter than ever, and will very possibly never come to any satisfactory conclusion. The stakes have never been higher, because as recently as 2003 an American academic, Jerome M. Eisenberg, made a startling announcement, based upon his reading of the figures, and once again the *London Times* devoted headlines to the vase. Eisenberg claimed that the vase was a fake. His theory was subsequently published in the reputable international journal *Minerva*, devoted to art and archaeology, of which Eisenberg himself is editor in chief.

Eisenberg based his theory on several points: first, the mystery surrounding the discovery of the vase, which throws doubt on its provenance; second, the multiplicity of theories regarding the interpretation of the figures, which suggest to Eisenberg that it is not the academics who are to blame for failing to come up with a convincing theory, but the fault of the creator of the vase for neglecting to design a coherent theme. Finally, Eisenberg detects what he describes as "numerous stylistic inconsistencies" between the vase and "genuine" ancient artifacts. Eisenberg maintains that the reason the figures on the vase cannot be identified is that they were made not in ancient Rome but were created during the Renaissance, when a sixteenth century artist carved the figures by copying them from various ancient works. However, this artist, whoever he was, did not have a proper understanding of classical mythology, and recklessly strewed his figures around the vase, heedless of the fact that he would be giving scholars headaches for centuries to come. According to Eisenberg, this unknown sixteenth-century craftsman adapted and misinterpreted figures from various preexisting friezes, in particular from a Roman sarcophagus of the third century A.D., which displays a scene in which Mars, the god of war, approaches Rhea Silvia, the princess who, as a result of their union, gave birth to Romulus

and Remus, the founders of Rome. The figure of Rhea on this sarcophagus does bear some resemblance to figure F on the vase; she reclines, one hand raised to her head, the lower half of her body covered in drapery.

Eisenberg also finds sources for the other figures on the vase, and other inconsistencies. Nowhere in ancient art can he find a representation of Cupid within a group where the winged god is actually in flight. Roman goddesses were usually depicted wearing sandals; the feet of all three female figures on the vase, human or divine, are bare. No male figure is depicted dropping a garment in ancient art—as figure A does—except on the vase. The serpent with figure C, Eisenberg contends, is a mixture of various different creatures, cobbled together by the Renaissance artist. The very quality of the carving undermines its ancient provenance; Eisenberg suggests that only with the Renaissance did artistic talents great enough to carve such figures arise.

Eisenberg's conclusion is that the vase was manufactured by one of the talented cameo engravers working in Rome in the sixteenth century, and produced in order to satisfy a demand for works of ancient art. He speculates that because the most powerful Roman families at that time—the Medicis, Borgheses, Farneses, and Ludovisis—had a virtual monopoly on ancient sculpture, the vase was commissioned by Fabrizio Lazzaro or Cardinal Francesco del Monte, to "upstage" others.

Eisenberg's theory is certainly ingenious, addressing as it does twin mysteries of the vase's origins and its figures. Though glass is not subject to carbon dating, which can only be used on organic matter, the glass of the vase has been scientifically analyzed in an attempt to discern its age. The opportunity to subject the vase to laboratory testing was created by Mr. Crocker of Putney, who brought the little box of glass chips back to the museum in the 1940s, forgotten since Doubleday's restoration a century before. The

research laboratory of the British Museum has examined these chips using various methods. They have been put under the electron microscope and surveyed by "non-destructive qualitative X-ray fluorescence spectroscopy." These tests achieved interesting findings; the proportion of the ingredients of the glass—soda, lime, and silica—have been shown to resemble those of other ancient Roman glassware, but these results are in no way conclusive. The only way the vase can be dated is by comparing it with other objects, in other words by interpretation. In this case Eisenberg's comparison—with the work of Renaissance artists—should be as valid as any with older works. In order to test his theory, it is necessary to examine other examples of Roman cameo glass.

Roman cameo glass vessels are rare; just over a dozen pieces exist in any state of preservation. Given the fragile nature of the medium, perhaps this is not surprising. More telling is the rarity of even fragments of cameo glass; there are less than two hundred of these. Considering the scale and wealth of Rome, and the fairly persistent activities of archaeologists and treasure hunters over the centuries, this is a startlingly small quantity. Of the few surviving pieces, two in particular bear comparison with the Portland Vase. Both are cameo works, in blue and white. Both, crucially, were discovered during the excavations in Pompeii. This means that they themselves can be confidently dated to ancient times, and to a period no later than the date of the eruption that engulfed Pompeii in A.D. 79. One of these objects is a jug, known as the Auldjo Jug, and it, too, is in the possession of the British Museum. It is not complete, nor is the carving on it as elaborate as that on the Portland Vase, but there are very strong similarities. The Auldjo Jug is decorated with a design of vine leaves, ivy, and laurel, in which small birds perch. The style of the carving is so similar to the Portland Vase that some have suggested that they are both products of the same workshop.

The other object is known as the Blue Vase. The Blue Vase is also

a cameo work in blue and white glass. It is decorated even more elaborately than the Portland Vase, with great swirls of vines and a gang of cupids who are harvesting grapes, treading on them, playing musical instruments, and generally having a gay old time. Beside the Portland Vase, this decoration looks busy and decadent. But there is one striking point of similarity. At the base of one of the scenes on the Blue Vase, and right in the center, is a square object, like a fallen pediment, with a notch cut in it; on this object rests the foot of one of the cupids. It is exactly the same as the object depicted on the Portland Vase under the foot of figure F. It is the same shape, in the same position: at the bottom of the scene, in the middle. Some researches have suggested that this object is some kind of signature, indicating that both the Portland Vase and the Blue Vase came from the same workshop.

The Blue Vase was found in Pompeii in the 1830s; its discovery was recorded because it took place during a royal visit. On December 29, 1837, Ferdinand II, King of the Two Sicilies, was inspecting the excavations, and a tomb belonging to the House of the Mosaics was opened in his presence. Inside this tomb was the Blue Vase, still containing the ashes with which it had been interred. It was the practice of the excavators to open a tomb, close it up, and re-excavate it for the benefit of watching VIPs, in order to avoid any embarrassing anticlimaxes. It is even possible that the Blue Vase was found elsewhere in the excavation, filled with ashes, and planted in the tomb, in order to impress the king. But it is beyond dispute that the Blue Vase was discovered at Pompeii, and therefore it must have been made earlier than A.D. 79. It is thus not possible that any Renaissance artist, living and working three centuries or so before the discovery of the Blue Vase, would have been aware of the images on it. Yet Eisenberg suggests that it was such an artist who created the scene on the Portland Vase, complete with its trademark fallen pediment. The coincidence is too great. Despite its stylistic differences, the Blue Vase anchors

the Portland Vase firmly in the ancient era, and Eisenberg's theory, however beguiling, cannot hold. The vase is not a fake.

Moreover, a spirited reply to his accusation was promptly forthcoming from the British Museum itself. Susan Walker, Deputy Keeper of Greek and Roman Antiquities, respectfully pointed out the strong resemblance between the iconography on the vase and that of other cameo vessels of the Roman period. She also took the opportunity to present her own, entirely original and highly persuasive theory about the figures, relating them to the politics surrounding the rise of Augustus, and claiming the vase as a work of pro-Augustan propaganda.

Walker begins with side I, which she considers to be a seduction scene; figure C reaches out to figure A, and this gesture will precipitate an erotic embrace. She points out that this seduction is taking place outdoors, and that this is very unusual in Roman art of the period. Sex—which is quite often depicted on Roman glass and silverware, as well as in the notorious wallpaintings of Pompeii—always takes place indoors. The outdoor setting is therefore significant; it implies something particularly abandoned about the behavior of the figures here. Figure C, then, is a female seducer, and of the shortlist of famous seductresses of myth and history, Walker selects the most notorious: Cleopatra. She suggests that figure C—Cleopatra, together with her "serpent of old Nile"—is reaching out to Mark Anthony, whom she famously bedded during the closing stages of the Roman civil war. Figure D is the son of Hercules, the mythical hero with whom Anthony identified; he looks on disapprovingly at the unheroic self-indulgence to which Anthony has abandoned himself.

The swooning lady on side II, figure F, is none other than Octavia, Augustus's sister. When Anthony and Augustus divided the empire between them, Octavia was given to Anthony in marriage, in order to cement this alliance. Cleopatra's superior charms did serious damage to the marriage, but in an attempt to heal the rift, Octavia, who had

been left in Rome while Anthony sported in Egypt, traveled out to meet her husband with men and money for his eastern campaigns. He took the reinforcements and packed her back off to Rome, thus providing Augustus, her outraged brother, with a pretext for war, and the final showdown between the two, which culminated at the battle of Actium. Figure E is Augustus, about to rise and revenge his abandoned sister, while figure G is Venus, who presided over the fortunes of Augustus and is now reassuring him that he will emerge the victor. According to this theory, the vase was therefore commissioned by, if not the emperor himself, someone close to his cause, after the victory at Actium, in order to commemorate the struggles that Augustus had successfully overcome, and this dark moment in the fortunes of his family.

It is quite remarkable, and a testimony to both Susan Walker's learning and the endless fascination of the vase, that even now after so many theories have been proposed, a fresh, entirely new, and perfectly plausible hypothesis can be concocted. The game, it would seem, can be played indefinitely. Whatever the relative merits of any interpretation, the truth is that there can be no final, definitive solution, because the necessary knowledge is lost to us; perhaps Bernard Ashmole came closest to the mystery when he suggested this. There are not enough clear attributes given to the figures on the vase to allow us to identify them with any certainty. There are, however, just enough clues to tempt us to try, and try we have, and will; it is our nature. In this respect, the story of the vase can have no ending until the limits of human ingenuity are reached, and human ingenuity may well prove to be infinite.

# THE BASE

# EPILOGUE

Picture, if you will, the many people who have owned the vase over the course of two millennia, all standing in a kind of timeline, queuing up within the Greek and Roman galleries of the British Museum. At the beginning of the line, away down the far end of the gallery, is an anonymous Roman glassblower in his leather smock. Next to him stands the "diatretarius," or engraver, perhaps Dioskourides himself; then Augustus Caesar, in his simple robe. A shadowy parade of later Caesars continues the line, ending—if the story of the finding of the vase has any truth—with Alexander Severus, the well-meaning but doomed young paragon.

At this point there is an abrupt change; the next figure has exchanged Roman robes for sixteenth-century britches and stockings. He is Fabrizio Lazzaro, holding his lantern and his shovel, and after him comes Cardinal del Monte, in his robes and affablility, and Maffeo Barberini, wearing the tiara and flanked by his nephews. Several generations of Barberini follow, gradually less sumptuously dressed, until we reach the cash-strapped figure of Donna Cornelia

Barberini-Colonna, Princess of Palestrina. Here the line changes again. Italian faces give way to northern ones: the dry and vinegary aspect of James Byres; tall, beaky Sir William Hamilton, with the Star of the Garter on his chest, young and lovely Emma on his arm, and an ironical gleam in his eye. After him, the dumpy figure of the Duchess of Portland, swaddled in her seven cloaks, and accompanied by her bonneted and scissor-wielding companion. Then comes the line of dukes: the third, frowning with the demands of office; the fourth, hale and hearty in his riding boots; the fifth, in his tall beaver hat, exuding strange melancholy; the sixth, peering into cabinets, and finally the seventh, after whom there are no owners of the vase, only guardians in the form of the Keepers of the British Museum—at first tweedy, smoking a pipe, then a cigarette; then dressed like you and me. Other figures stand beside the line, or prowl around it: John Doubleday with his adhesives; John Northwood and William Blake with their engraving tools; Josiah Wedgwood with his jasper copy; Cassiano dal Pozzo clutching pages from his paper museum; Tommaso Campanella in his magician's robes, and, lurking over behind a display case, the trembling figure of William Mulcahy, clutching his lump of basalt.

According to the nobly democratic principles of the museum, the vase now belongs to us all. Indeed, in order to fight off the claims of nations who are in the habit of asking for their treasures back, the musem declares that it houses a collection that belongs to the whole world; so if you go and stand by the case in which it still sits, you can put yourself at the end of this line, part owner and descendant— however indirectly—of all previous owners. The vase is our inheritance, a symbol of and participant in the last two millennia of the fortunes and follies of the whole human family. It survives as does the race, changed but still the same, flawed and beautiful, full of incident, and somewhat mysterious. Perhaps you would like to take it home, in your imagination, and put some flowers in it.

# BIBLIOGRAPHY

Ackroyd, Peter. *Blake*. London: Sinclair-Stevenson, 1995.

Anson, E., and F. Anson, eds. *Mary Hamilton. From Letters and Diaries*. London: J. Murray., 1925.

Ashmole, Bernard. "A New Interpretation of the Portland Vase." *Journal of Hellenic Studies* 87 (1967).

Beard, Geoffrey. W. *Nineteenth Century Cameo Glass*. Newport, Eng.: Ceramic Book Co., 1956.

Bimson, Mavis, and Ian Freestone. "An Analytical Study of the Relationship Between the Portland Vase and Other Roman Glass Cameos." *Journal of Glass Studies* 25 (1983).

Black, Jeffrey. *The British Abroad: The Grand Tour in the Eighteenth Century*. New York: St. Martin's Press, 1992.

Blunt, Anthony. *Nicolas Poussin*. New York: Boulingen Foundation, 1967.

Brown, E. L. "The Portland Vase." *American Journal of Archaeology* 74 (1970).

Castiglione, Baldasarre. *The Book of the Courtier*. Translated by Thomas Hoby. London: Dent, 1974.

Caygill, Marjorie. "Whodunit?" *British Museum Society Bulletin* 48 (1985).

————. *Treasures of the British Museum*. New York: H. N. Abrams, 1985.

Caygill, Marjorie, and Christopher Date. *Building the British Museum*. London: British Museum, 1999.

Constantine, David. *Fields of Fire: A Life of Sir William Hamilton*. London: Weidenfeld and Nicolson, 2001.

Clairmont, C. W. "A Note on the Portland Vase." *American Journal of Archaeology* 72 (1968).

Clarke, Michael, and Nicholas Penny, eds. *The Arrogant Connoisseur: Richard Payne Knight, 1751–1824*. Manchester: Manchester University Press, 1982.

Farrer, K., ed. *Correspondence of Josiah Wedgwood 1781–94*.

Fothergill, Brian. *Sir William Hamilton*. New: Harcourt, Brace and World, 1969.

————. *Walpole and His Circle*. Boston: Faber and Faber, 1983.

Gibbon, Edward. *Memoirs*. Edited by Henry Morley. Lonson: Routledge, 1891.

Goethe, Johann. *Travels in Italy*. Translated by Morrison and Nisbet. London: Bell and Sons, 1892.

Grabsky, Phil. *I, Caesar*. Parkwest, N.Y.: BBC Books, 1998.

Gray, John M. *James and William Tassie: Jem Cutters*. Edinburgh: n.p., 1894.

Harden, Donald B. *Glass of the Caesars*. Milan: Olivetti, 1987.

————. *Masterpieces of Glass*. London: British Museum, 1968.

Harrison, E. B. "The Portland Vase: Thinking It Over." *Essays in Archaeology*. Mainz: 1976.

Haskell, Francis. *Patrons and Painters: A Study in the Relations Between Italian Art and Society in the Age of the Baroque*. New Haven, Conn.: Yale University Press, 1980.

Haynes, Denys Eyre Lankester. *The Portland Vase*. London: British Museum, 1975.

Hibbert, Christopher. *The Grand Tour*. New York: G. P. Putnam's Sons, 1969.

Hind, J. G. F. "Greek and Roman Epic Scenes on the Portland Vase." *Journal of Hellenic Studies* 99 (1979.)

Ingamells, John, ed. *A Dictionary of British and Irish Travellers in Italy*. New Haven, Conn.: Yale University Press, 1997.

Jenkins, Ian D., ed. *Vases and Volcanoes. London:* British Museum, 1996.

Karslake, B. "Early Days of the Portland Vase." *Country Life* 171 (1982).

Langdon, Helen. *Caravaggio, A Life.* New York: Farrar, Straus and Giroux, 1999.

Leppmann, Wolfgang. *Winckelmann.* London: Victor Gollanz, 1971.

Lewis, S., ed. *Catalogue to the Sale of the Duchess of Portland's Museum.* New York: Grolier.

Llanover, Lady. *The Autobiography and Correspondence of Mary Granville, Mrs. Delaney.* London: R. Bentley, 1862.

Magnusson, Torgil. *Rome in the Age of Bernini.* Stockholm: Almquist and Wiksell International, 1982.

Mankowitz, Wolf. *The Portland Vase and the Wedgwood Copies.* London: Deutsch, 1952.

Miller, Edward. *That Noble Cabinet: A History of the British Museum.* London: Deutsch, 1973.

Miller, Peter N. *Peiresc's Europe: Learning and Virtue in the Seventeenth Century.* New Haven, Conn.: Yale University Press, 2000.

Moore, John. *A View of Society and Manners in Italy.* London: n.p., 1790.

Mowl, Timothy. *Horace Walpole: The Great Outsider.* London: Murray, 1996.

Newby, Martine, ed. *Early Imperial Roman Glass.* London: 1990.

Newby, Martine, and Kenneth Painter, eds. *Roman Glass: Two Centuries of Art and Invention.* London: Society of Antiquaries of London, 1991.

Neuburg, Frederic. *Ancient Glass.* Translated by Michael Bullock and Alissa Jaffa London: Barrie and Rockliff, 1962.

Nicolson, Harold. *The Age of Reason.* London: Constable, 1960.

Northwood, J. II. "Noteworthy Productions of the Glass Craftsman's Art: The Reproduction of the Portland Vase." *Journal of the Society of Glass Technology* 8 (1924).

Pastor, Ludwig von. *History of the Popes.* Translated by Frederick Ignatius Antrobus and Ralph Kerr. St. Louis, Mo.: B. Herder, 1902.

Portland, William John Arthur Charles James Cavendish-Bentinck, Duke of. *Men, Women and Things: Memories of the Duke of Portland.* London: Faber and Faber, 1938.

Ranke, Leopold von. *The Ecclesiastical and Political History of the Popes of Rome.* Translated by Sarah Austin. London: n.p., 1868.

Raspe, Rudolf Erich. *A Descriptive Catalogue of Engraved Gems.* London: J. Tassie, 1791.

Reilly, Robin. *Josiah Wedgwood.* London: Macmillan, 1992.

———. *Wedgwood: The New Illustrated Dictionary.* Woodbridge, Suffolk: Antique Collector's Club, 1995.

Reston, James. *Galileo, A Life.* London: Cassell, 1994.

Schnapp, Alain. *The Discovery of the Past.* London: British Museum, 1996.

Scott, John B. *Images of Nepotism: The Painted Ceilings of Palazzo Barberini.* Princeton, N.J.: Princeton University Press, 1991.

Smart, J. D. "The Portland Vase Again." *Journal of Hellenic Studies* 104 (1984).

Stuart-Jones, Henry. "The British School at Rome." *The Atheneum* 4244 (1909).

Suetonius. *The Lives of the Twelve Caesars.* Translated by Alexander Thomson. London: Bell and Sons, 1903.

Tassie, James. *A Catalogue of Impressions in Sulphur.* London: n.p., 1775.

Trethewey, Rachel. *Mistress of the Arts.* London: Review, 2002.

Turberville, Arthur Stanley. *A History of Welbeck Abbey.* London: Faber and Faber, 1939.

Vermeule, Cornelius C. *European Art and the Classical Past.* Cambridge, Mass.: Harvard University Press, 1964.

Vose, Rose Hurst. *Glass.* London: Collins, 1980.

Walker, Daniel Pickering. *Spiritual and Demonic Magic.* Notre Dame, Ind.: University of Notre Dame Press, 1975.

Wedgwood, Josiah. *Reprint of a Description of the Portland Vase.* London: n.p., 1845.

Whitehouse, David B., ed. *Journal of Glass Studies.* Vol. 32. Corning, N.Y.: Corning Museum of Glass, 1990.

Williams, Nigel. *The Breaking and Remaking of the Portland Vase.* London: British Museum, 1989.

Wilson, Mona. *The Life of William Blake.* New York: Oxford University Press, 1971.

Windus, Thomas. *A New Elucidation of the Subjects on the Celebrated Portland Vase.* London: W. Pickering., 1845.

Zanker, Paul. *The Power of Images in the Age of Augustus.* Translated by Alan Shapiro. Ann Arbor, Mich.: University of Michigan Press, 1998.

# ACKNOWLEDGMENTS

Thanks to the British Museum, for permission to use the images of the vase, and in particular to Dr. Susan Walker, deputy curator of the Department of Greek and Roman Antiquities. Of all the sources used, a special debt of gratitude is owed to the experts who compiled the *Journal of Glass Studies*, volume 32, the most thorough and scholarly account of the vase in all its aspects: William Gudenrath, Kenneth Painter, David Whitehouse, and Ian C. Freestone. Special thanks also to Scott Waxman; to Simon Trewin at PFD; to my wife, Fiona McAlpine, for all her encouragement and support; and last and least to Clive Brill.

# INDEX

Delaney's flower pictures in, 130
first restoration of vase at,
169–70, 205, 206, 207
Hamilton vase collection and,
103, 137
Northwood and, 184
Portland Vase on loan at, 167
Portland Vase smashed at, 9–19,
172–73
purchases Portland Vase, 198–99
second restoration of vase at,
199–200
third restoration of vase at,
205–9
WW II and, 196–98
British Parliament, 103
House of Lords, 161–62
British Royal Academy, 147, 154
British Royal Library, 65
British Royal Navy, 168
British Royal Society, 103, 145, 147
British School at Rome, 32–33
Bulstrode Park, 127, 128, 130, 167
Bunyan, 153
Burghley, ninth earl of, 95
Burghley, tenth earl of, 95
Burke, Edmund, 162
Bute, count of, 161
Byres, James, 80, 82–89, 101, 119,
228
buys Portland Vase, 88–89
commissions copies of Portland
Vase, 90–91, 95, 98
on crafting of Portland Vase,
87–88
sells Portland Vase to Hamilton,
98, 104–5, 114, 118

Byres, Patrick, lord of Tonley,
80–82
Byron, Lord, 92

Caesar, Julius, 23, 75, 212, 213
cameo glass, 187
ancient Roman, compared with
Portland Vase, 220–23
origin and process of, 22–24
16th century Roman, 219
Campanella, Tommaso, 59–61, 228
Capitelli, Bernardino, 73
Capitoline Museum, 33
Capricorn, 211
Caravaggio, 39–41
Carthaginian Wars, 205
Casanova, 79
Castiglione, 37
*Castle of Otranto, The* (Walpole), 124
Castor, 72, 110
*Catalogue of Impressions in Sulphur of
Antiques and Modern Gems*
(Tassie), 91–92
Catherine the Great, empress of
Russia, 92, 117
Catullus (poet), 77, 173
Causeus, Michael Angelus, 69–70
Cavendish-Bentinck, Edward "Jolly
Heart," 134, 160–61, 168
Centini, Cardinal Felice, 59
Centini, Giacinto, 59
Cerberus, 110
Ceres, 70, 71
Cesi, Prince Federico, 62, 63
Charles I, king of England, 131,
132
Charles II, king of England, 131